25 HOUSES

UNDER 1500 SQUARE FEET

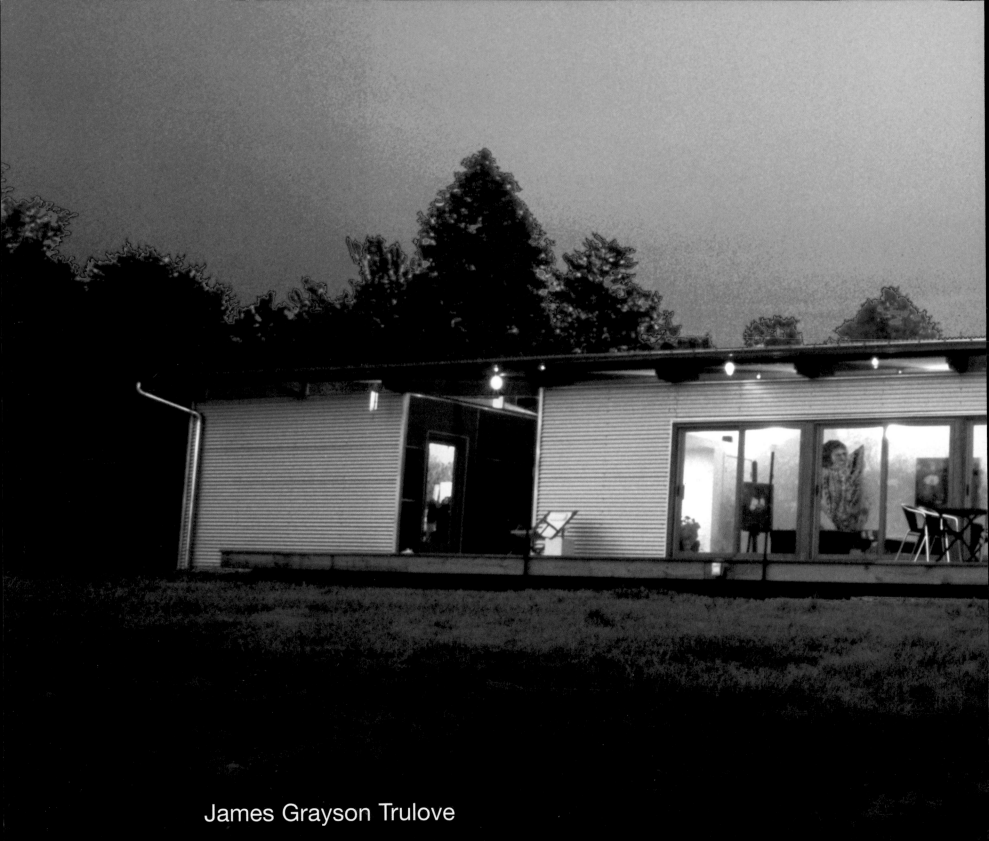

James Grayson Trulove

25 HOUSES

UNDER 1500 SQUARE FEET

HDi

HARPER
DESIGN
international

25 HOUSES UNDER 1500 SQUARE FEET
COPYRIGHT 2004 © BY JAMES GRAYSON TRULOVE AND
HARPER DESIGN INTERNATIONAL

PUBLISHED IN 2004 BY
HARPER DESIGN INTERNATIONAL, AN IMPRINT OF
HARPERCOLLINS PUBLISHERS
10 EAST 53RD STREET
NEW YORK, NEW YORK 10022-5299

DISTRIBUTED THROUGHOUT THE WORLD BY:
HARPERCOLLINS INTERNATIONAL
10 EAST 53RD STREET
NEW YORK, NY 10022
FAX: (212) 207-7654

HARPERCOLLINS BOOKS MAY BE PURCHASED FOR EDUCATIONAL, BUSI-
NESS, OR SALES PROMOTIONAL USE. FOR INFORMATION, PLEASE WRITE:
SPECIAL MARKETS DEPARTMENT, HARPERCOLLINS PUBLISHERS INC.,
10 EAST 53RD STREET, NEW YORK, NY 10022.

PACKAGED BY:
GRAYSON PUBLISHING, LLC
JAMES G. TRULOVE, PUBLISHER
1250 28TH STREET NW
WASHINGTON, DC 20007
202-337-1380
JTRULOVE@AOL.COM

LIBRARY OF CONGRESS CONTROL NUMBER: 2004109426

ISBN: 0-06-074506-1

MANUFACTURED IN SOUTH KOREA
FIRST PRINTING, 2004
1 2 3 4 5 6 7 8 9 / 06 05 04 03

FULL TITLE PAGE: STRAWBERRY FIELD;
PHOTOGRAPH BY JIM ROUNSEVELL

THE AUTHOR WOULD LIKE TO EXPRESS HIS
GRATITUDE TO ARCHITECT JOHN RIODIAN FOR
HIS INVALUABLE ASSISTANCE IN LOCATING
MANY OF THE PROJECTS IN THIS BOOK.

CONTENTS

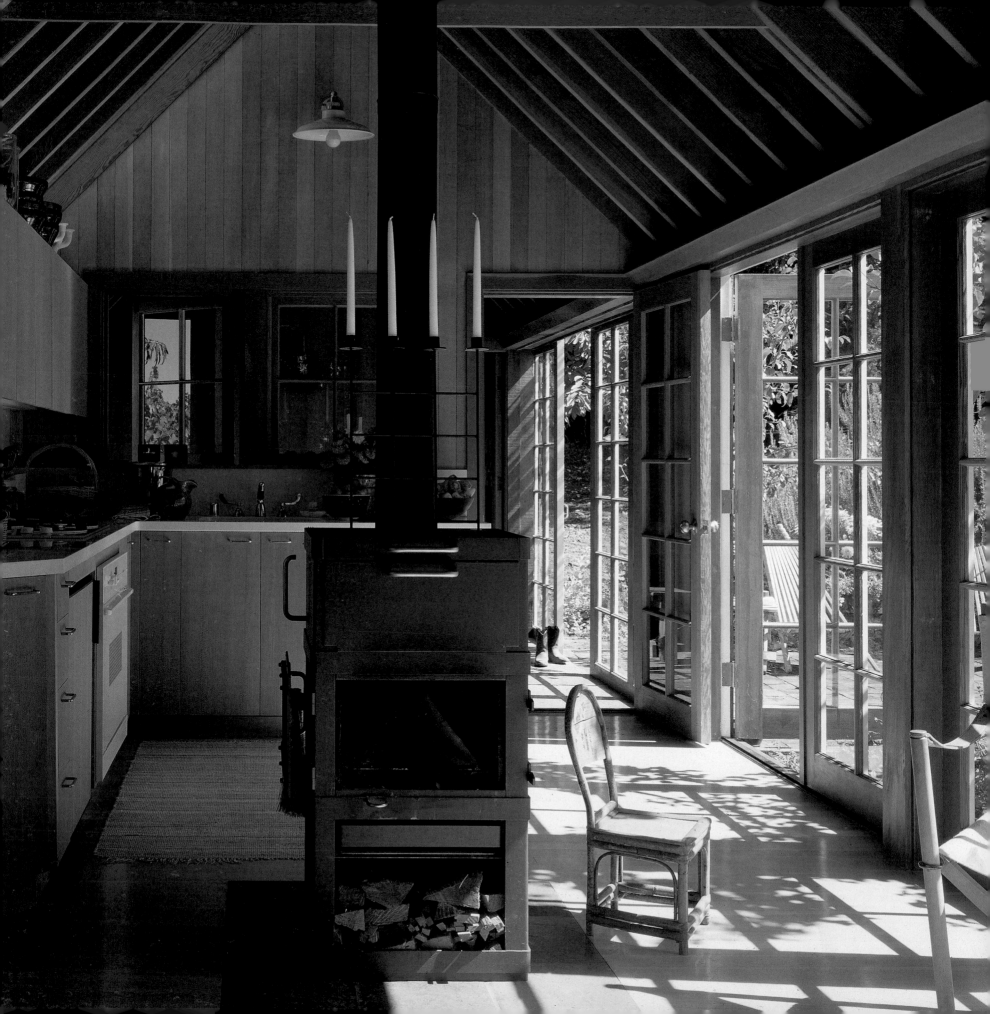

FOREWORD

IN MY PREVIOUS BOOK, 25 HOUSES UNDER 2500 SQUARE FEET, I LAMENTED THE TREND TOWARD BUILDING EVER LARGER HOUSES FOR EVER SMALLER HOUSEHOLDS, AND ARGUED THAT MUCH JOY CAN BE FOUND IN LIVING IN COMPACT, WELL-DESIGNED SPACES. THE SUCCESS OF THAT BOOK HAS LED TO THIS VOLUME, WHICH LOOKS AT PROPERTIES RANGING IN SIZE FROM 640 SQUARE FEET TO 1,500 SQUARE FEET WITH AN AVERAGE SIZE OF AROUND 1,200 SQUARE FEET.

IN RESEARCHING THIS BOOK, I WAS AMAZED AT THE NUMBER OF ARCHITECTS DESIGNING SUCH SMALL HOMES AND I WAS EQUALLY SURPRISED AT THE RELATIVELY LARGE AMOUNT OF PROGRAM THAT COULD BE ACCOMMODATED—AS MANY AS THREE BEDROOMS AND THREE BATHS, IN ONE CASE. THE RANGE OF USES FOR THESE SMALL BUILDINGS IS EQUALLY IMPRESSIVE. AS WOULD BE EXPECTED, MANY ARE USED FOR VACATION HOMES, BUT EMPTY NESTERS ALSO FIND THAT, PROPERLY DESIGNED, THEY ARE SUITABLE FOR YEAR-ROUND LIVING. THEY ARE IDEAL AS GUESTHOUSES AND SPECIALTY USES SUCH AS GARDEN HOUSES AND LIBRARIES ARE ALSO COMMON.

ALL OF THE PROJECTS IN THIS BOOK SHARE ONE THING IN COMMON: THEY ARE ALL WELL DESIGNED. SPACES ARE CAREFULLY CONCEIVED, AND ARCHITECTURAL SURPRISES ABOUND. APPEARING SMALL FROM THE OUTSIDE, THE INTERIORS OFTEN SOAR TO DOUBLE-HEIGHT SPACES. EXTENSIVE USE OF GLASS—CLEAR OR TRANSLUCENT—VISUALLY PULL OTHERWISE TIGHT INTERIORS INTO THE LANDSCAPE. CAREFUL FINISHING AND DETAILING RESULT IN JEWEL BOX—LIKE REFINEMENT. MANY OF THEM ARE LABORS OF LOVE BECAUSE THE OWNERS HAVE PUT THEIR OWN SWEAT INTO BUILDING THEM.

Left: Teviot Springs; photography by Mark Darley

Long Meadow

1200 Square Feet

Turnbull Griffin & Haesloop Architects

Photography: Cesar Rubio

LONG MEADOW RANCH IS A FAMILY FARM, CATTLE RANCH, AND VINEYARD LOCATED ON THE WEST SIDE OF THE NAPA VALLEY AT THE FOOT OF THE MAYACAMUS MOUNTAINS. THE GUESTHOUSE IS THE FIRST VISIBLE BUILDING, MARKING THE CORNER OF THE RANCH.

THE ROOMS OF THE DWELLING ARE ORGANIZED ALONG THE CONTOUR OF THE HILL, ALLOWING THE LIVING AREA TO OPEN OUT TO THE MEADOW ABOVE AND VIEW OF THE VALLEY BELOW. THE BEDROOMS ARE LOCATED AT EITHER END OF THE HOUSE WITH UPPER LOFT WINDOWS THAT OPEN INTO THE LIVING ROOM, REINFORCING THE OUTDOOR QUALITY OF THE CENTRAL SPACE.

THE CONSTRUCTION IS WOOD FRAME WITH VERTICAL WOOD SIDING PAINTED TO MATCH EXISTING FARM BUILDINGS. THE TWO END GABLE WALLS ARE ARTICULATED TO RESPOND TO THE DIFFERENT EXTERIOR CONDITIONS. THE LARGE WINDOW WALL OPENS TO THE VIEW OF THE FOREST, AND THE 'GREEN' TRELLIS WALL FRONTS ONTO THE RIDING ARENA.

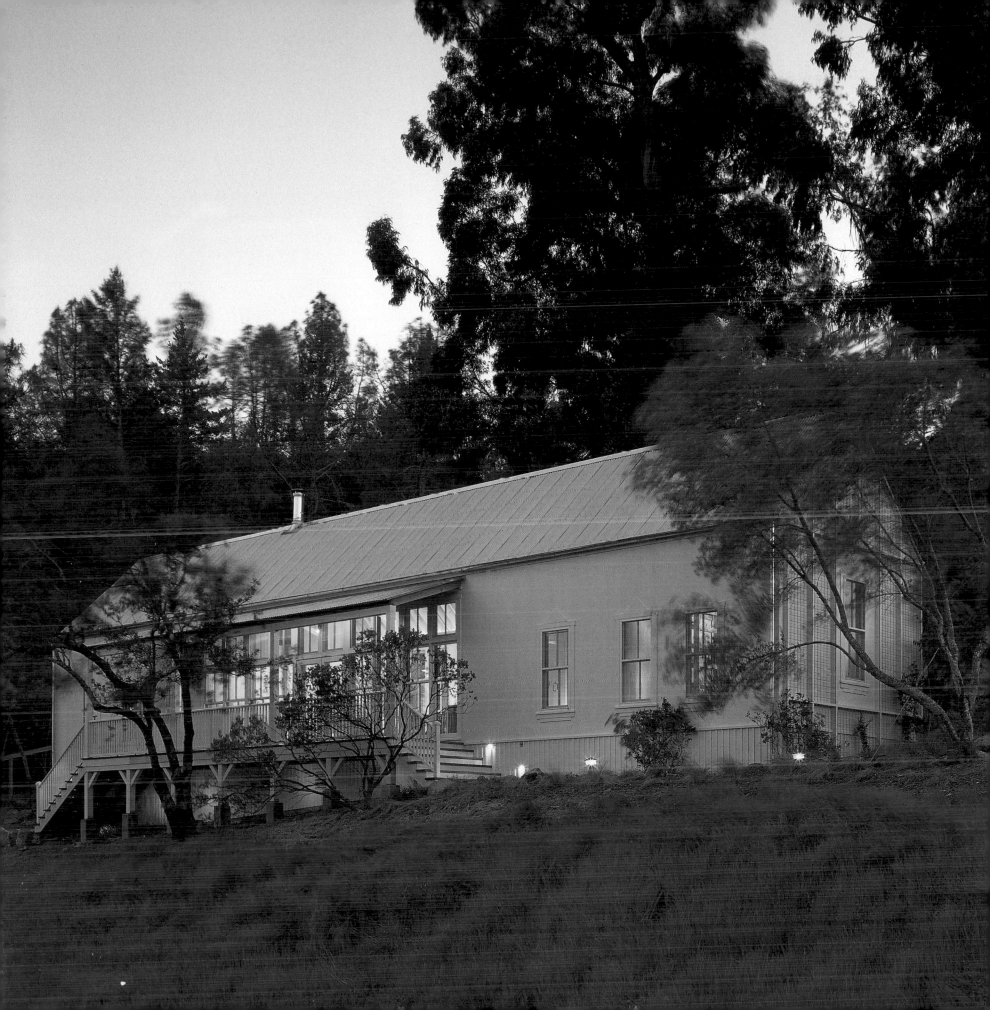

Axonometric

Previous Pages: The entry façade at dusk.
Below: Side elevation
Right: Rear elevation

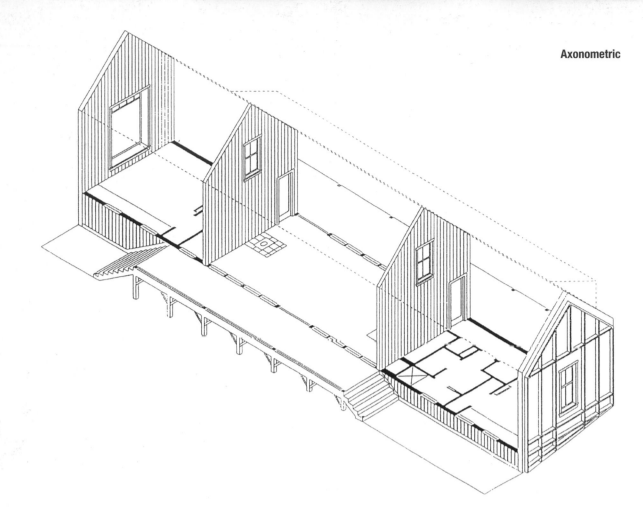

Elevation

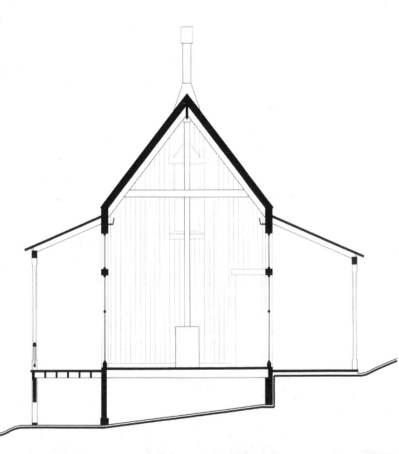

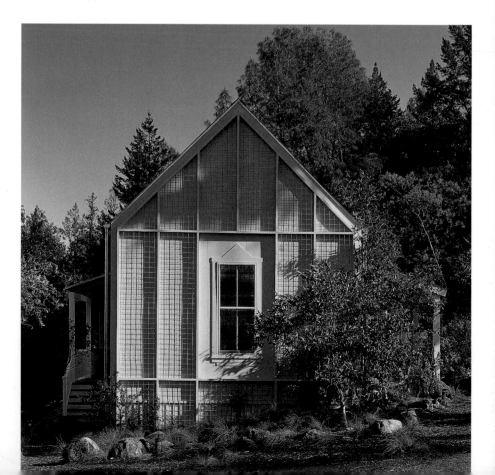

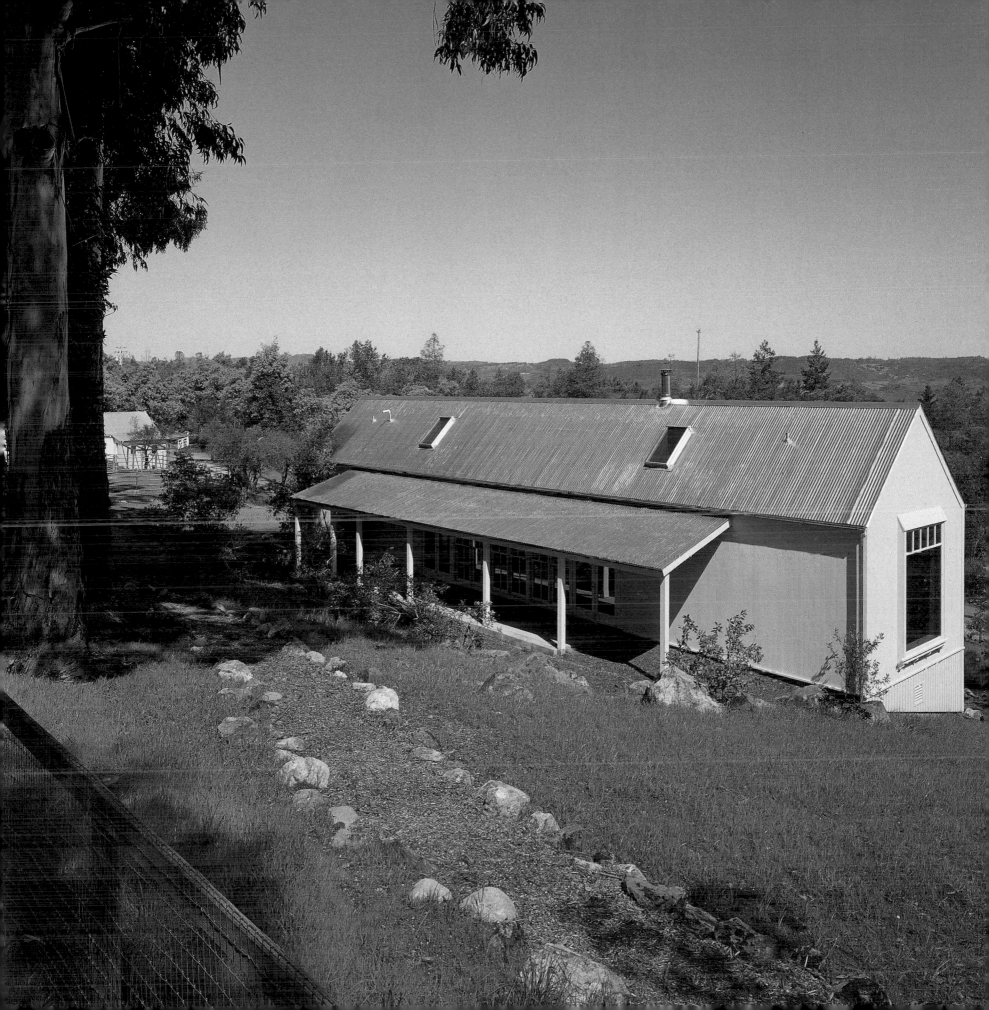

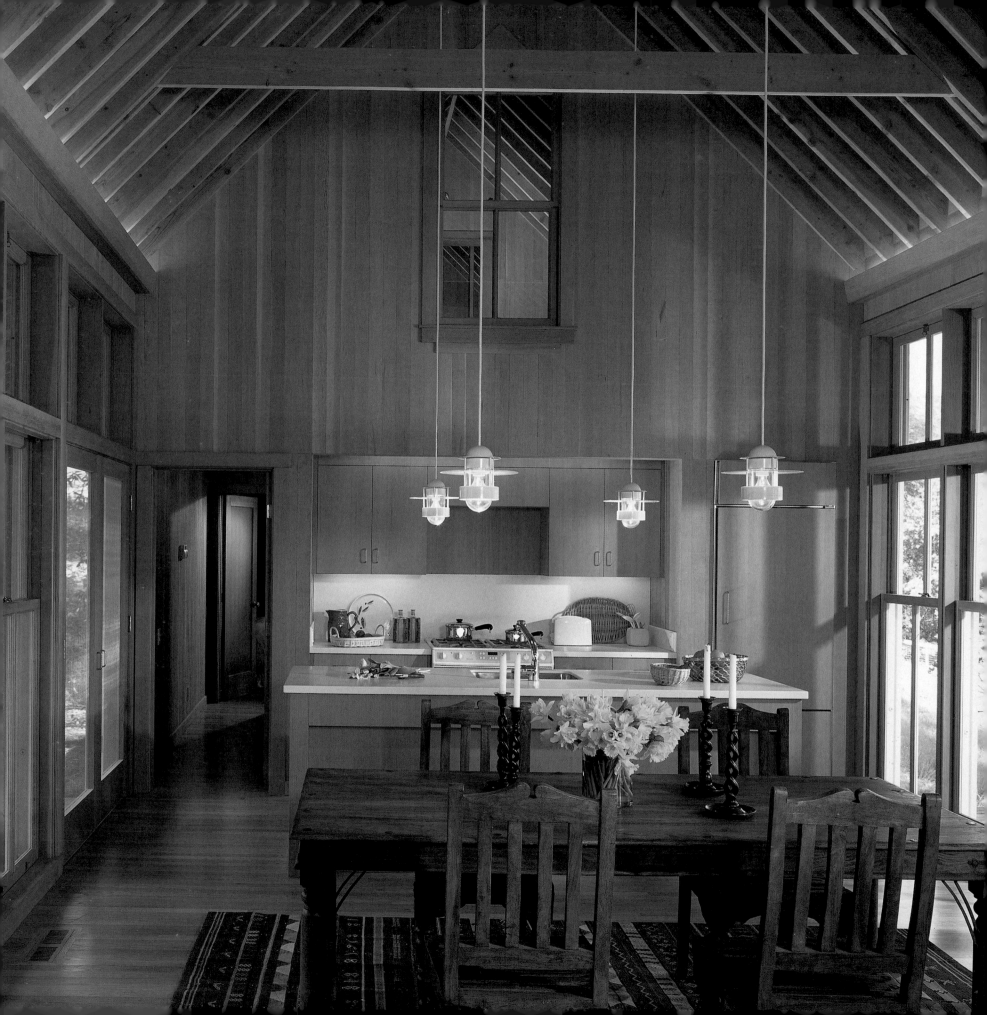

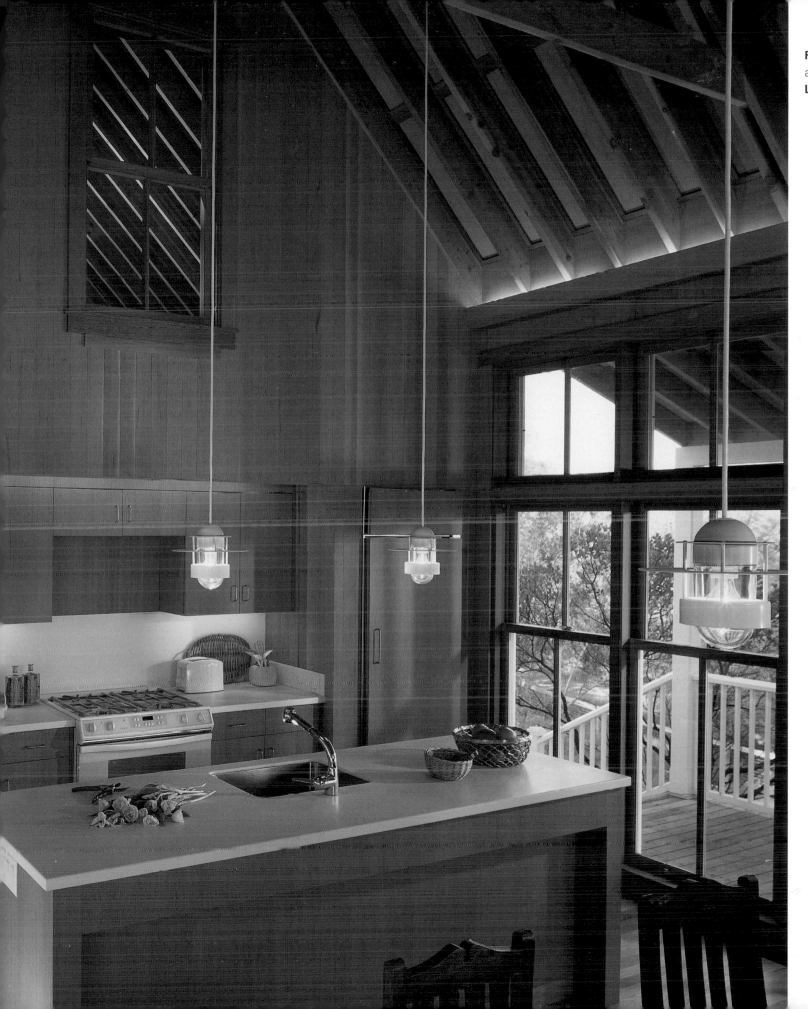

7

Marsh Pavilion

915 Square Feet

Centerbrook Architects and Planners

Photography: Norman McGrath, Scott Francis, James Van Sweden

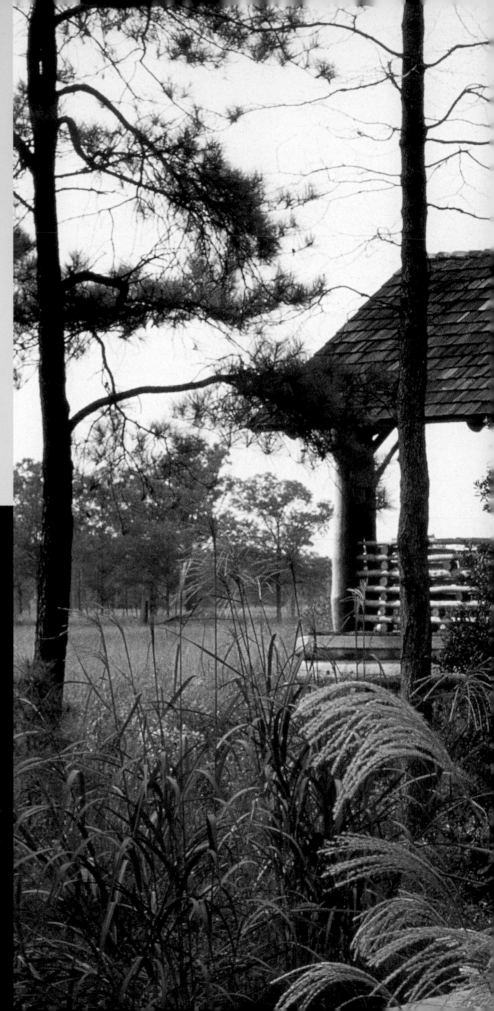

LOCATED SEVERAL HUNDRED FEET FROM A MUCH GRANDER LODGE, THIS PAVILION WAS DESIGNED PRIMARILY AS A BREAKFAST OR TEA HOUSE FOR QUIET ESCAPE FROM THE BUSY LODGE. IT ALSO SERVES AS A SECLUDED GUESTHOUSE ON THIS 3,000-ACRE ESTATE SET IN MID-ATLANTIC MARSHES AND LOW-LYING FORESTS.

THE PAVILION IS A WHITE OAK LOG CABIN WITH A CEDAR SHAKE ROOF AND A PRESSURE-TREATED YELLOW PINE DECK. IT IS POSITIONED TO ALLOW SWEEPING VIEWS OF THE WILDLIFE ACTIVITY OVER THE MARSHES. PORCHES ON THE FRONT AND BACK GABLE ENDS EACH USE NOVEL STRUCTURES TO HOLD THE ROOF OVERHANGS.

WITHIN THE PAVILION, THE SITTING ROOM HAS FRENCH DOORS ON THREE SIDES AND CENTERS ON A COPPER-CLAD FIREPLACE ON THE FOURTH SIDE. THERE IS ALSO A CLOSET AND A SKYLIT BATHROOM.

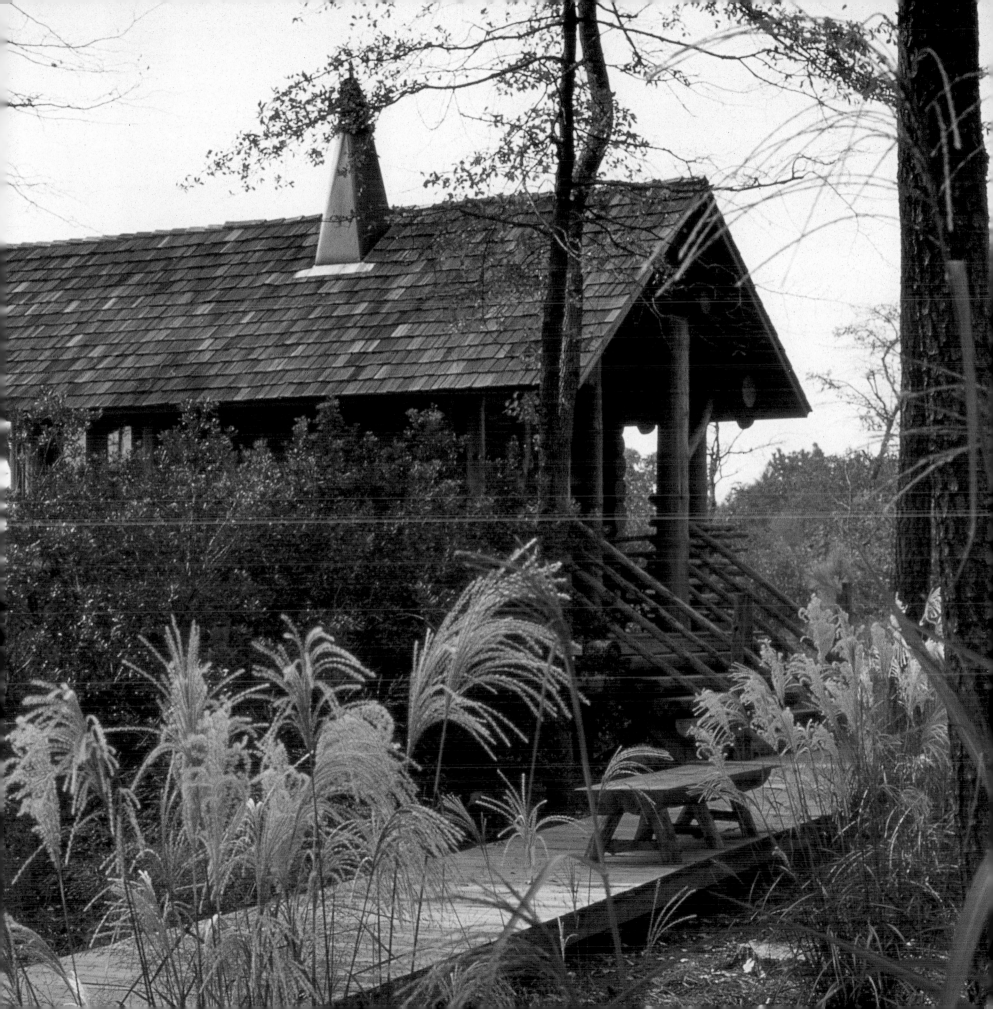

Floor Plan

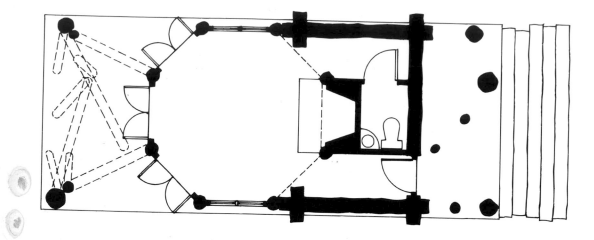

Previous Pages: The log pavilion is nestled among the marshes.
Below and Right: It has front and back porches with deep overhangs.

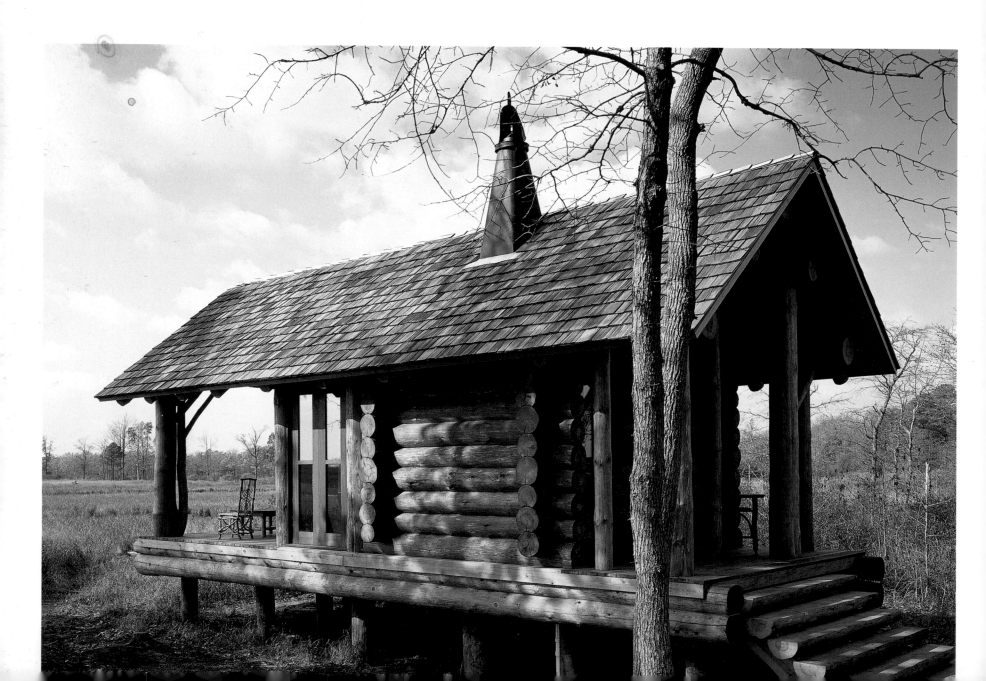

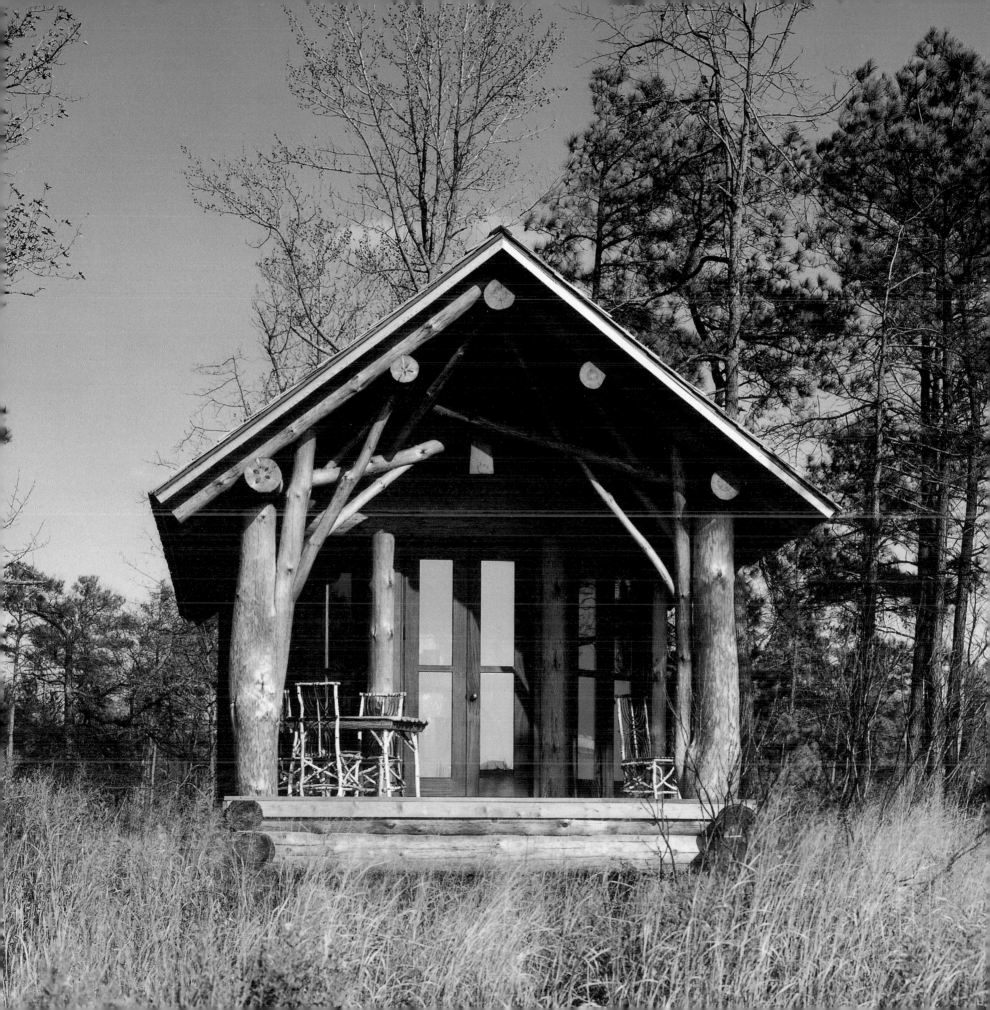

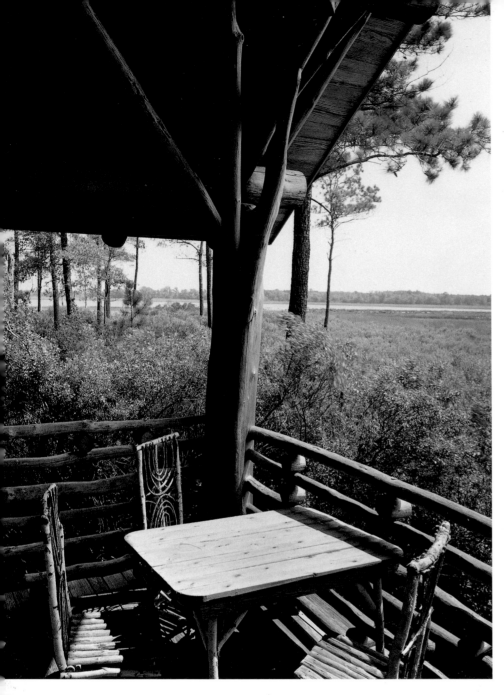

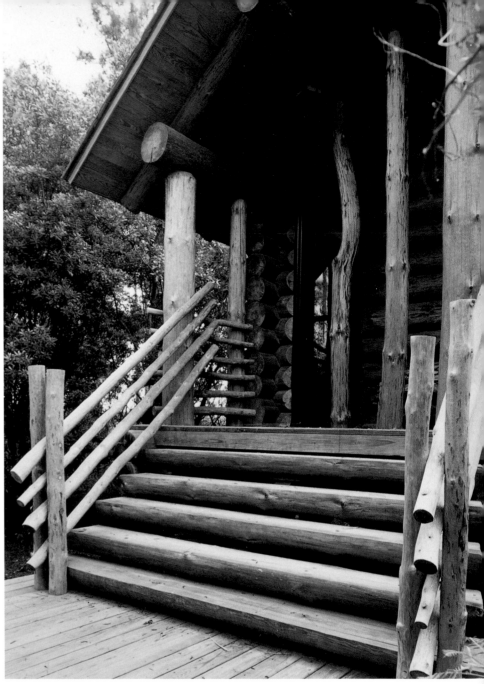

Above Left: The porches
provide a platform for
viewing wildlife.
Above: Entry
Right: The copper-clad
fireplace

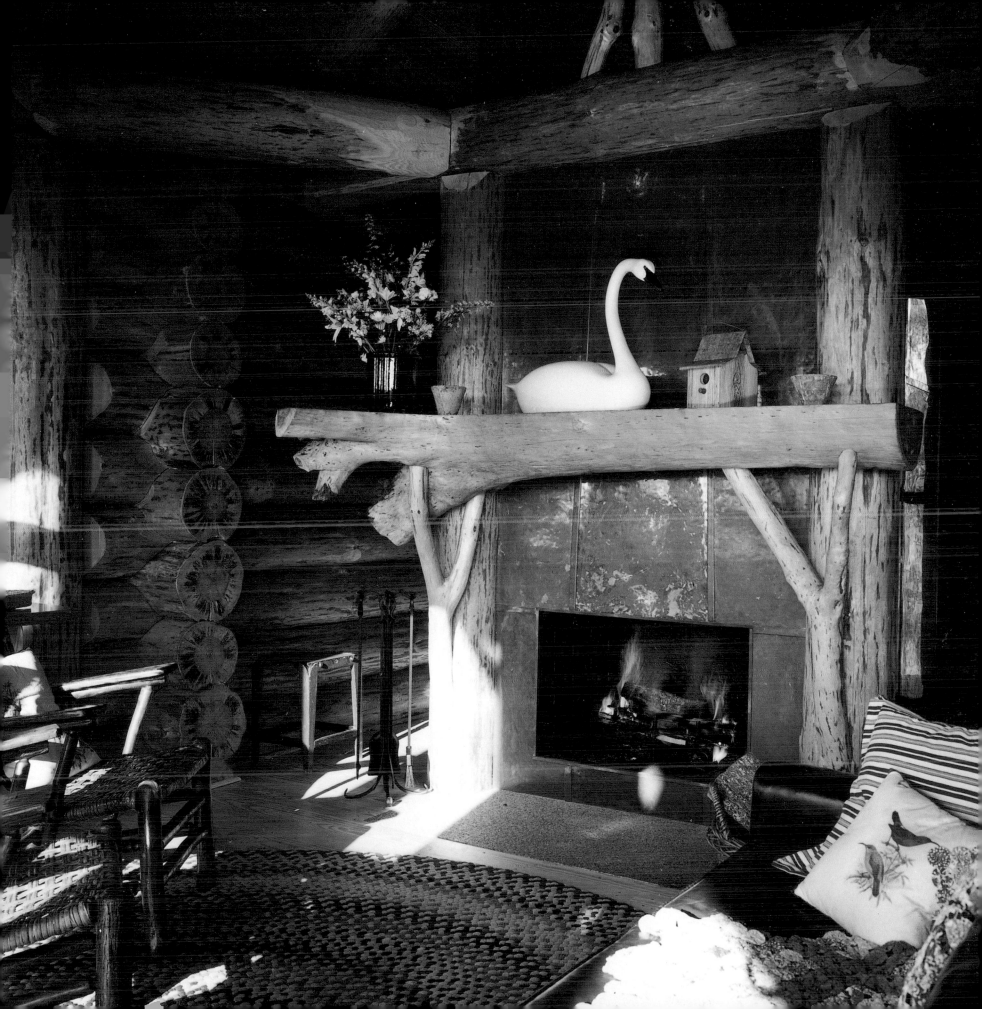

Mihalyo/Han House

1350 Square Feet

Lead Pencil Studio
Photography: Philip Newton

AN EXTREMELY LIMITED BUDGET—ONLY $70,000—MEANT THAT THE ARCHITECT-OWNERS UNDERTOOK MOST OF THE WORK THEMSELVES TO BUILD THIS HOUSE. RESEMBLING AN INDUSTRIAL LOFT MORE THAN A BUNGALOW IN SUBURBIA, WHERE IT IS LOCATED, IT IS A THOROUGHLY INTEGRATED LIVE/WORK SPACE FOR THE COUPLE, SERVING AS AN ARCHITECTURE AND SCULPTURE STUDIO AS WELL AS HOME.

IN KEEPING WITH THEIR DESIRE TO CREATE A SUSTAINABLE PIECE OF ARCHITECTURE, THEY RECYCLED EVERYTHING FROM BATHROOM FIXTURES TO THE FRONT DOORS. INSULATION IS DOUBLE WHAT THE LOCAL BUILDING CODES REQUIRE, AND A SOUTH FACING PASSIVE SOLAR WINDOW PROVIDES ADDED WARMTH DURING THE WINTER. ADDITIONAL COMFORT IS PROVIDED BY RADIANT HEATING IN THE GROUND-LEVEL CONCRETE FLOOR.

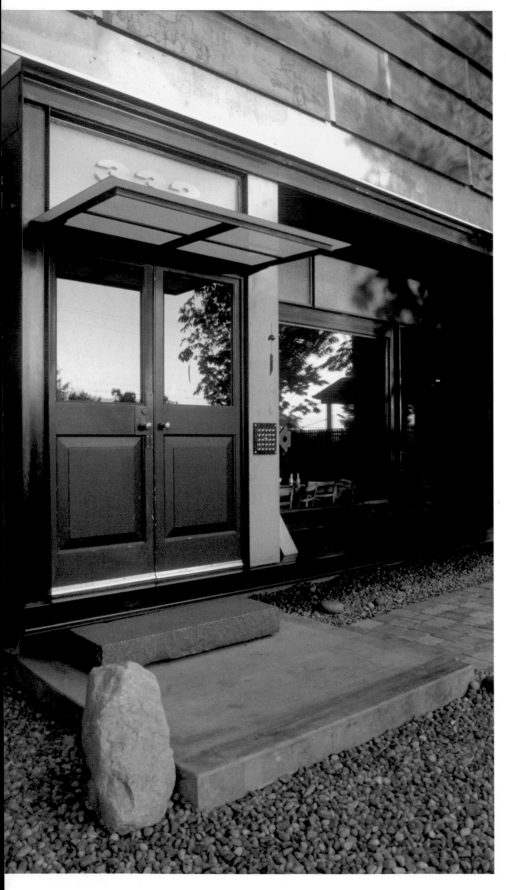

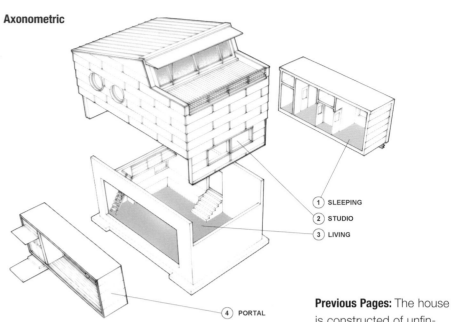

1 SLEEPING
2 STUDIO
3 LIVING

4 PORTAL

Previous Pages: The house is constructed of unfinished wood, steel, and concrete.
Left: Entrance
Below: Window detail
Right: View of dining area and terrace

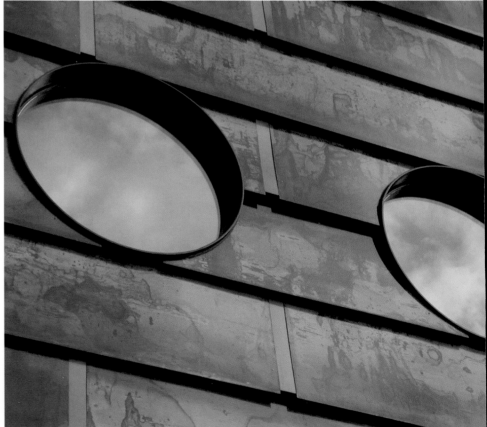

First Floor Plan

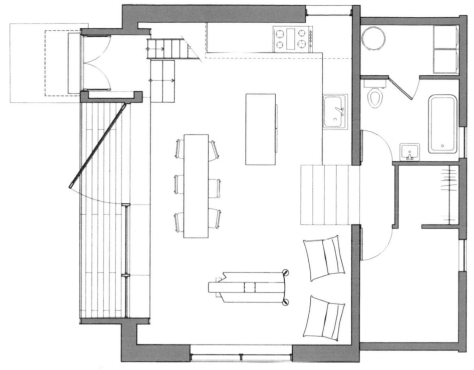

Second Floor Plan

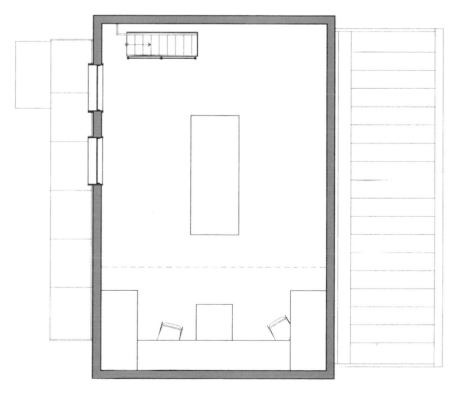

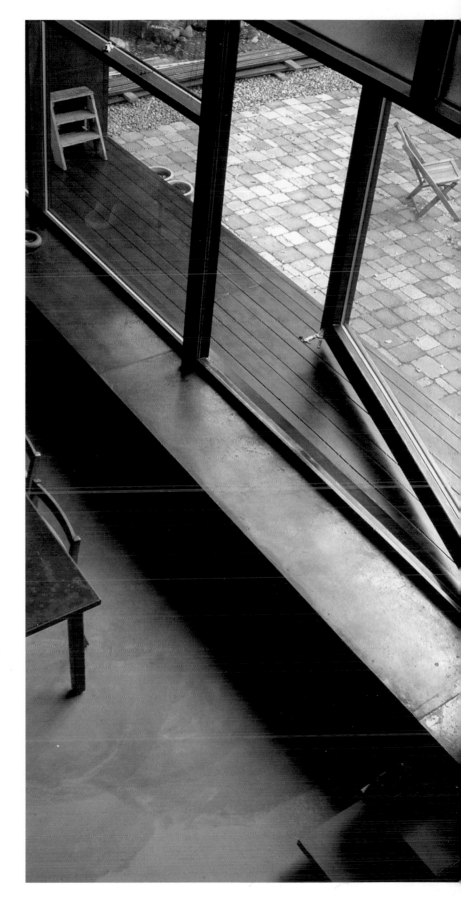

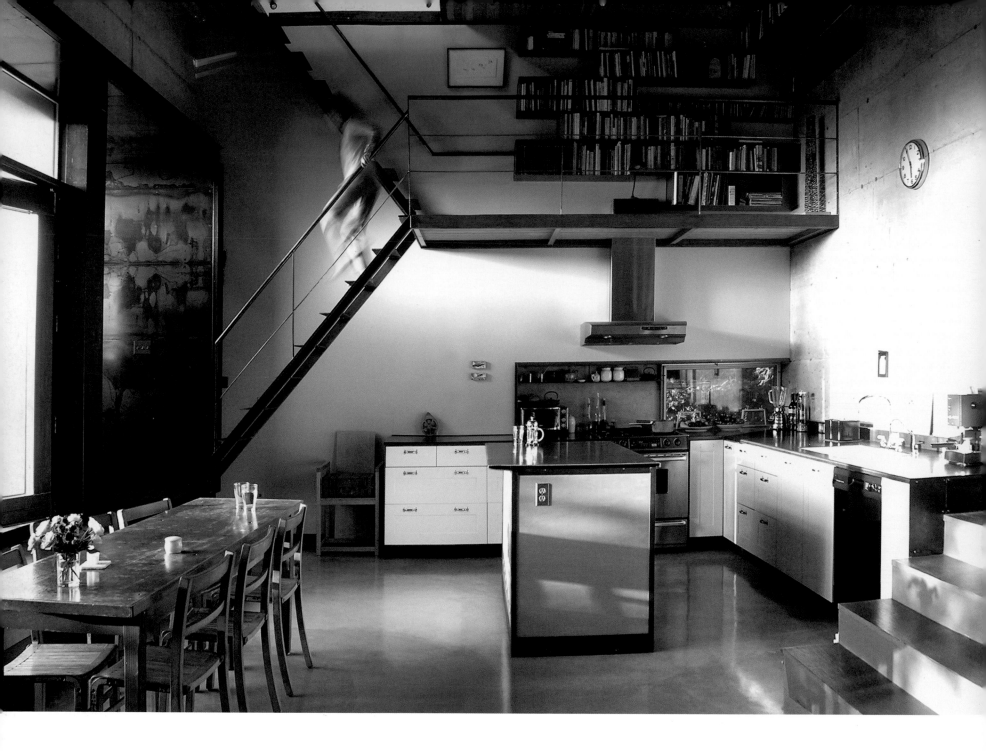

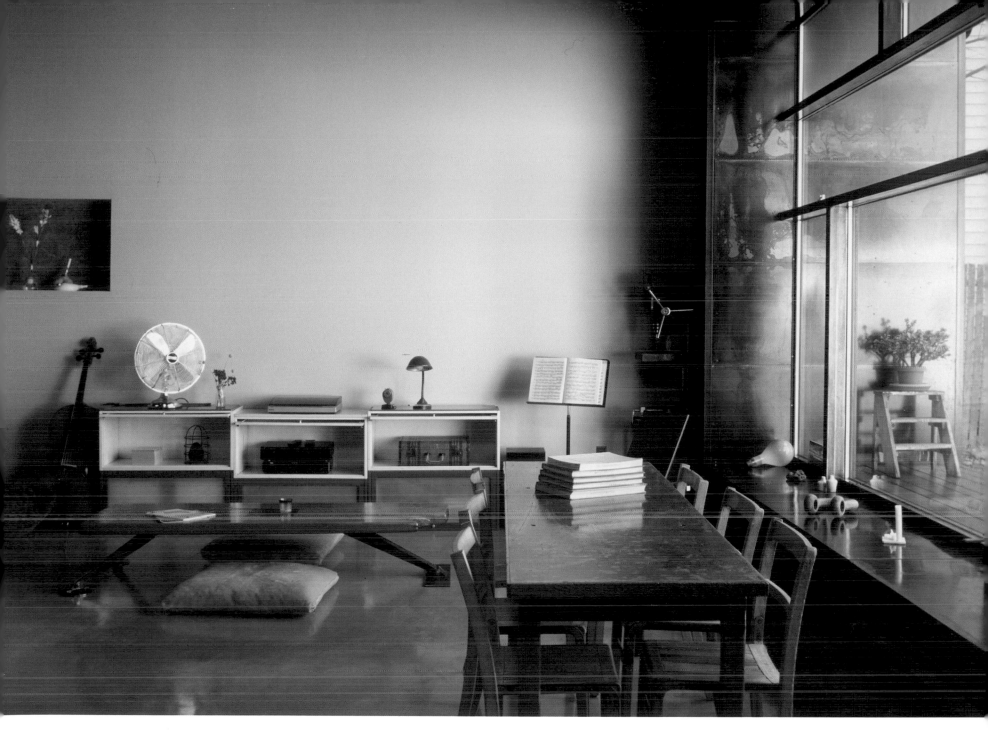

Left: The first floor has an
open loft appearance
Above: Dining area

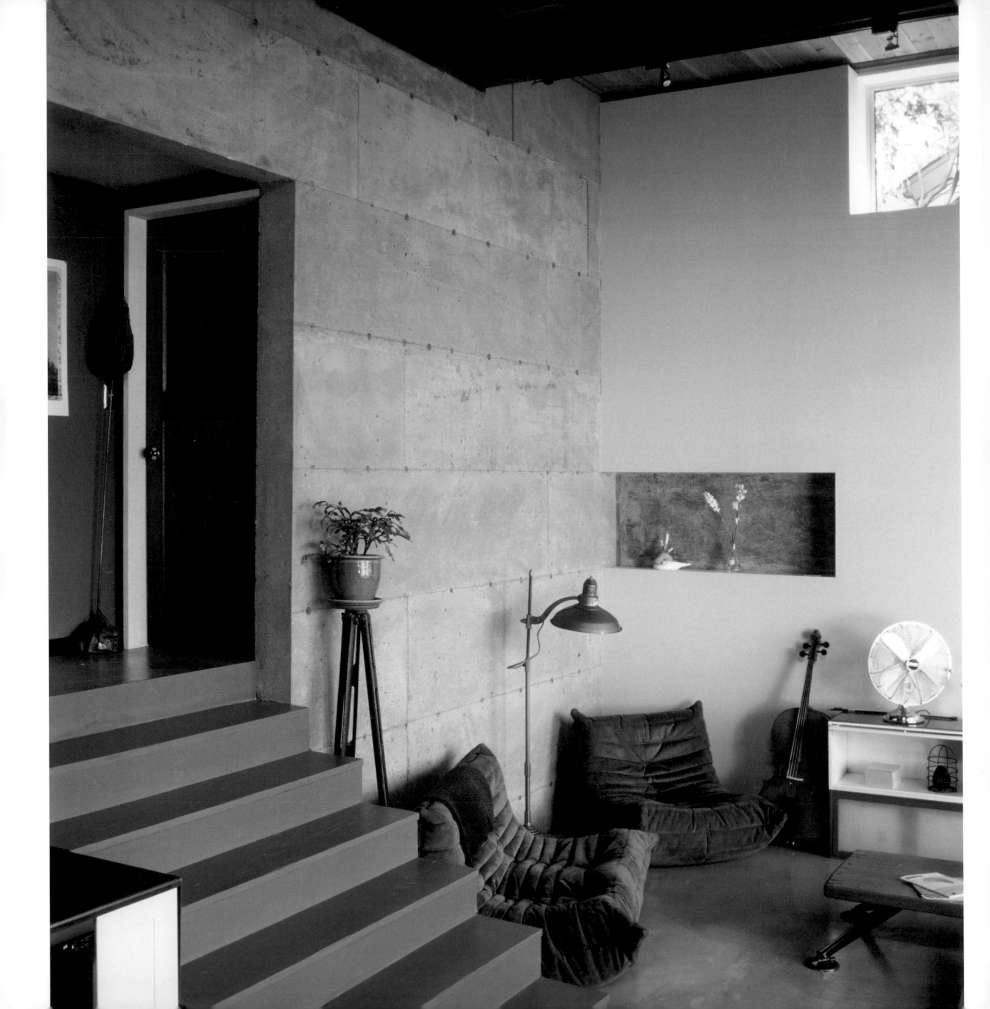

Far Left: Steps lead to the bedroom and bathroom
Left: The second floor studio
Above: The kitchen

Grevstad Cabin

1500 Square Feet

Suyama Peterson Deguchi Architects
Photography: Claudio Santini

T HIS SIMPLE ISLAND RETREAT, SITED IN A RUGGED NORTHWEST LANDSCAPE, WAS DESIGNED FOR USE ON WEEKENDS AND HOLIDAYS. IT CONSISTS OF THREE SEPARATE STRUCTURES CONJOINED BY A CONCRETE PLINTH AND A LARGE SHED ROOF. A SMALL OUTBUILDING ALLOWS FOR STORAGE AND PROVIDES A SENSE OF ARRIVAL TO THE WOODED SITE.

IN THE LIVING AREA, OVERSIZED SLIDING GLASS DOORS OPEN AT THE SOUTHEAST CORNER, VISUALLY EXTENDING THE SPACE INTO THE LANDSCAPE. OPPOSITE THIS GLASS WALL IS A CLUSTER OF WOOD-SIDED VOLUMES, WHICH CONTAIN THE KITCHEN, MASTER BEDROOM, AND GUEST QUARTERS. THE CAREFUL PLACEMENT OF THESE VOLUMES TO ONE ANOTHER AND THEIR RELATIONSHIP TO THE ROOF, PLINTH, AND GLASS WALL PROVIDE A CONTRAST TO THE OPEN AND EXPANSIVE LIVING SPACE. A ROOFTOP DECK IS LOCATED OVER THE KITCHEN AND ACCESSED THROUGH AN EXTERIOR SPIRAL STAIRWAY.

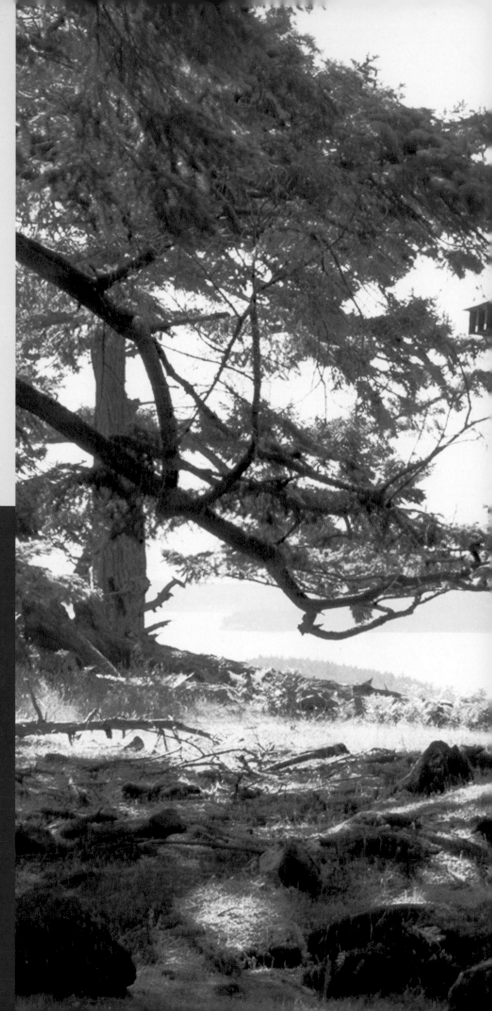

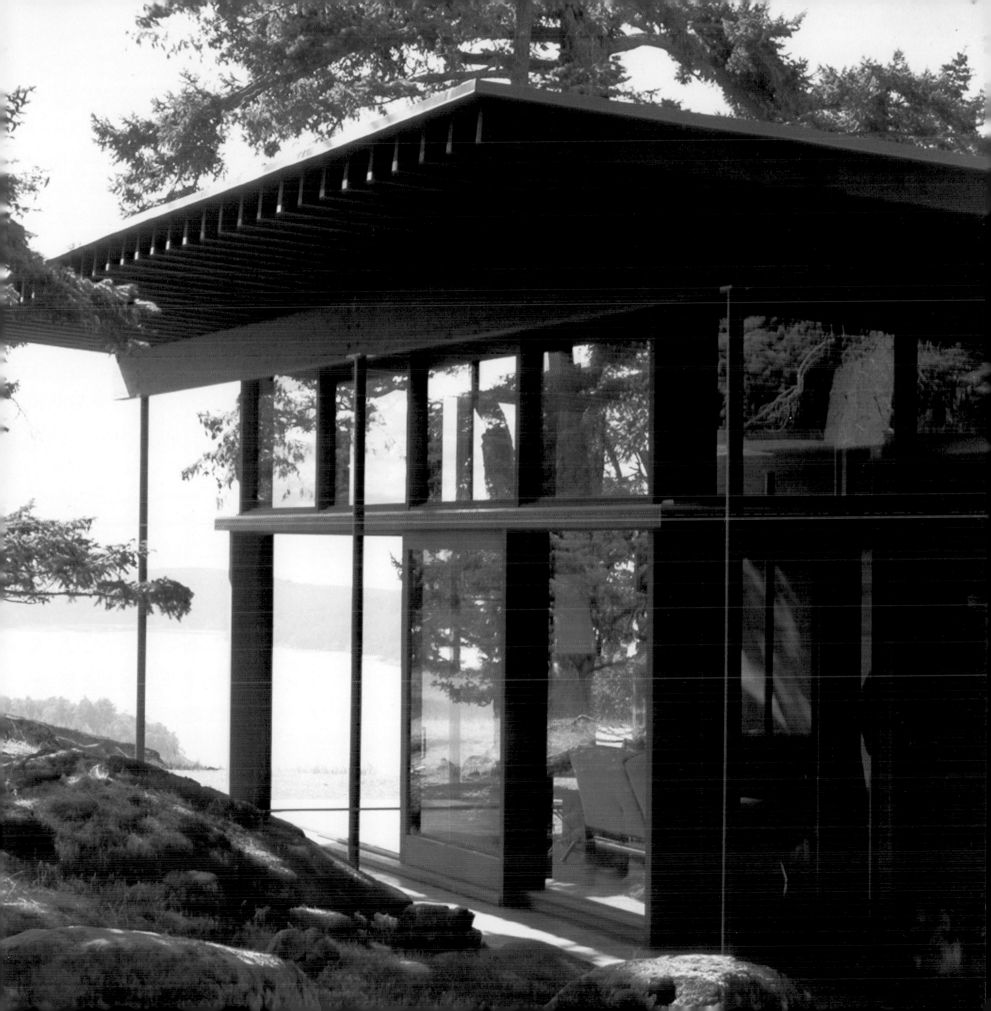

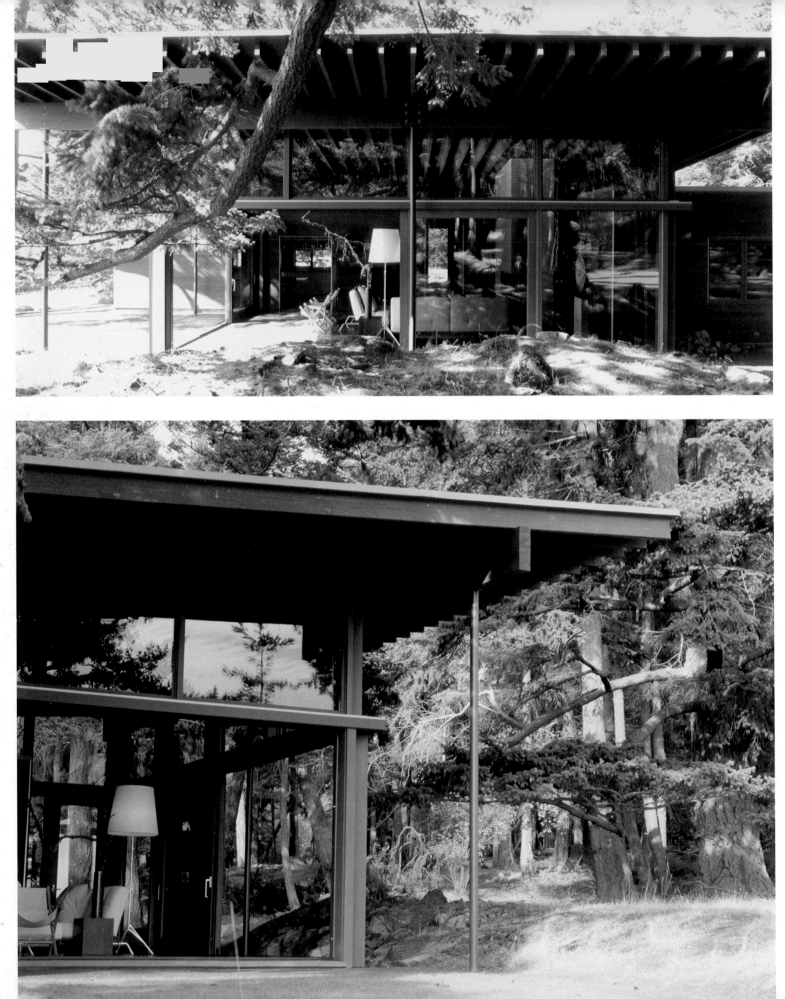

Site Plan/Main Level Floor Plan

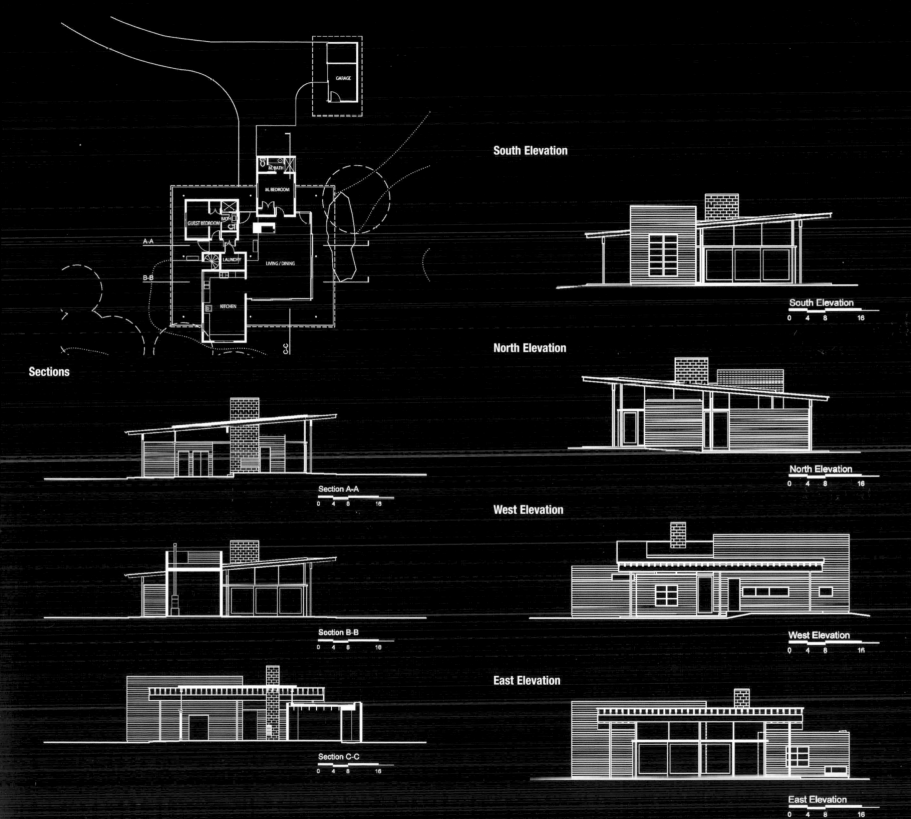

GARAGE

M. BATH

M. BEDROOM

GUEST BEDROOM

BATH

A-A

LAUNDRY

LIVING / DINING

B-B

KITCHEN

C-C

Sections

Section A-A
0 4 8 16

Section B-B
0 4 8 16

Section C-C
0 4 8 16

South Elevation

South Elevation
0 4 8 16

North Elevation

North Elevation
0 4 8 16

West Elevation

West Elevation
0 4 8 16

East Elevation

East Elevation
0 4 8 16

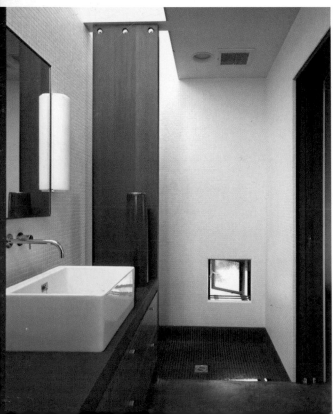

Left: Entry
Lower Left: Bathroom vanity
Below: Living room fireplace
Right: Living room

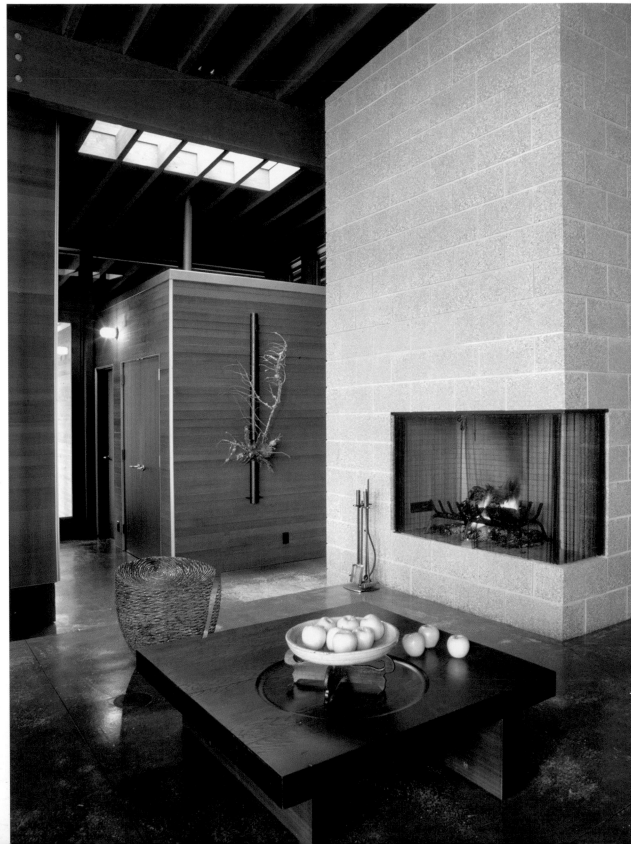

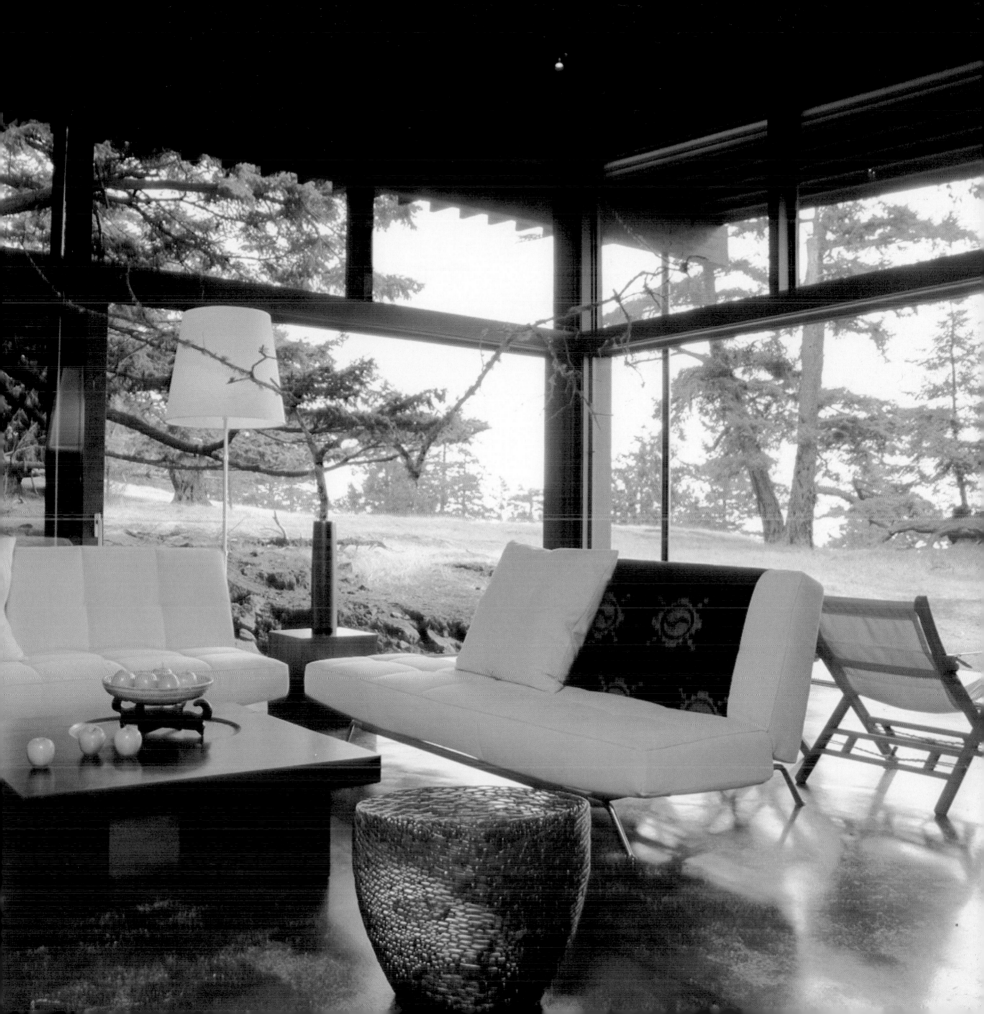

Elysian Park House

1497 Square Feet

Central Office of Architecture

Photography: COA

Organized on two levels, this house is built on a steep hill site with sweeping views of downtown Los Angeles, the distant coastline, and the Hollywood Hills.

The ground floor contains individual bedrooms, service spaces, and an open carport. Above are a large, open loft space, a kitchen, an office, and an outdoor terrace. Continuous areas of glass on the view side and a double-insulating layer of translucent polycarbonate panels along the street side define this light-filled volume.

A custom-fabricated, aluminum brise-soleil controls western sun at the end of the day. Back-to-back fireplaces serve both the living space and the terrace. Interior finishes include Trespa paneling, wood flooring and cabinetry, and stainless steel countertops.

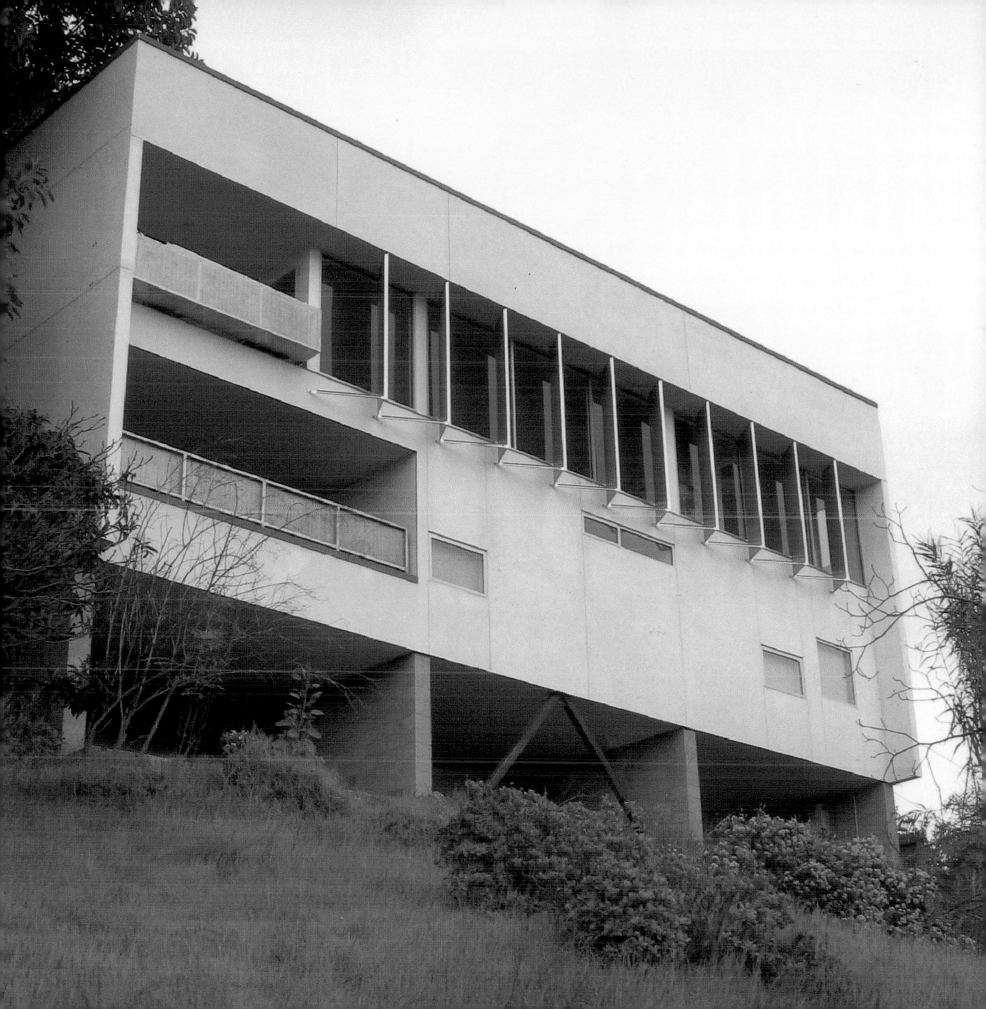

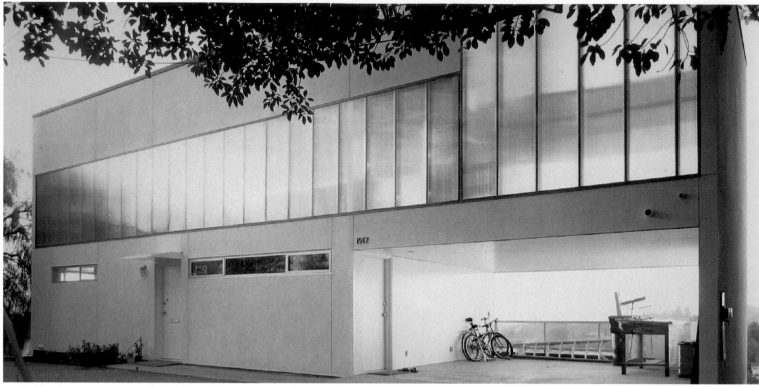

First Floor Plan

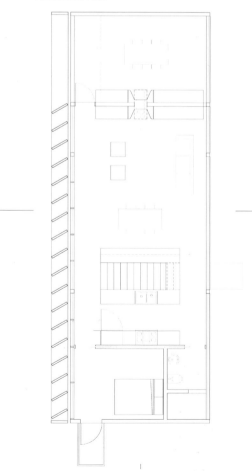

Ground Floor Plan

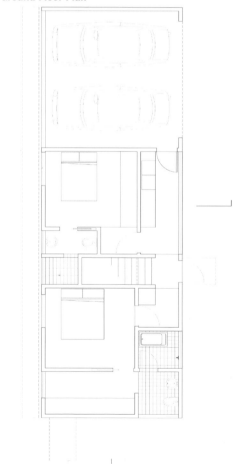

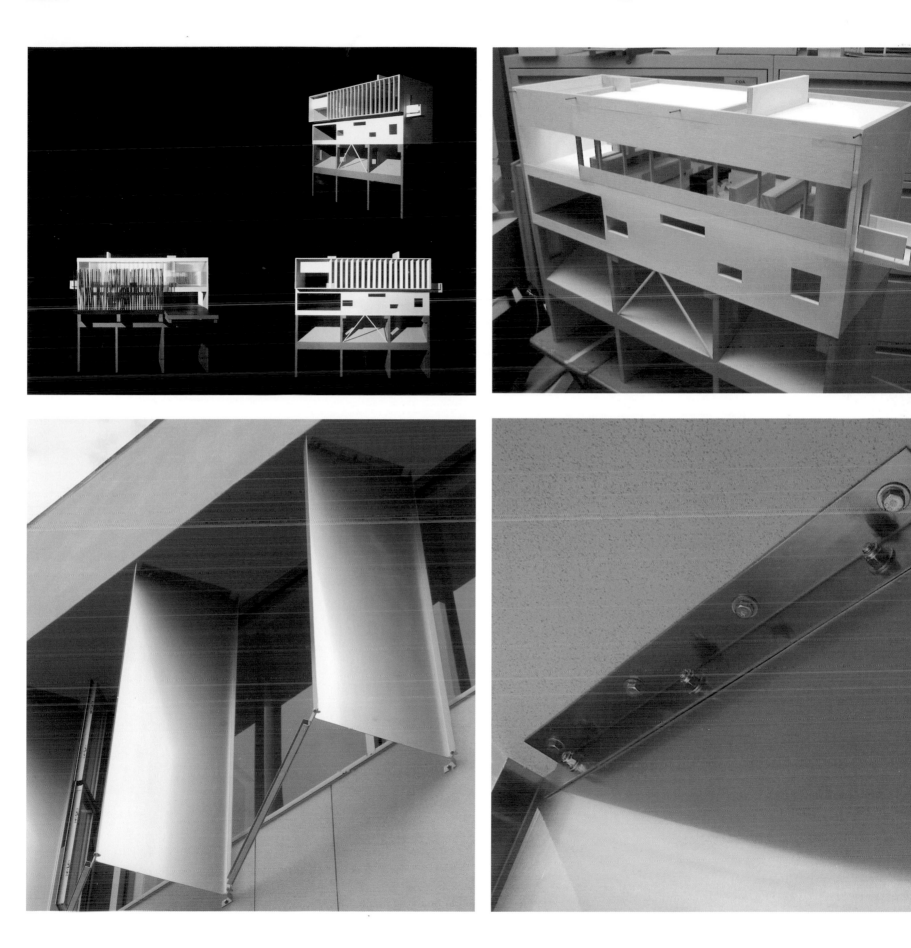

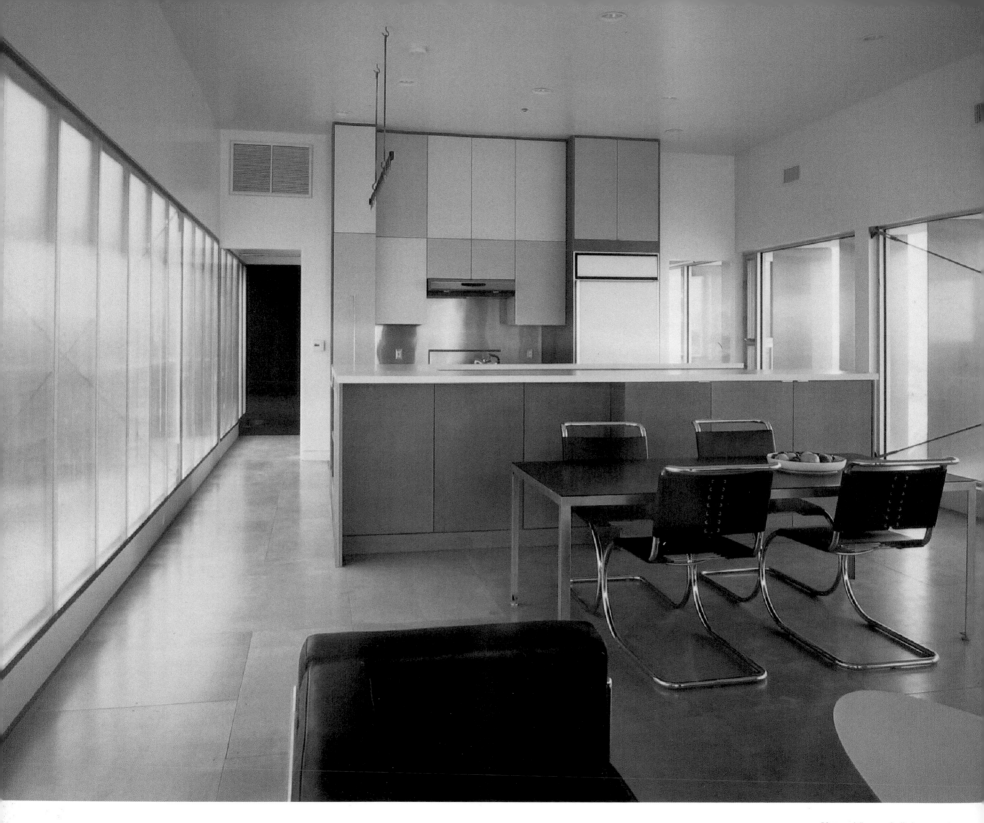

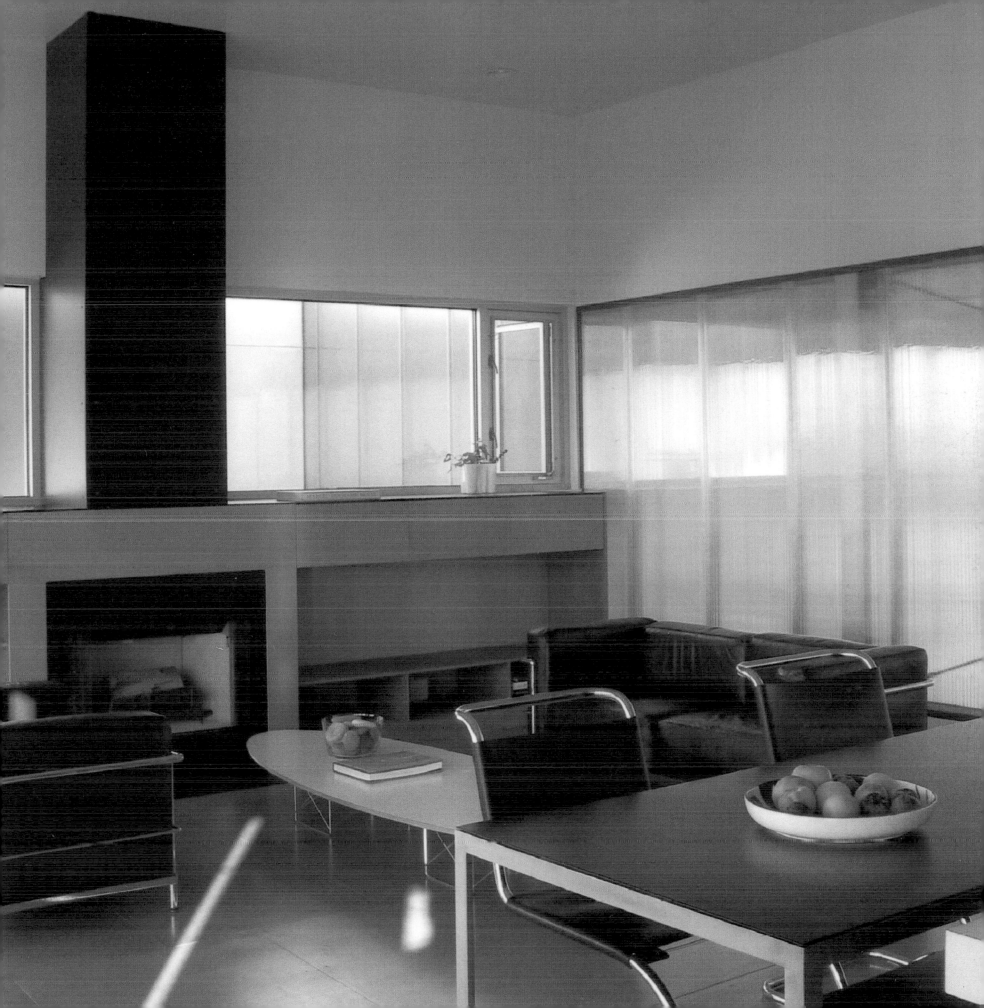

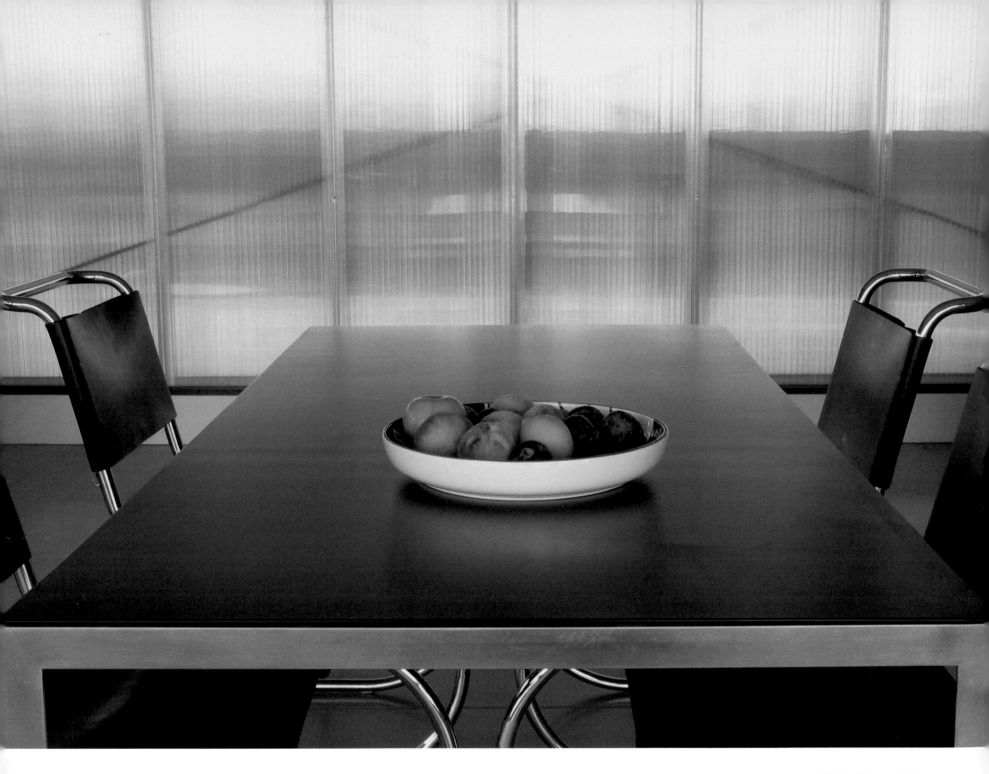

Above: Filtered light enters the dining area from the translucent polycarbonate panels.
Right: Street side entry

Writer's Studio

1325 Square Feet

Carol A. Wilson Architects
Photography: Brian Vanden Brink, Kristen Shaw

THE CLIENT, A WRITER, WANTED A SPACE THAT WOULD TAKE ADVANTAGE OF THE BEAUTY OF THE SITE AND THE VIEWS, WHILE RESPECTING THE FRAGILE LAND-SCAPE. THE RESULTING DESIGN IS A STUDIO THAT FLOATS ABOVE THE LANDSCAPE, WITH MINIMAL IMPACT ON THE SHORE AND AND VEGETATION. THE ENTIRE STRUCTURE IS CLAD IN CEDAR SHINGLES. THEIR BARKLIKE TEXTURE AND THE STUDIO'S TRANSPARENT CONNECTION TO THE GROUND MAKE THE BUILDING SEEM TO BE A PART OF THE WOODS. INSIDE, THE CEILING OF THE STUDIO CONTINUES THROUGH THE GLASS WALL, CARRYING THE EYE INTO THE VIEW BEYOND AND MAKING A SEAMLESS CONNECTION FROM INSIDE TO OUTSIDE.

STORAGE IS CONTAINED IN MAPLE CABINETRY ALONG THE NORTH WALL. THE BATH AND KITCHEN CORE CREATE A BUILD-ING WITHIN A BUILDING. UPSTAIRS, THE LOFT PROVIDES A MORE INTIMATE SPACE IN CONTRAST WITH THE OPENNESS AND HEIGHT OF THE STUDIO.

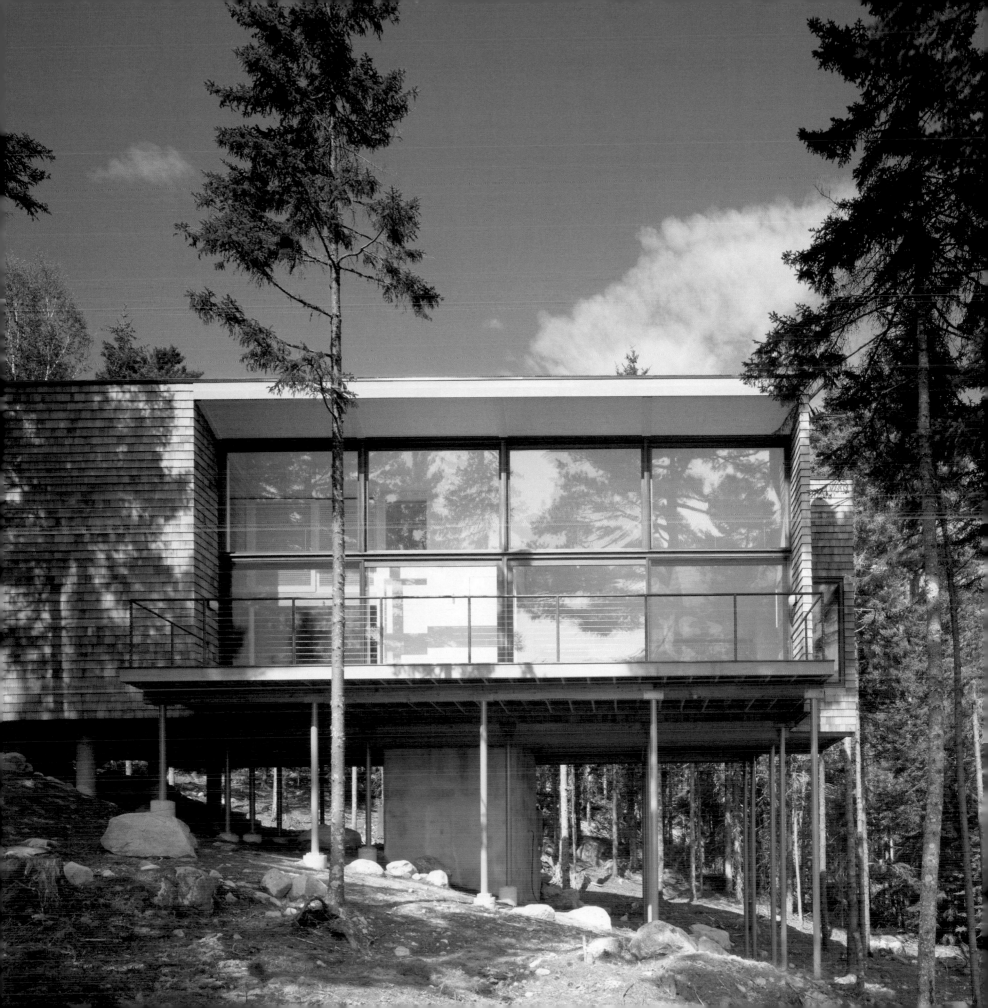

First Floor Plan

Previous Pages: South elevation
Below: View of the studio from the water
Right: View of the deck outside the studio

Perspective Drawing

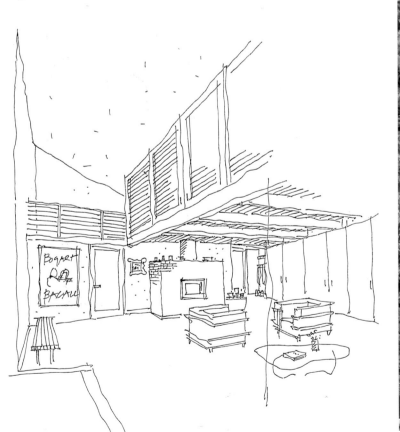

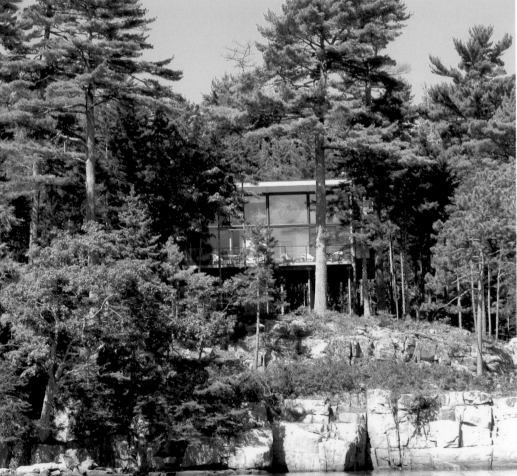

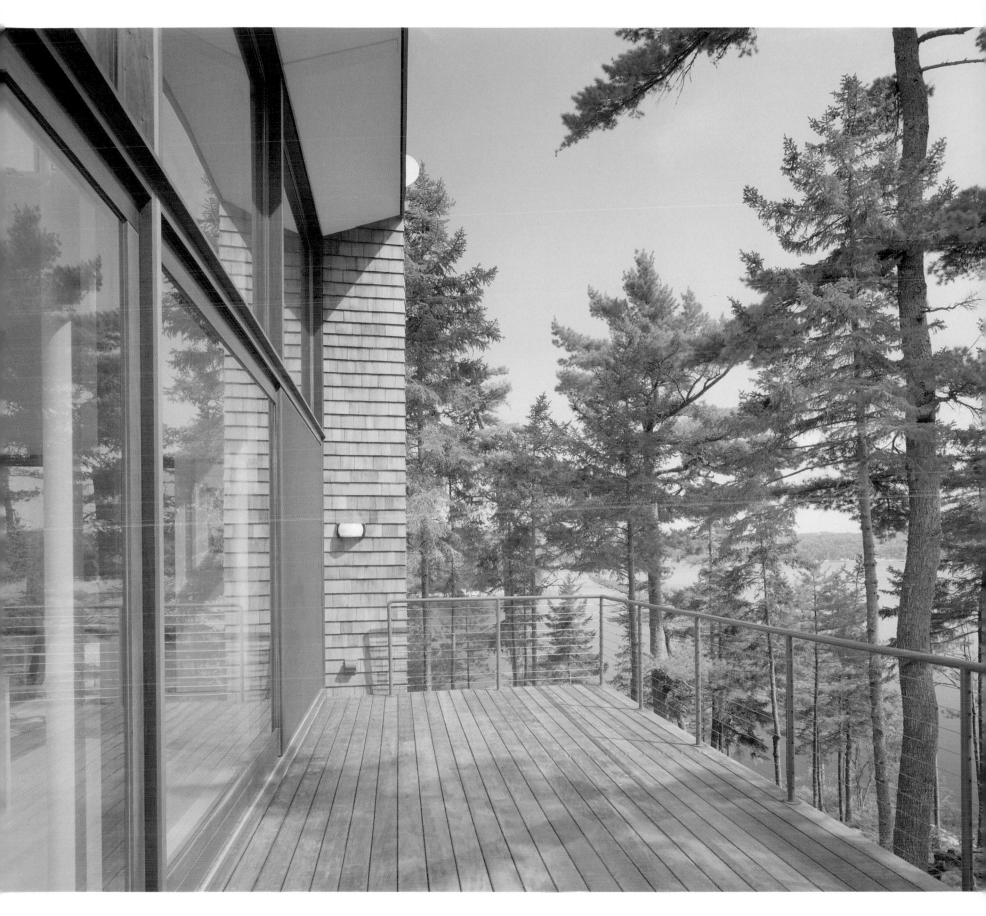

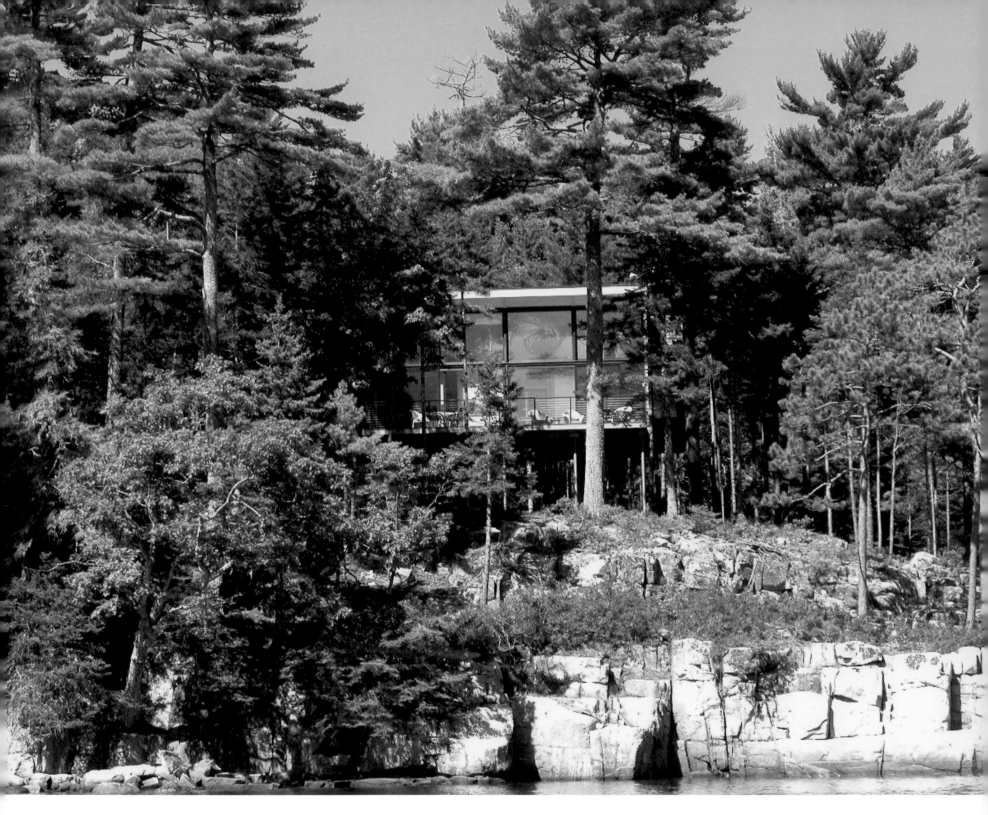

Above: The studio is supported by steel columns
Right: South elevation

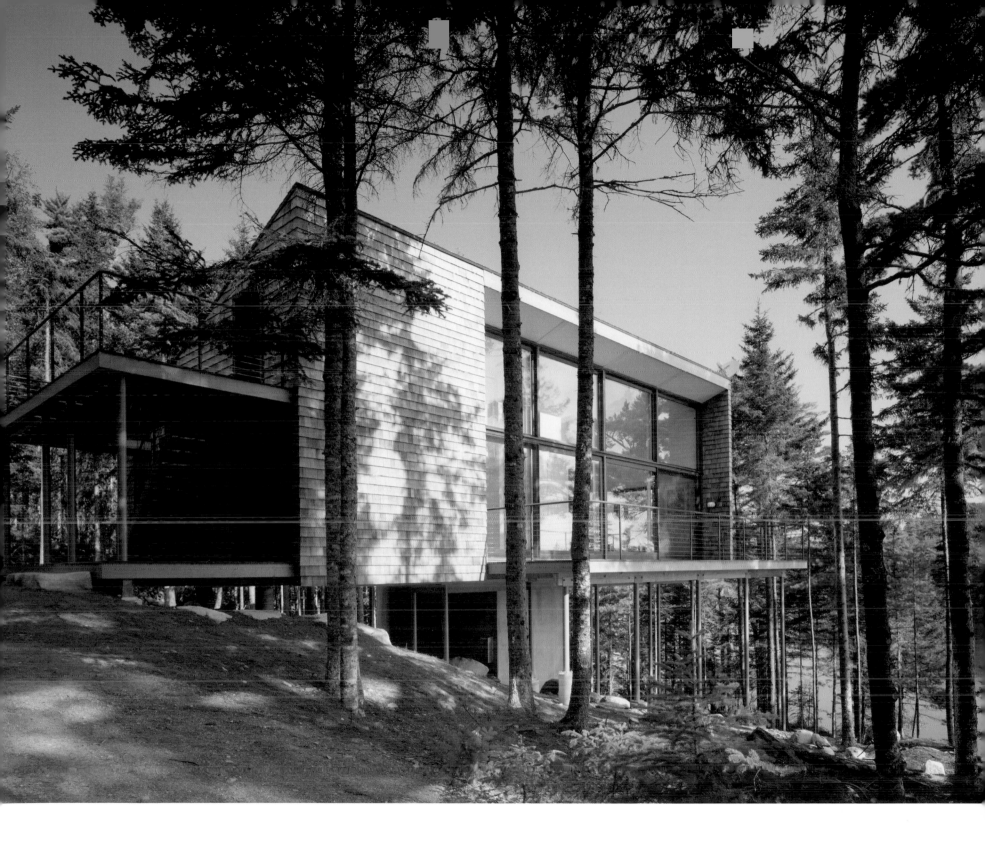

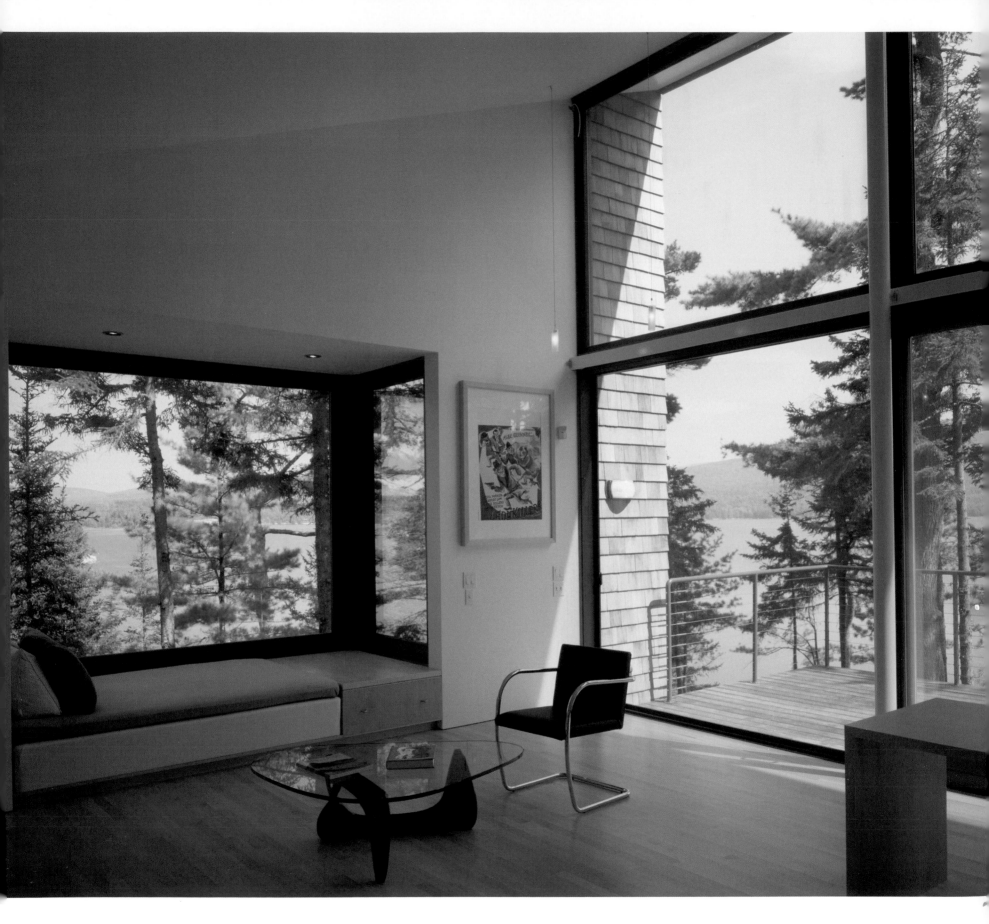

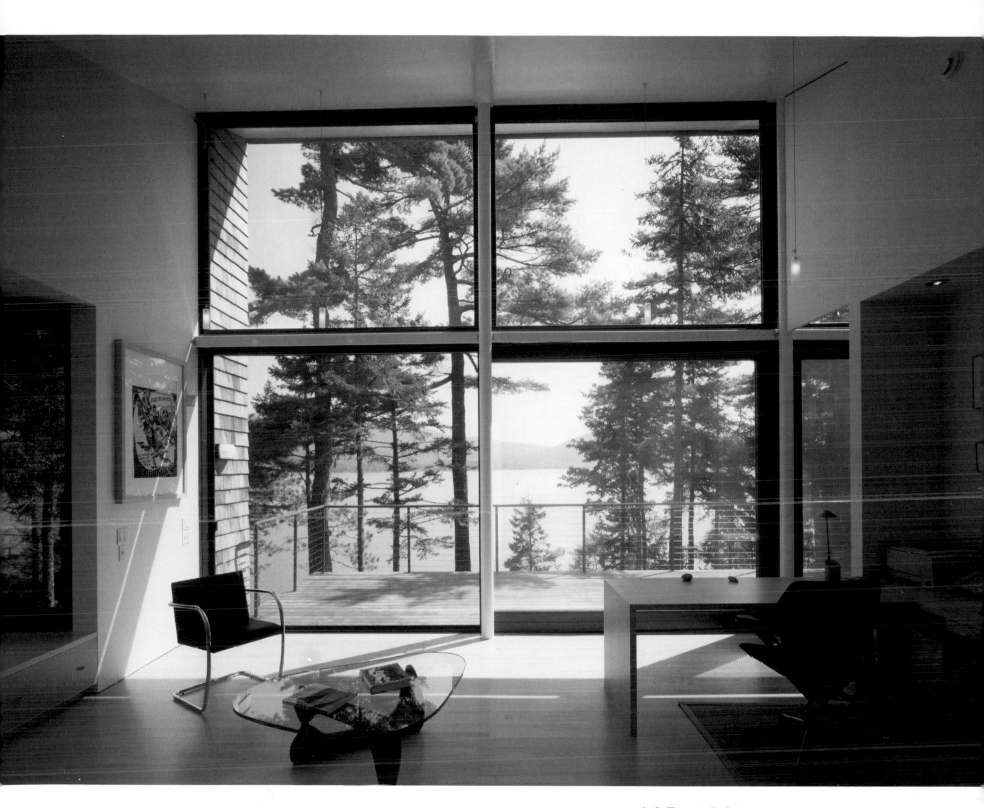

Left: The studio features a cantilevered window seat/daybed.
Above: The ceiling of the studio continues through the glass wall.

43

Vineyard Guest House

1200 Square Feet

Cutler Anderson Architects
Photography: Art Grice

Located in Napa, California, Meteor Vineyards consists of 27 acres of old and new Oak trees, vineyards, and meadows. the project comprises a large main house and two smaller buildings.

The guest house has an open floor plan with kitchen, living room, and dining room overlooking the vineyard. Three bedrooms are across an exterior hallway, which is covered by the roof. That hallway becomes a walkway that extends 130 feet to the main house. the butterfly roof captures rainwater and channels it into a pool for guests.

The exterior walls are made of rammed earth and were created using several different soil types from the Napa area. The soil is compacted to into 30-inch-thick walls that vary in shape and size.

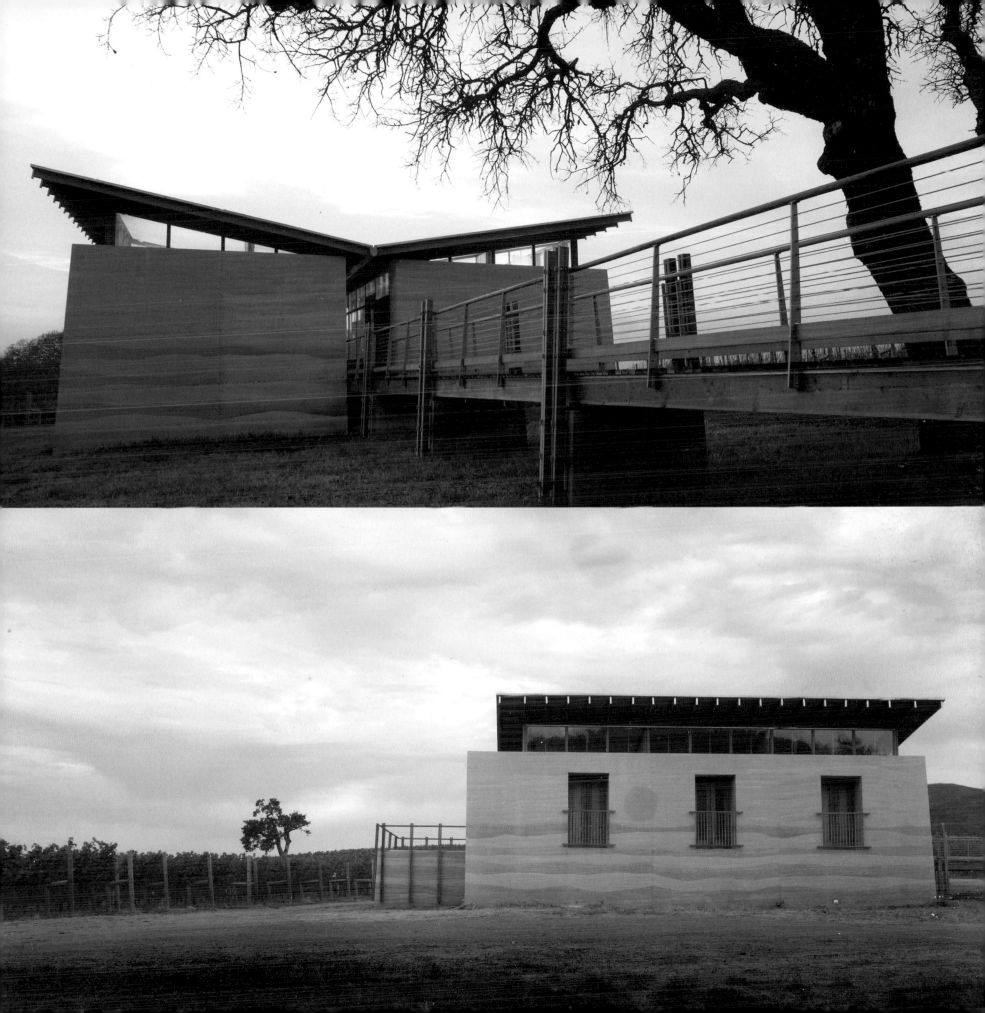

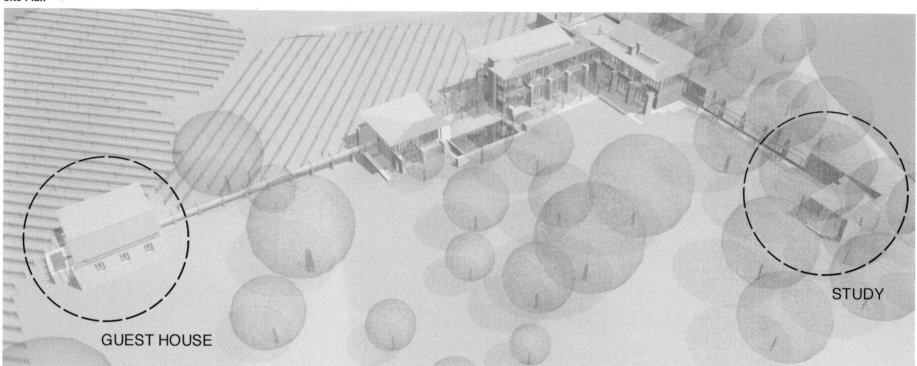

GUEST HOUSE

STUDY

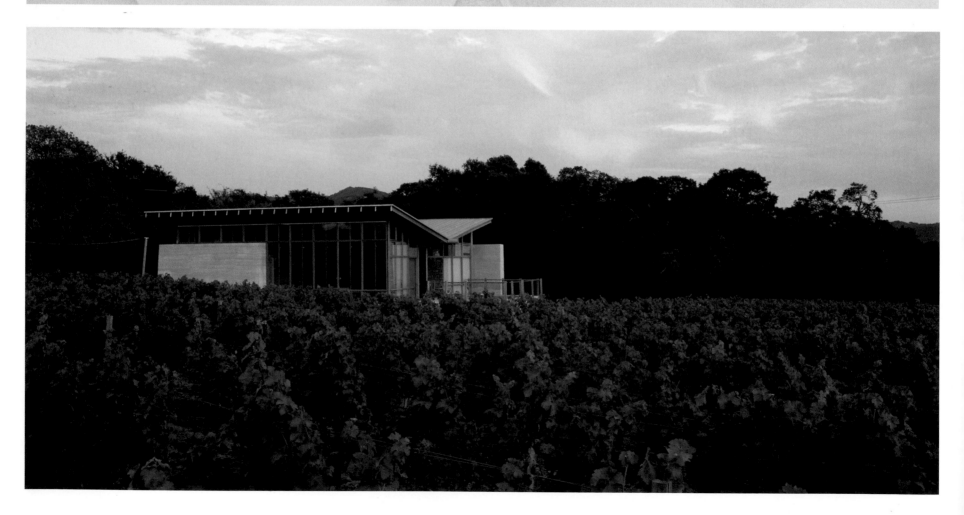

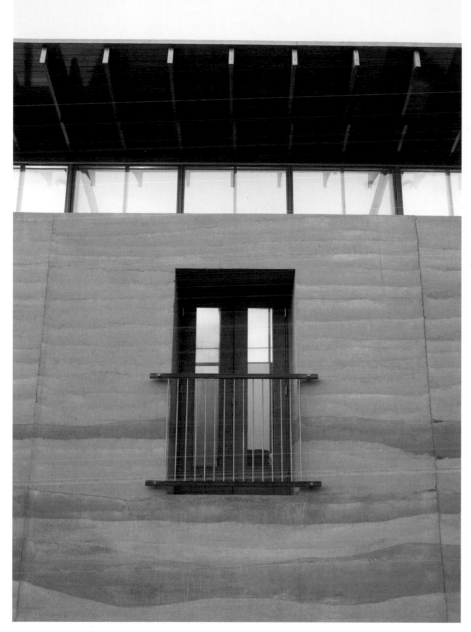

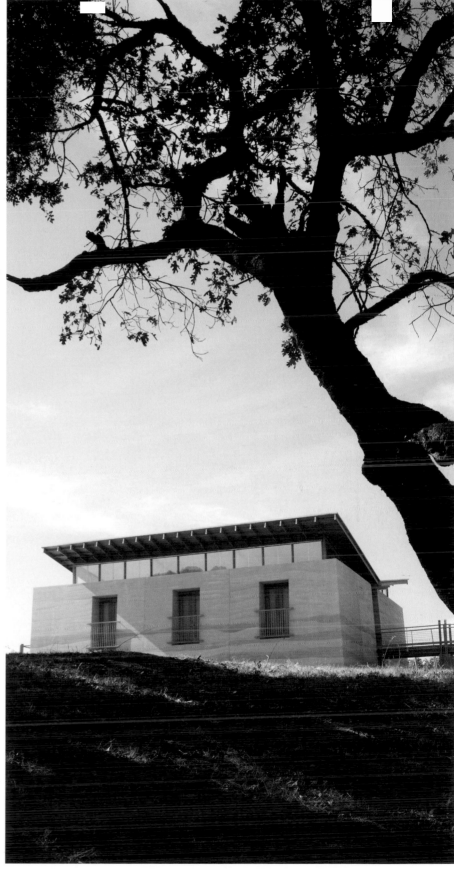

Previous Page: View of the guest house from the walkway to the main house and from the vineyard

Left: The guest house sits low within the vineyard.

Above: Different soils were used to create the rammed earth walls.

Right: Mature oak trees populate the site.

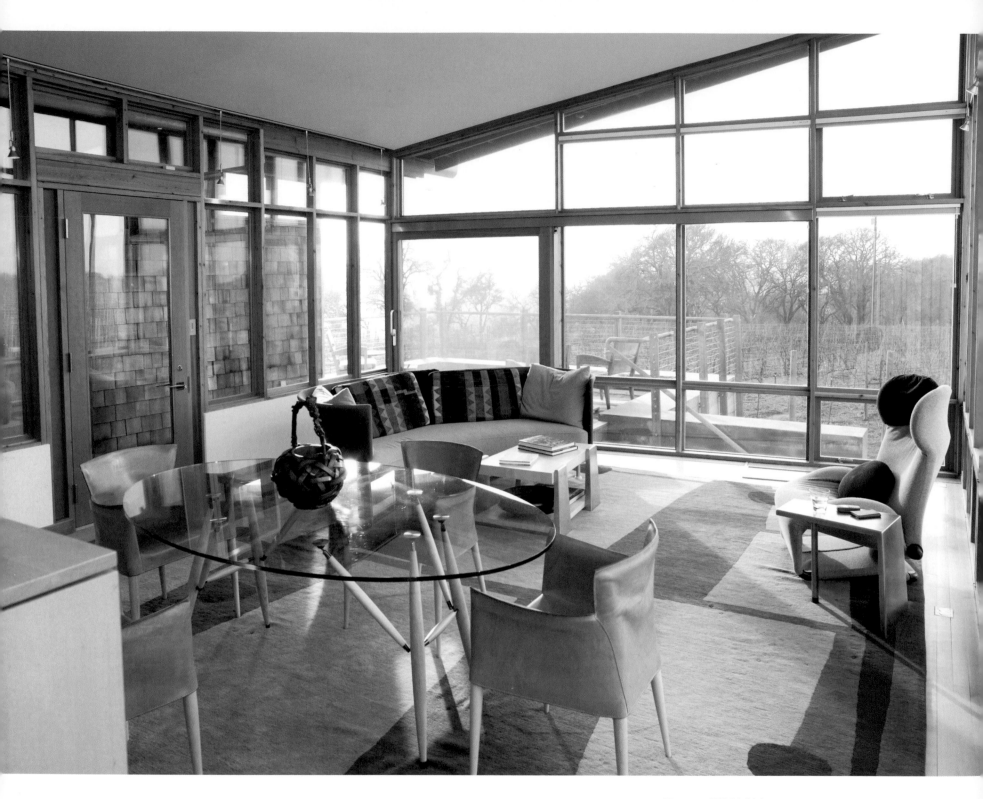

Above and Right: Living area with a view over vineyards

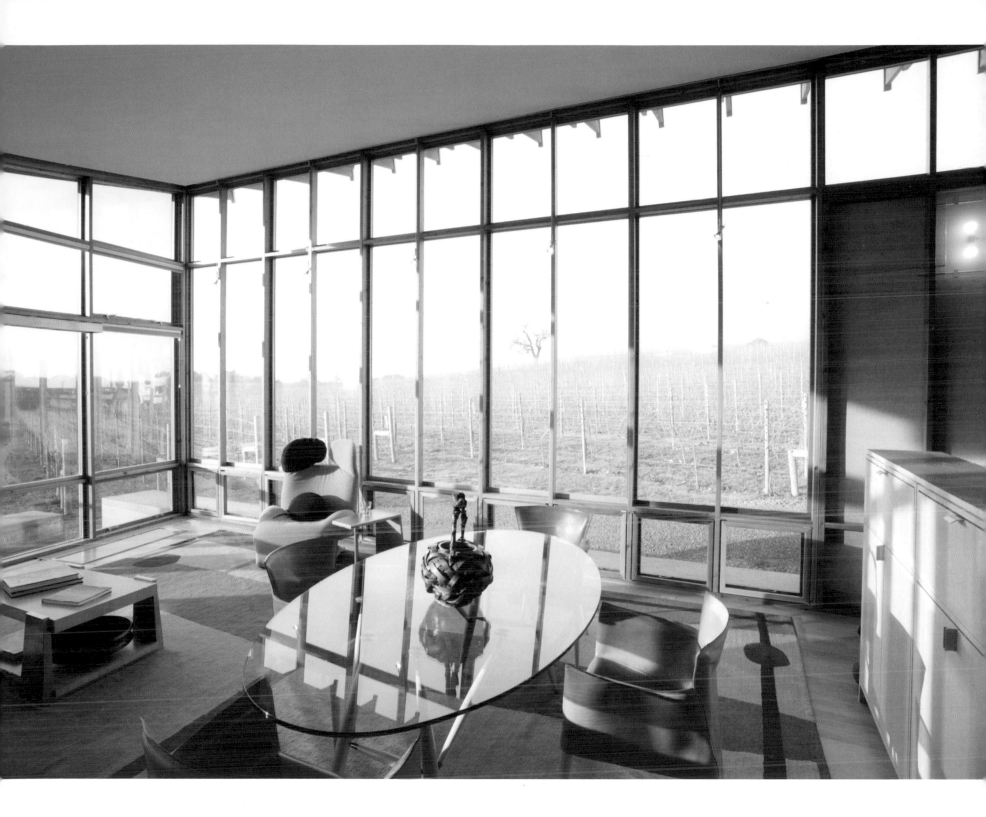

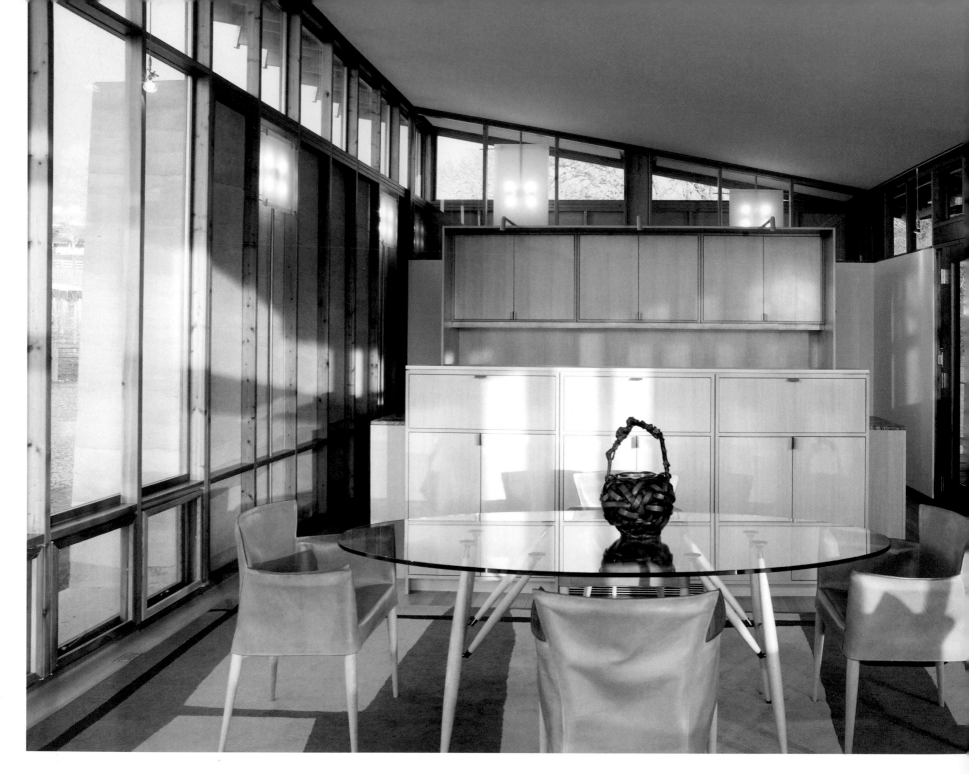

Above: Dining area
Right: Bedroom

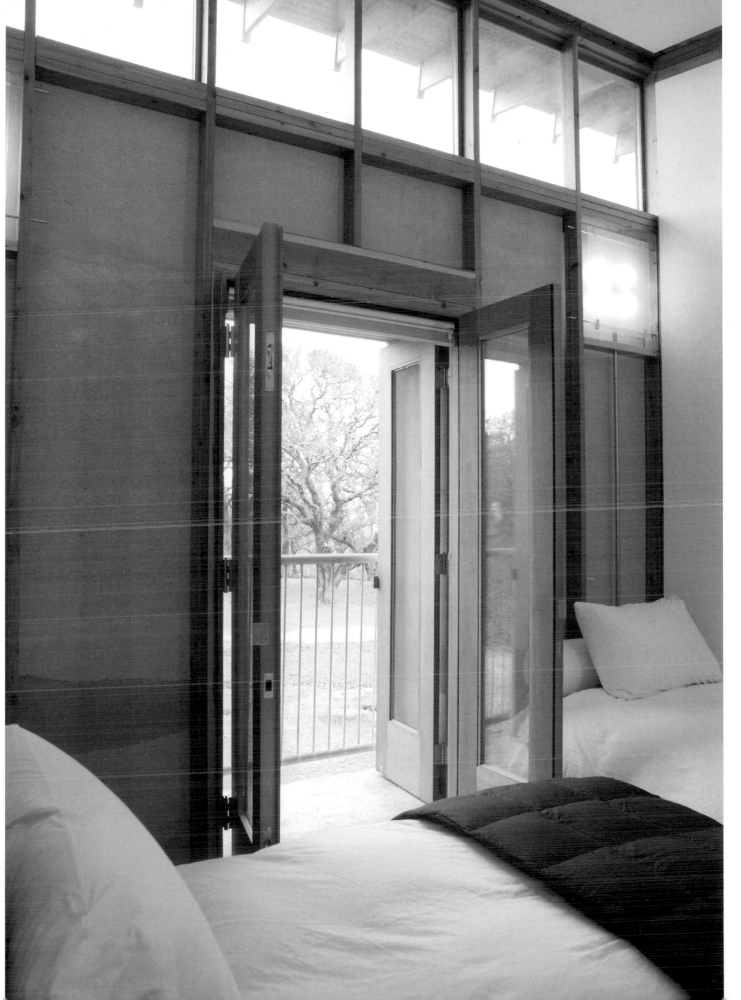

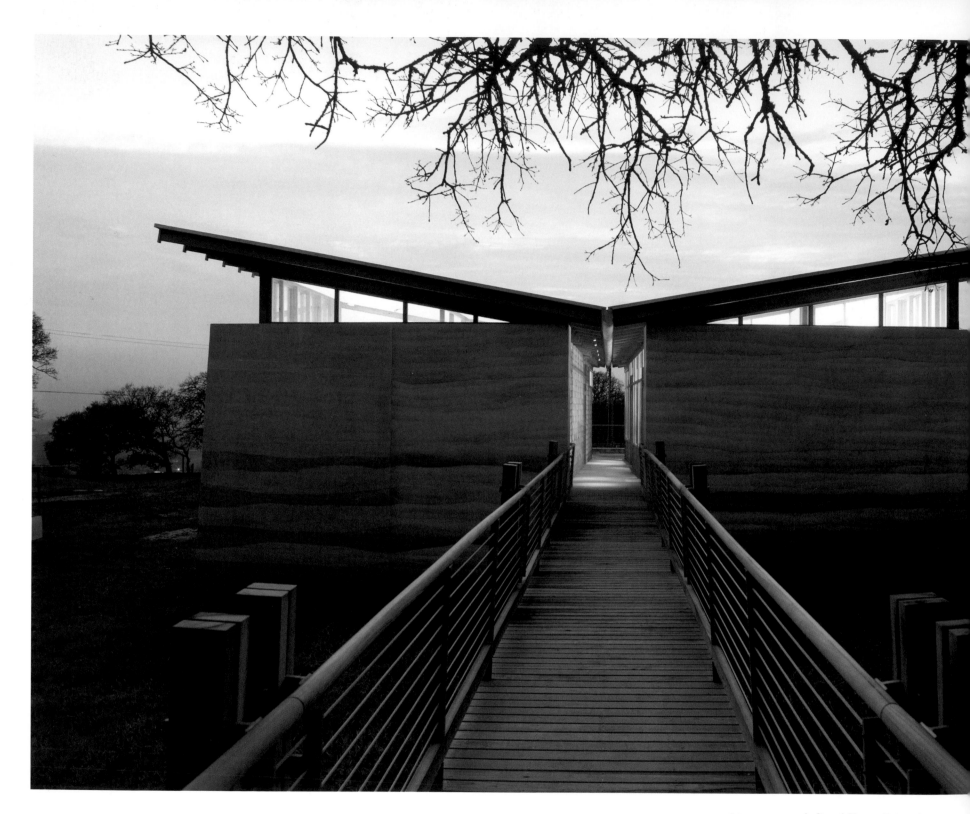

Left and Above: Entry at dusk

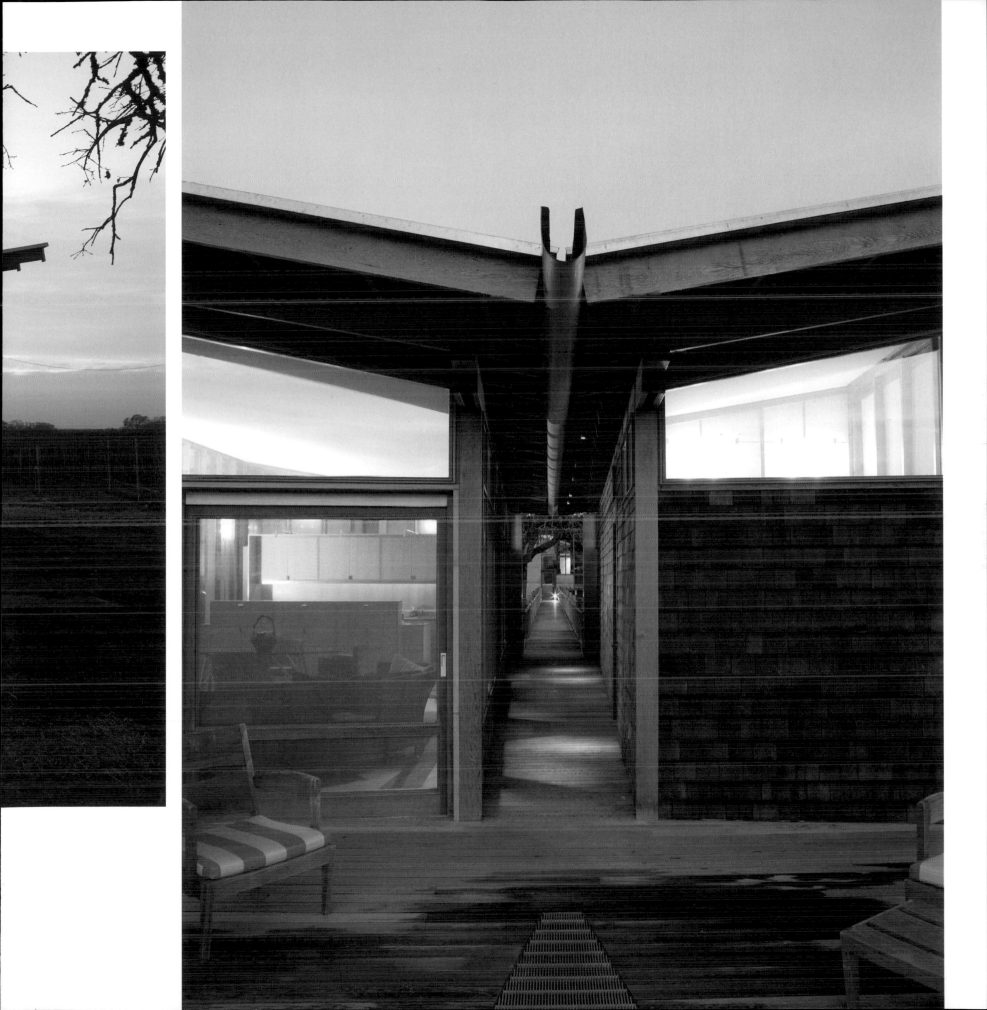

The Study Building

370 Square Feet

Cutler Anderson Architects
Photography: Art Grice

THE SECOND STRUCTURE ON THE METEOR VINEYARDS ESTATE IS THE SO-CALLED STUDY BUILDING, WHICH CONSISTS OF ONE LARGE ROOM AND A SMALL BATHROOM. TWO OF THE EXTERIOR WALLS ARE RAMMED EARTH; TWO ARE GLASS AND LOOK OUT THROUGH THE SURROUNDING OAK TREES TO THE VINEYARDS BEYOND. THE STUDY MIMICS THE SHAPE OF THE MAIN HOUSE WITH ITS METAL ROOF AND RAMMED EARTH WALLS. THE TWO RAMMED-EARTH WALLS FORM AN "L", WHERE A SMALL OUTDOOR POOL IS LOCATED. AS WITH THE GUEST HOUSE, WHEN IT RAINS, WATER DRAINS OFF THE ROOF AND INTO THE POOL. A 124-FOOT WALKWAY EXTENDS FROM THE STUDY TO THE MAIN HOUSE.

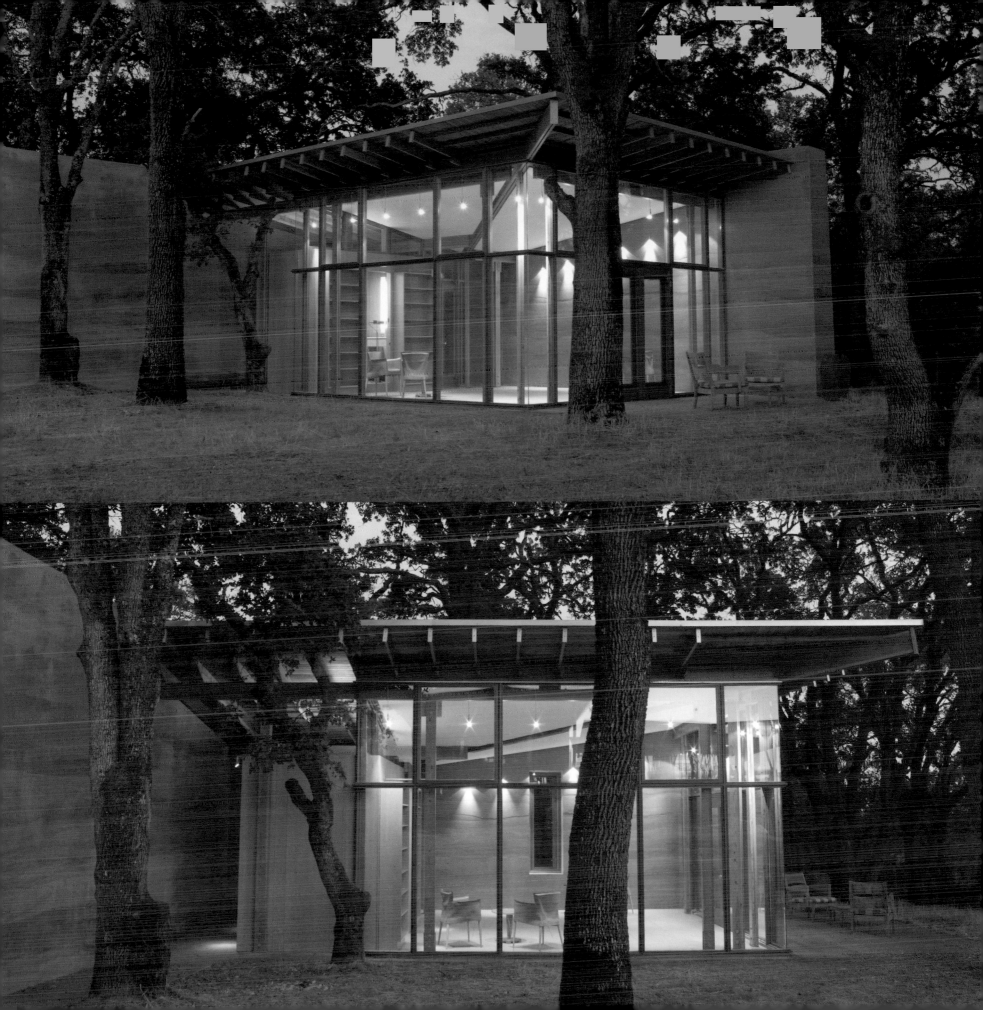

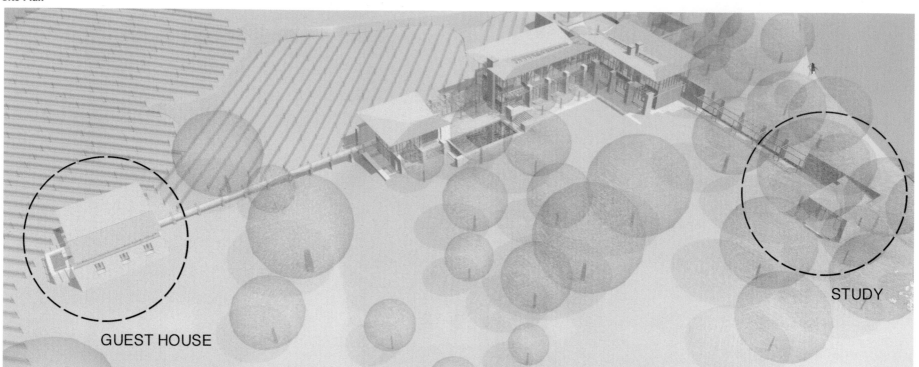

GUEST HOUSE

STUDY

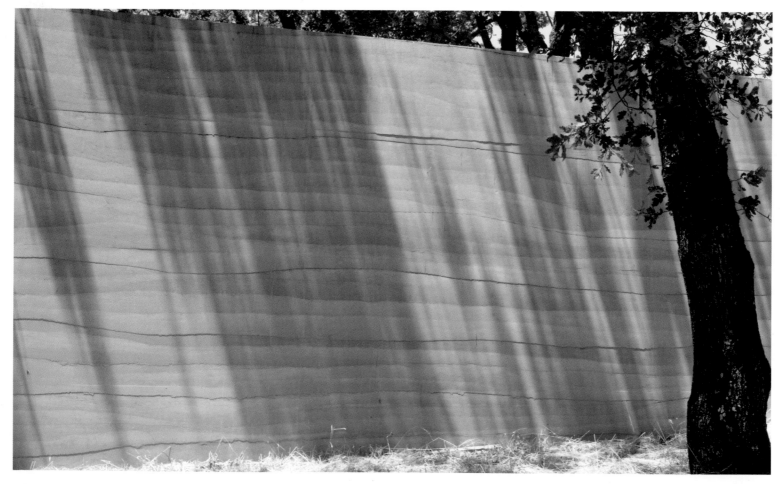

Previous Page: The warm tones of the wood and rammed-earth walls create a comforting study environment.

Left, Above Right, and Right: The two rammed-earth walls form an "L" around the structure.

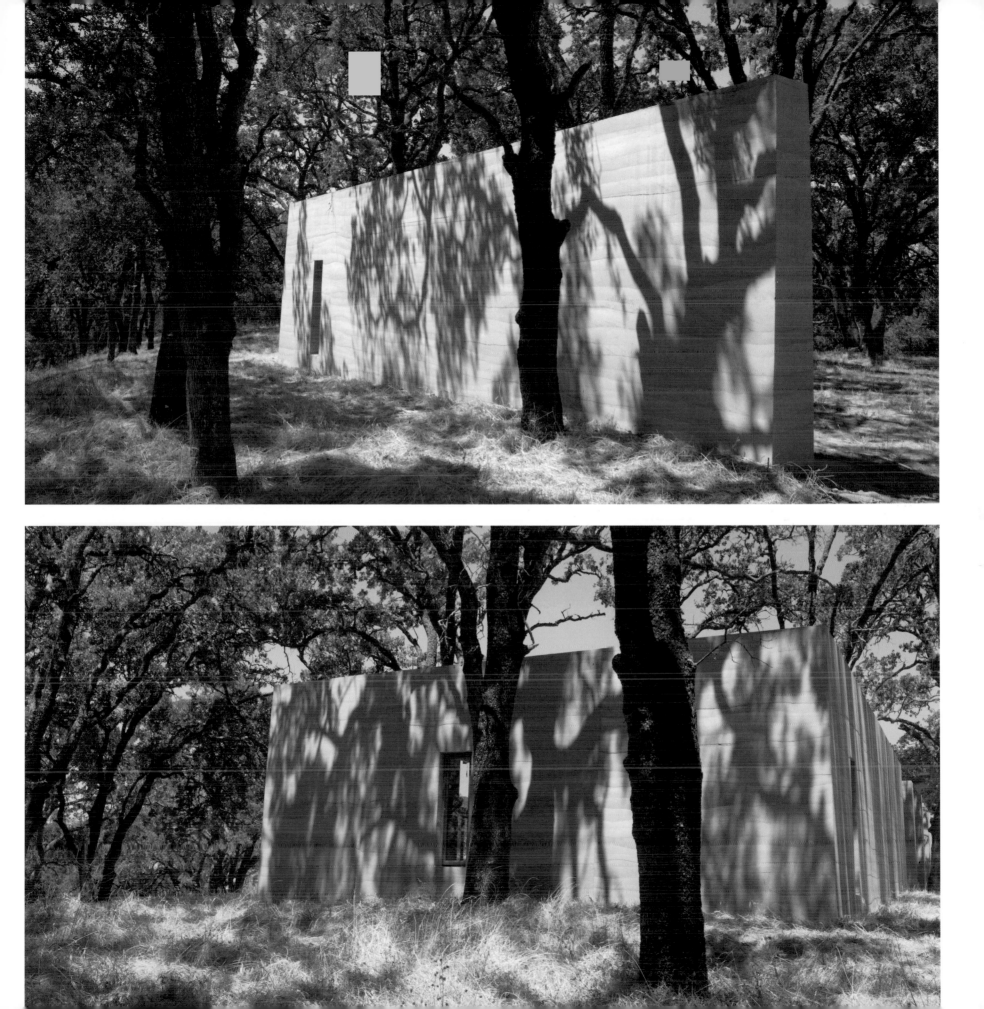

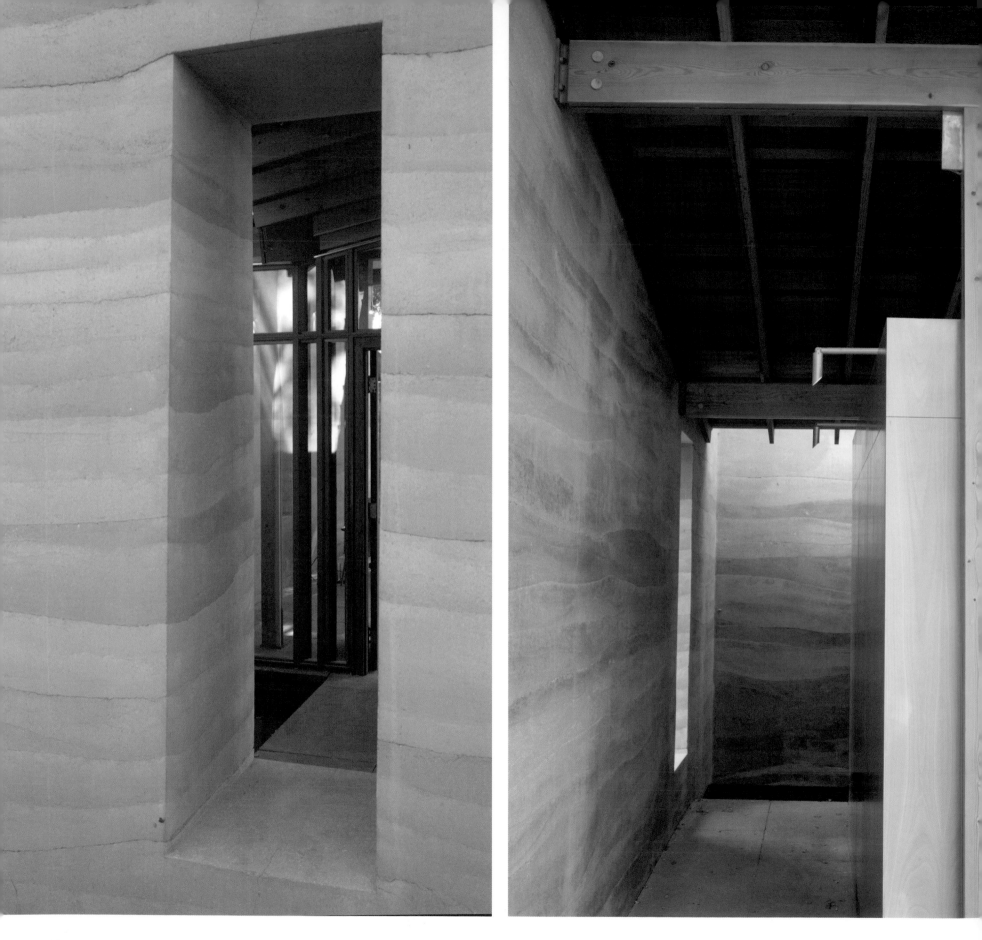

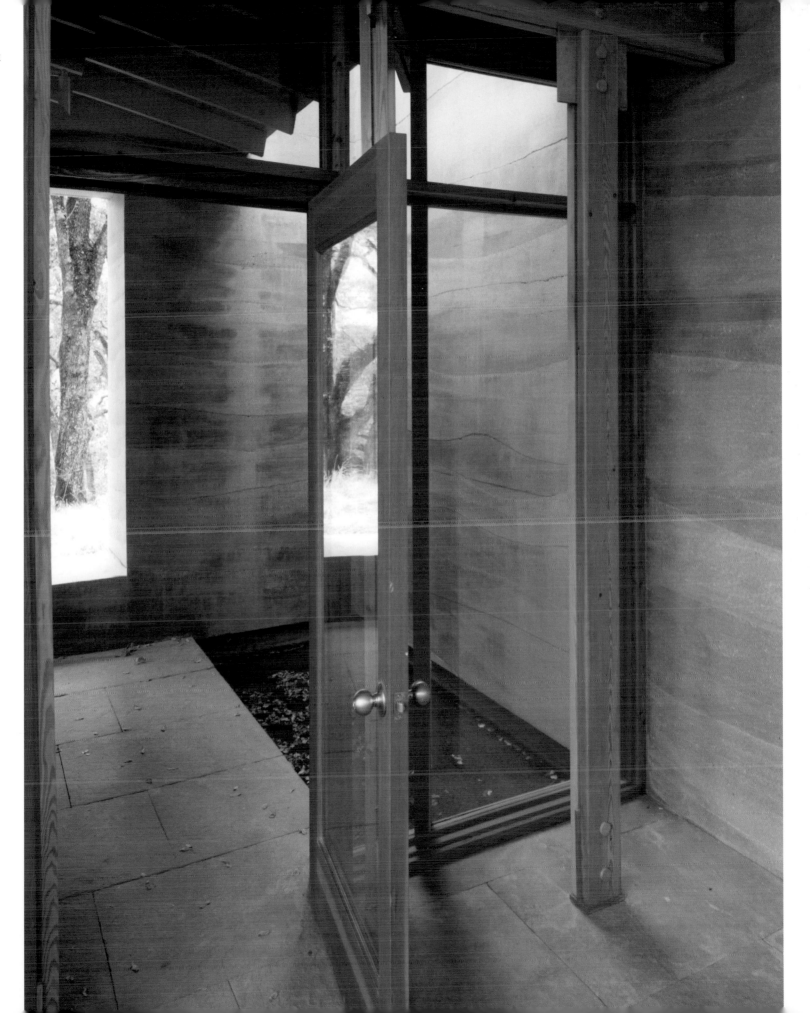

Far Left and Left: The thick walls give a fortresslike quality to the building.
Right: Entry

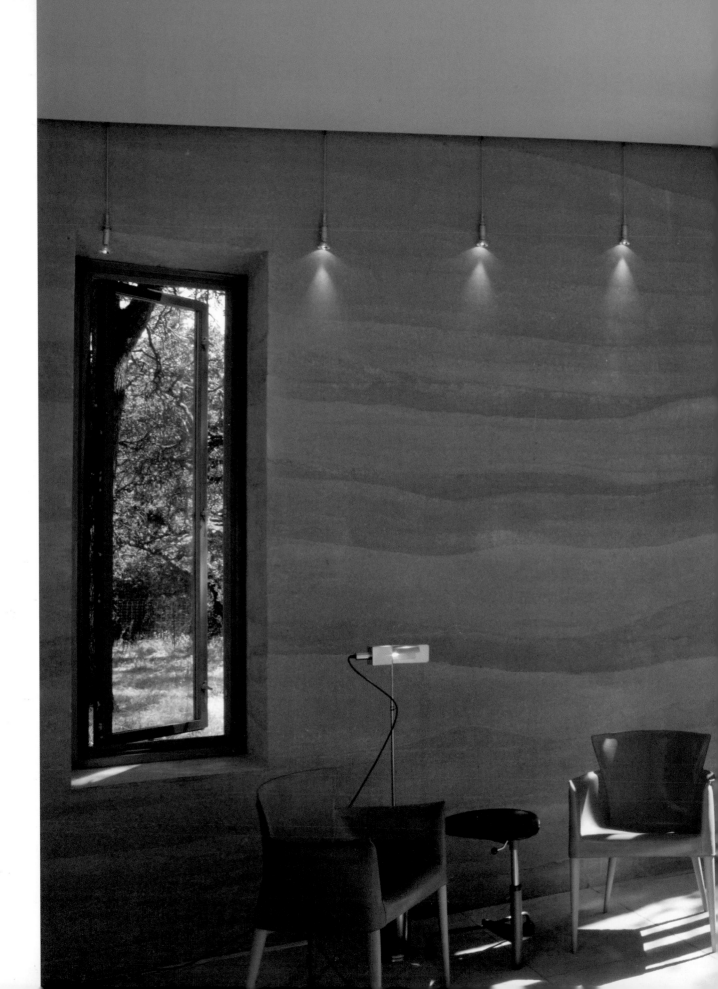

Right: View to the exterior

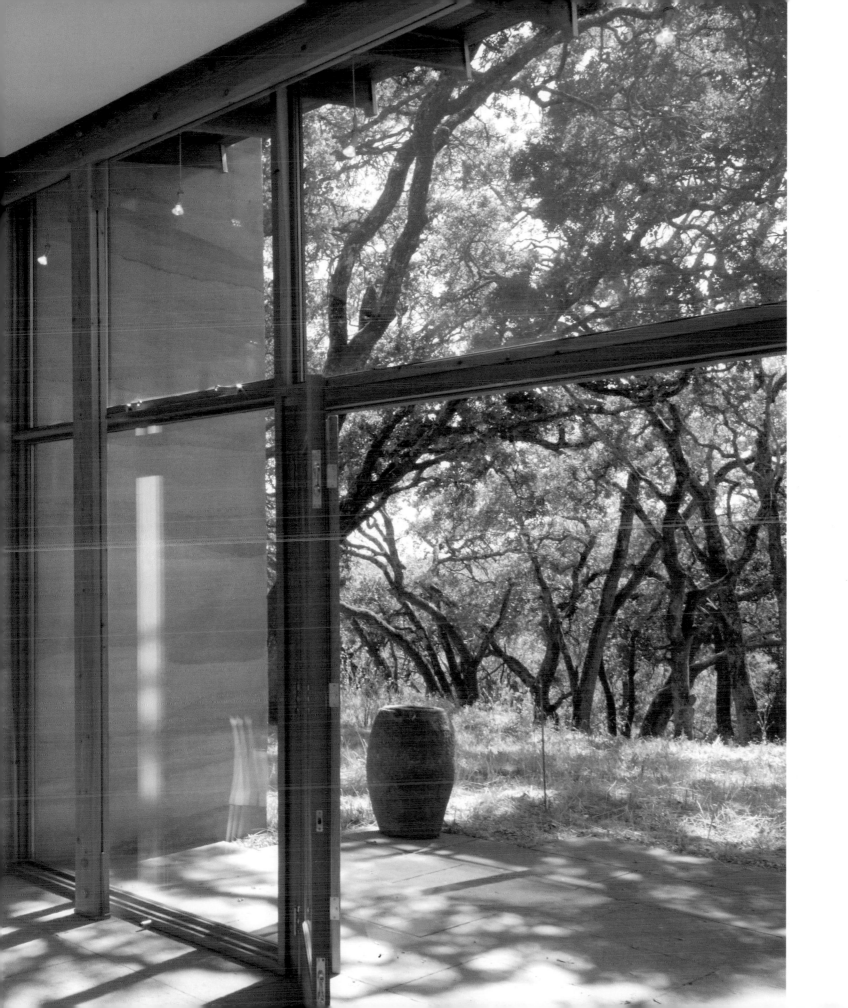

Artist's Studio

1100 Square Feet

Centerbrook Architects and Planners

Photography: Scott Francis

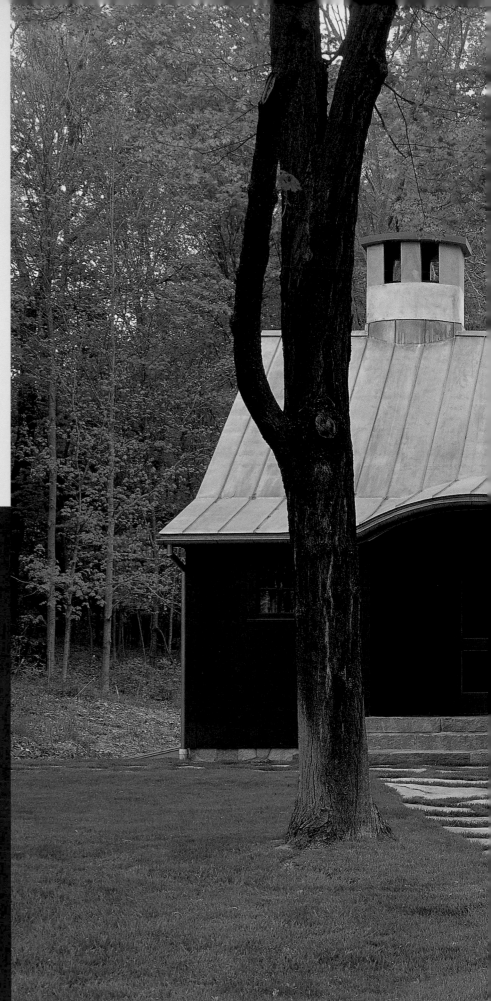

A SUCCESSFUL SCULPTOR USES THIS STUDIO, WHICH IS SET AT THE EDGE OF THE WOODS ACROSS A FIELD FROM HIS HOUSE AS A PLACE TO THINK, SKETCH, AND CRAFT MAQUETTES OF HIS WORK.

A LARGE, ARCHED WINDOW FACES NORTH FOR EVEN LIGHT, WHILE ANOTHER WINDOW FACES A LONG VIEW TO THE EAST. A SMALLER ARCH OVER THE FRONT DOOR ANNOUNCES THE ENTRY TO THIS BARNLIKE SALTBOX.

MATERIALS ARE SIMPLE BUT DELIBERATE. A LARGE STUCCO CHIMNEY DISTINGUISHES THE STANDING SEAM, LEAD-COATED COPPER ROOF. VERTICAL CEDAR BOARD SIDING IS PAINTED A CERULEAN BLUE, AND A PANELED MAHOGANY DOOR PROVIDES A GENEROUS ENTRY.

INSIDE THE SINGLE LARGE WORKROOM, MULTICOLORED SLATE FLOORING AT THE ENTRY AND FIREPLACE ABUTS MAPLE FLOORING AND WAINSCOTS. THERE IS A SMALL KITCHEN AND BATHROOM, AND AN ARCHITECT-DESIGNED ADJUSTABLE WORKTABLE IN THE CENTER OF THE ROOM.

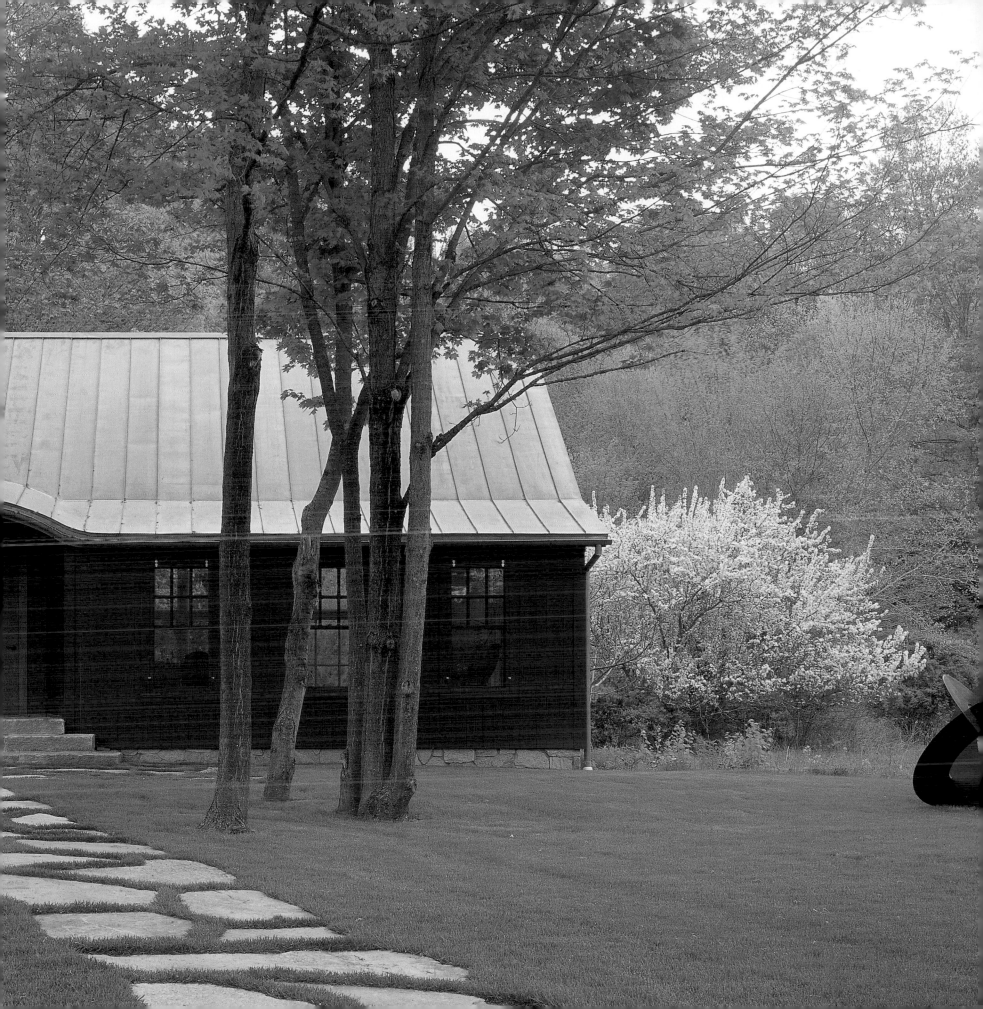

Site Plan

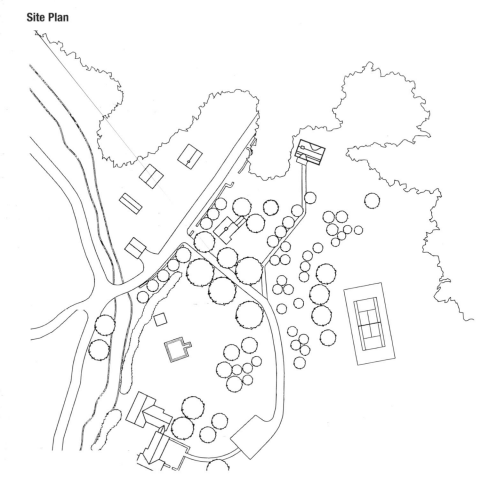

Attic Floor Plan

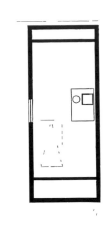

Previous Pages: The sculptor's work is displayed around the studio.
Below Left: The entry façade
Right: The studio consists of one large, light-filled room.

First Floor Plan

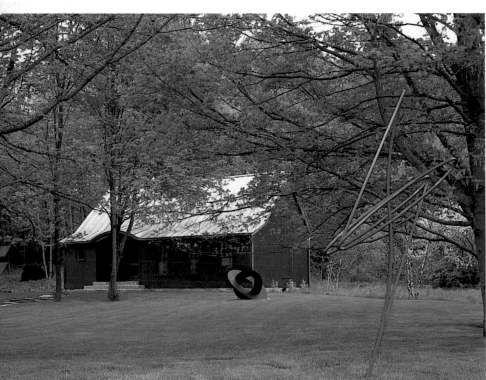

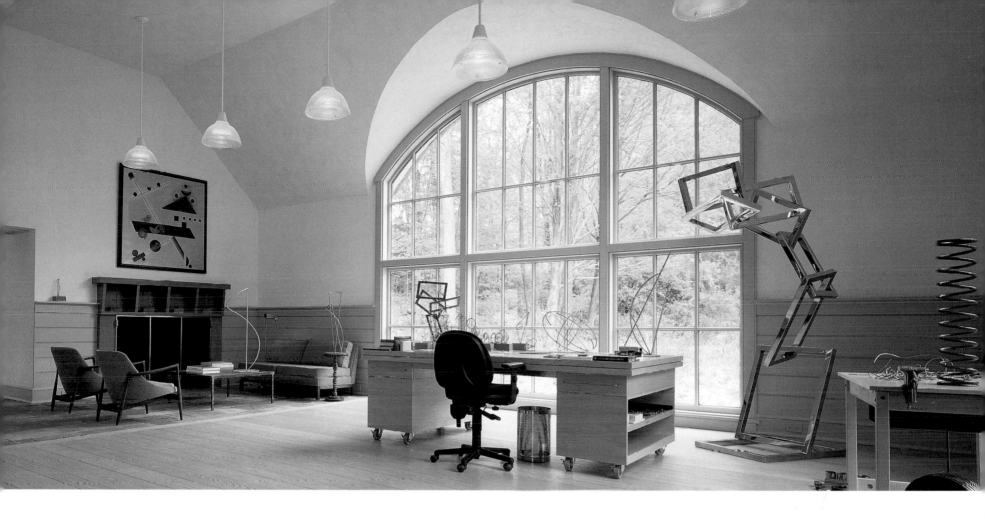

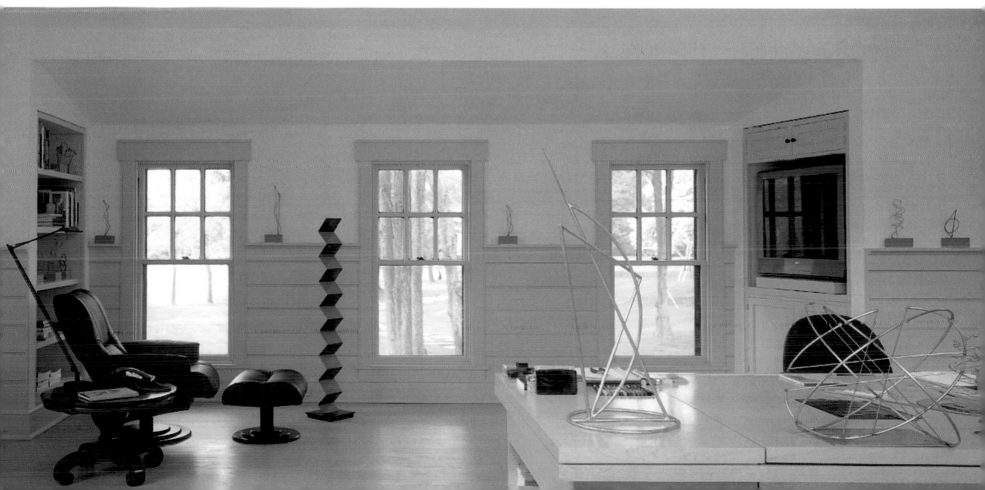

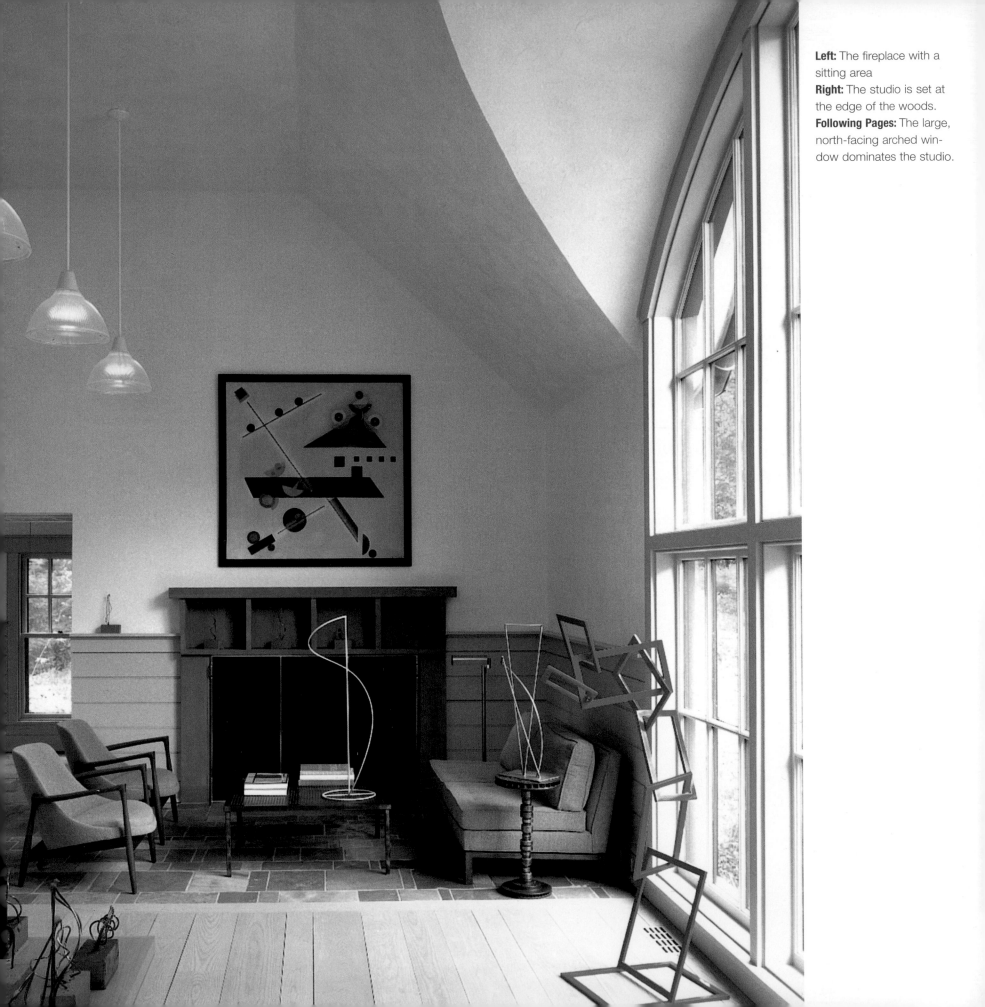

Left: The fireplace with a sitting area
Right: The studio is set at the edge of the woods.
Following Pages: The large, north-facing arched window dominates the studio.

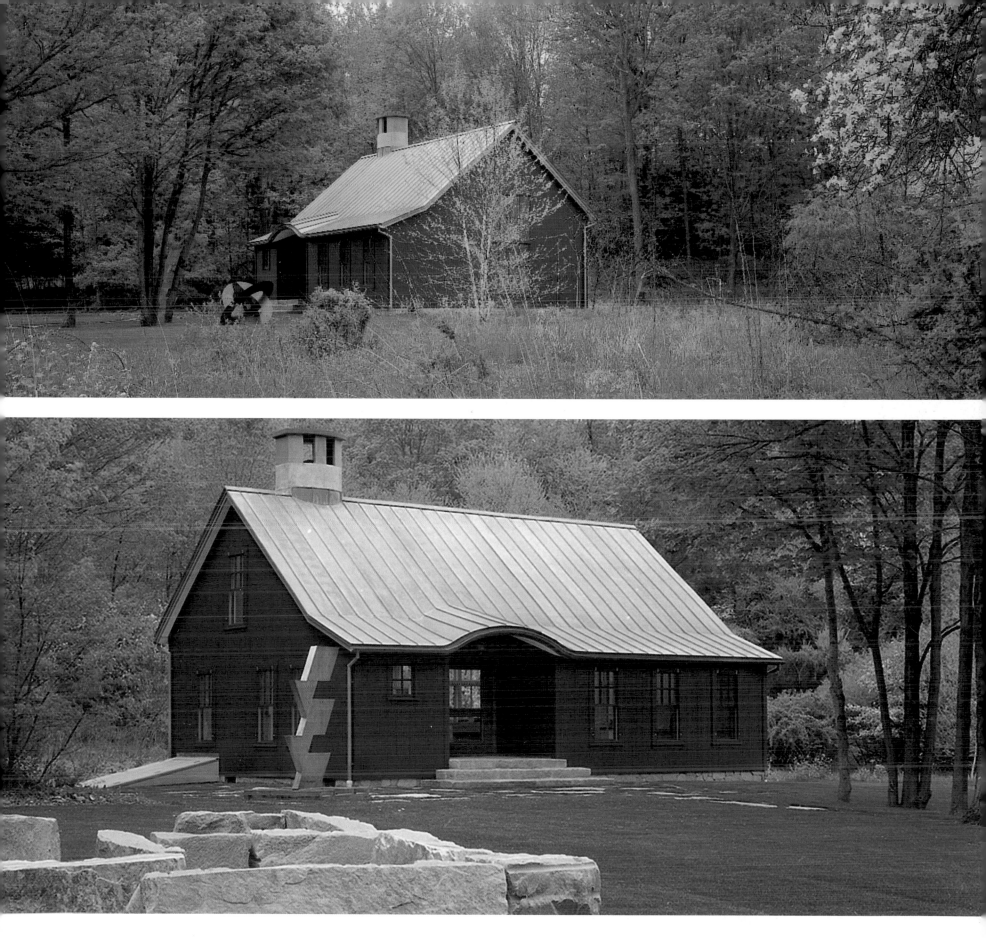

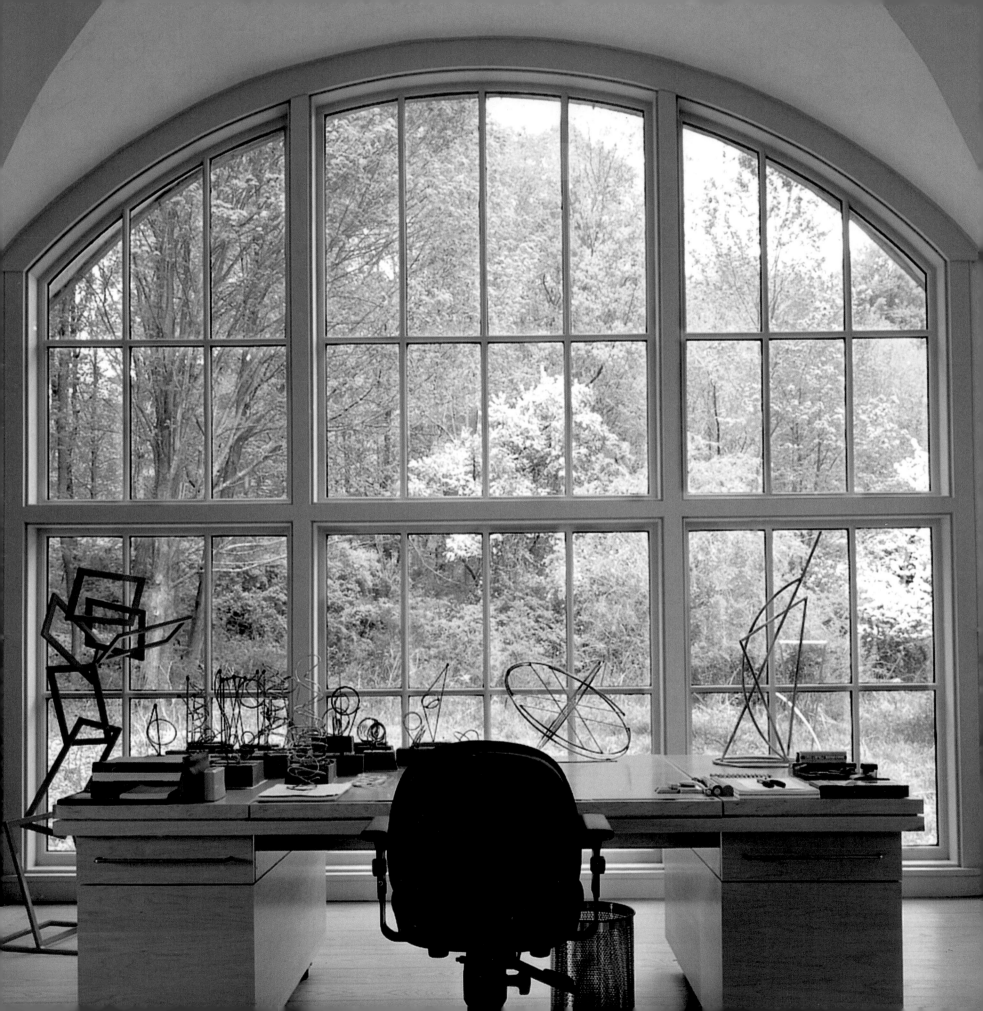

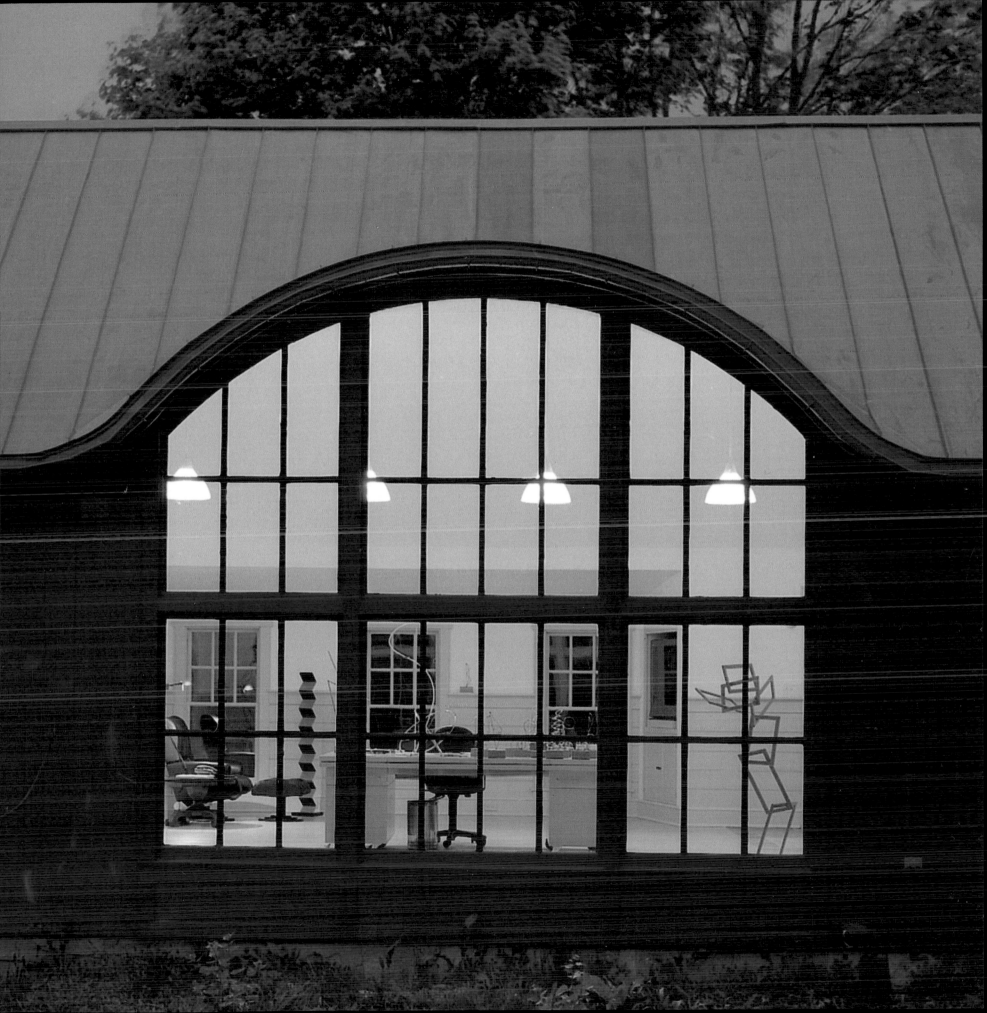

Laneway House

1350 Square Feet

Shim-Sutcliffe Architects

Photography: James Dow, Steven Evans

Within the City of Toronto, there is an extensive network of laneways servicing the rear portion of many residential neighbourhoods, and a derelict site within this intense urban condition is the location of this single-family residence.

A concrete garden wall wraps the property and protects a delicate, wooden pavilion within it. The project was conceived of as a series of interior and exterior gardens and courts. Rich textural materials and pivoting window planes between the primary living and garden spaces blur the relationship between inside and outside.

Basic construction techniques were used, with concrete block foundations and wood framing. The exterior consists of acrylic stucco, Douglas fir vertical siding, mahogany windows, door frames, and plywood panels. Interior walls are exposed concrete block and plaster. The floors are Jatoba wood and slate.

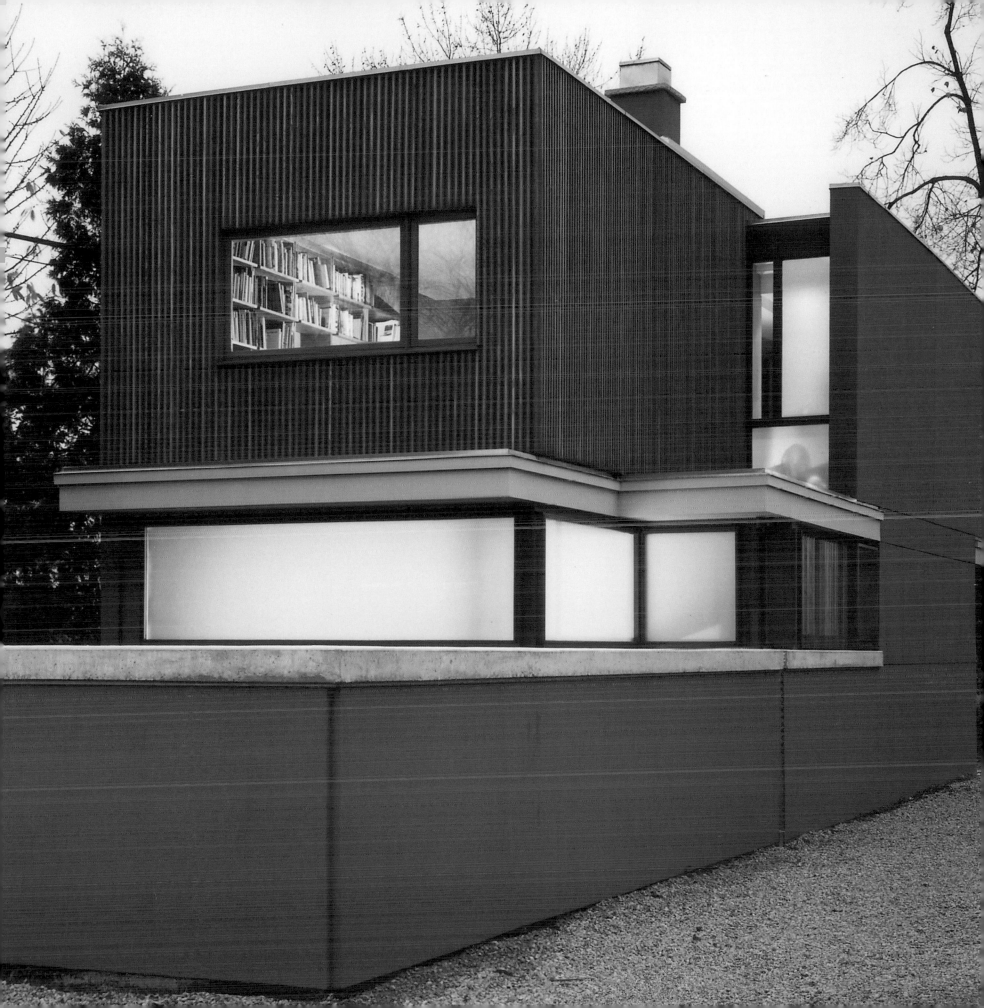

Second Floor Plan

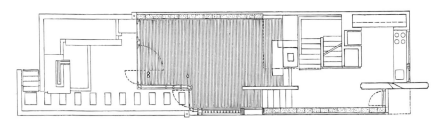

First Floor Plan

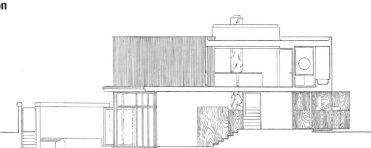

Elevation

Previous Pages: The garden wall wraps around the rear of the dwelling.
Left: Model
Right: Entry at dusk

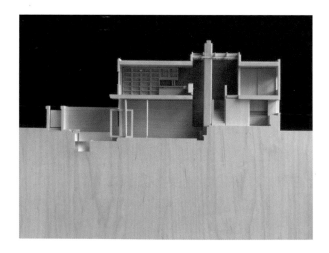

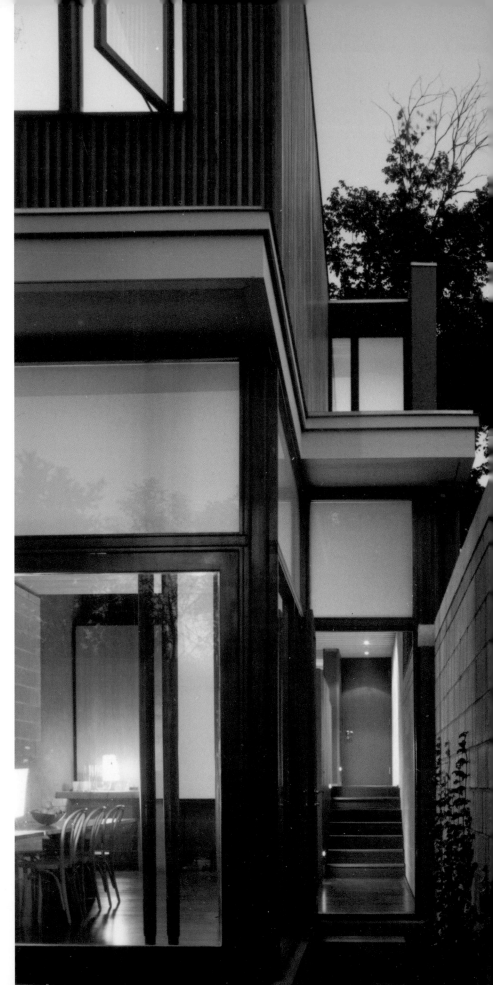

Above: View of the garden from the dining room window

73

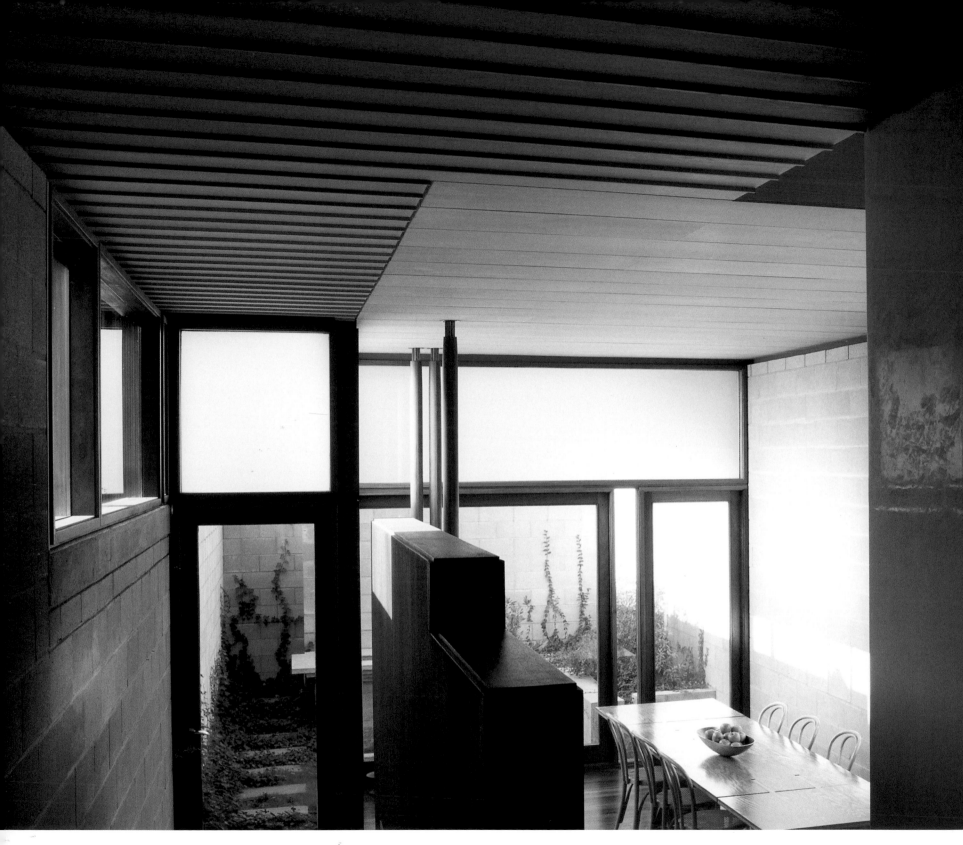

Above and Right: The dining area overlooking the garden in summer and winter

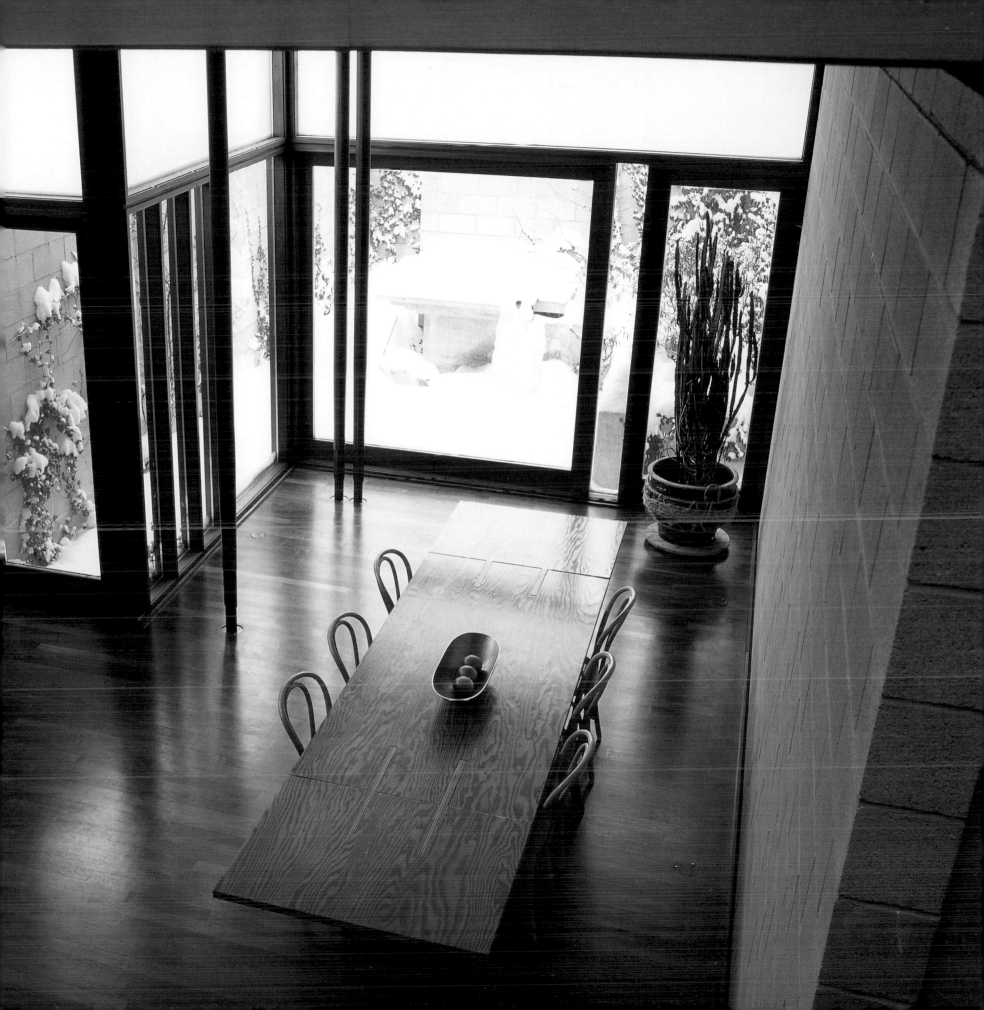

Strawberry Field

1500 Square Feet

Jim Rounsevell, Architect

Photography: Jim Rounsevell

THE HOUSE IS SITED ON A MODEST RIDGE IN AN OPEN FIELD OF WILD STRAWBERRIES. IT IS LAID OUT AS A BAR FOR EVEN DAYLIGHT DISTRIBUTION, MAXIMUM EXPOSURE TO PANORAMIC MOUNTAIN VIEWS, AND FOR PRIVACY. THE CLIENTS WANTED A SHELTER CLOSELY TIED TO THE LAND AS WELL AS AN OPEN PLAN FOR ENTERTAINING GUESTS.

WORKING WITH AN EXTREMELY LIMITED BUDGET, THE DESIGN OF THE HOUSE IS INSPIRED BY LOCAL VERNACULAR FORMS AND MATERIALS, SPECIFICALLY THE SOUTHERN DOGTROT HOUSE.

THE FOUR-FOOT ROOF OVERHANG SHIELDS A CONTINUOUS BAND OF CLEARSTORY GLAZING FROM HOT SOUTHERN SUN WHILE ADMITTING DIRECT SUNLIGHT DURING WINTER MONTHS. ROOF AND WALLS ARE CLAD WITH CORRUGATED GALVANIZED STEEL PANELS. NATURAL STAINED WOOD WINDOWS AND DOORS COMPLIMENT THE SOFT GRAY METAL.

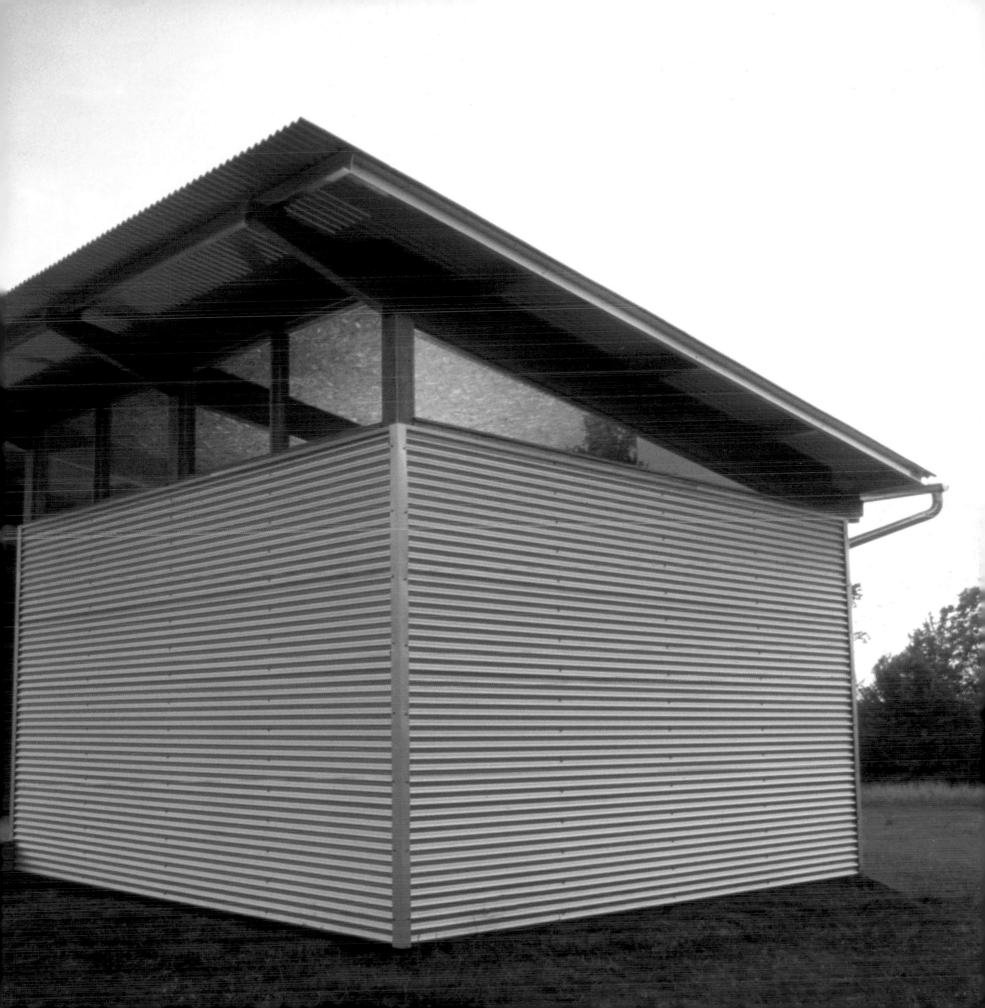

Site Plan

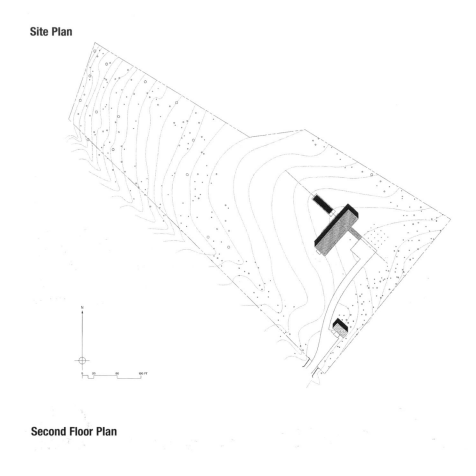

N

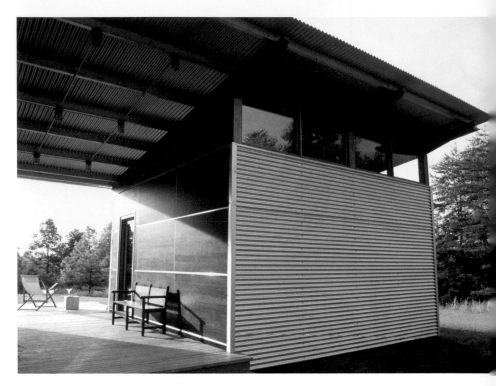

Second Floor Plan

First Floor Plan

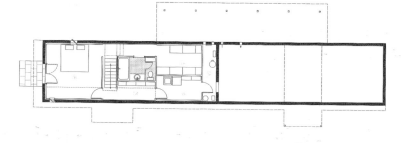

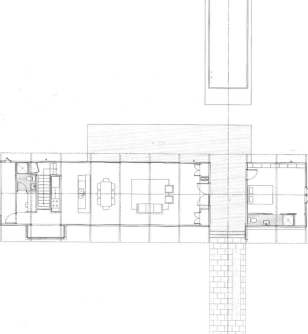

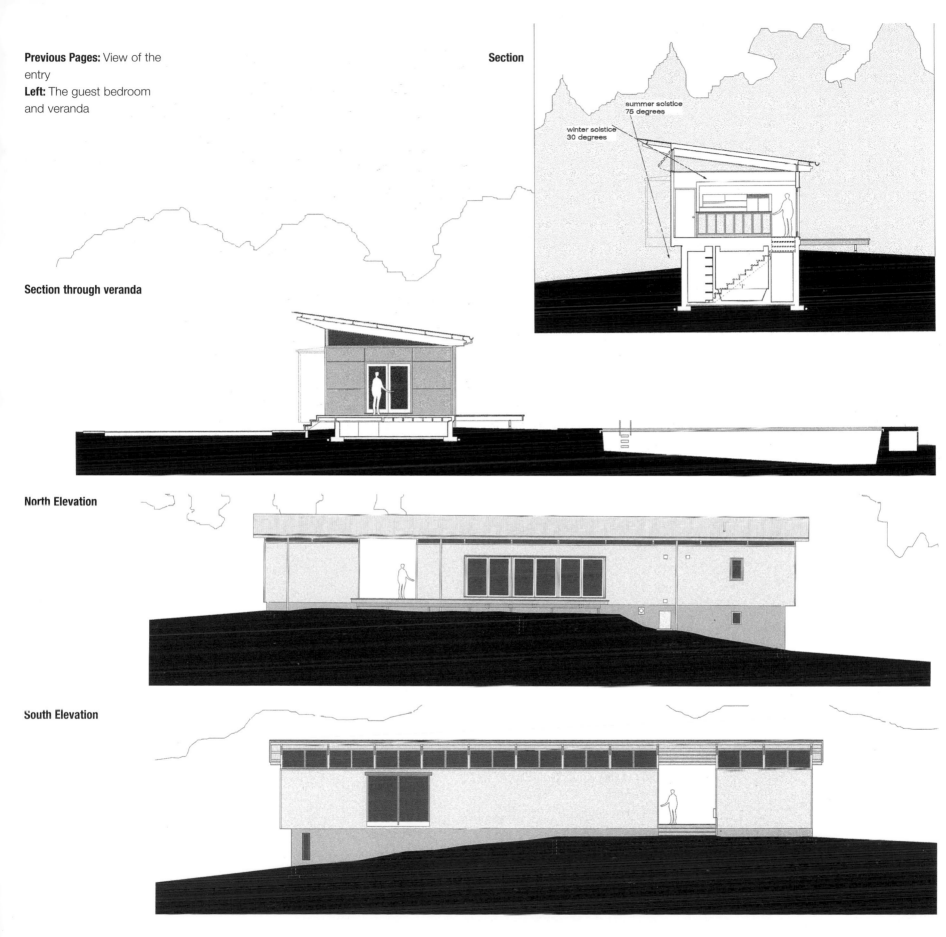

Previous Pages: View of the entry

Left: The guest bedroom and veranda

Section

summer solstice 75 degrees

winter solstice 30 degrees

Section through veranda

North Elevation

South Elevation

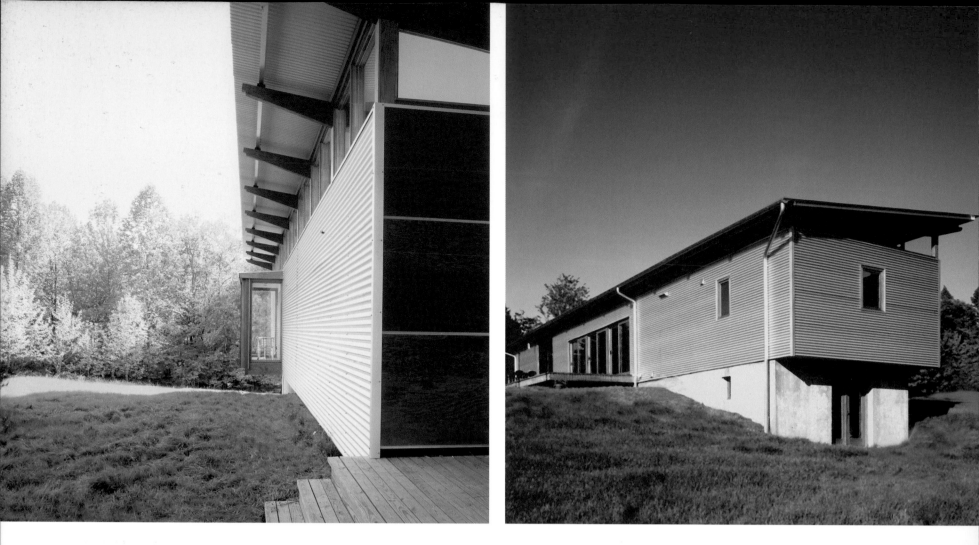

Above: View of the south elevation
Above Right: Southwest corner
Right: North elevation

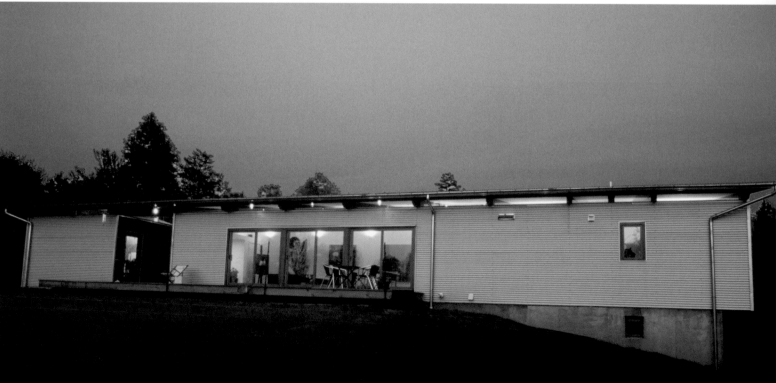

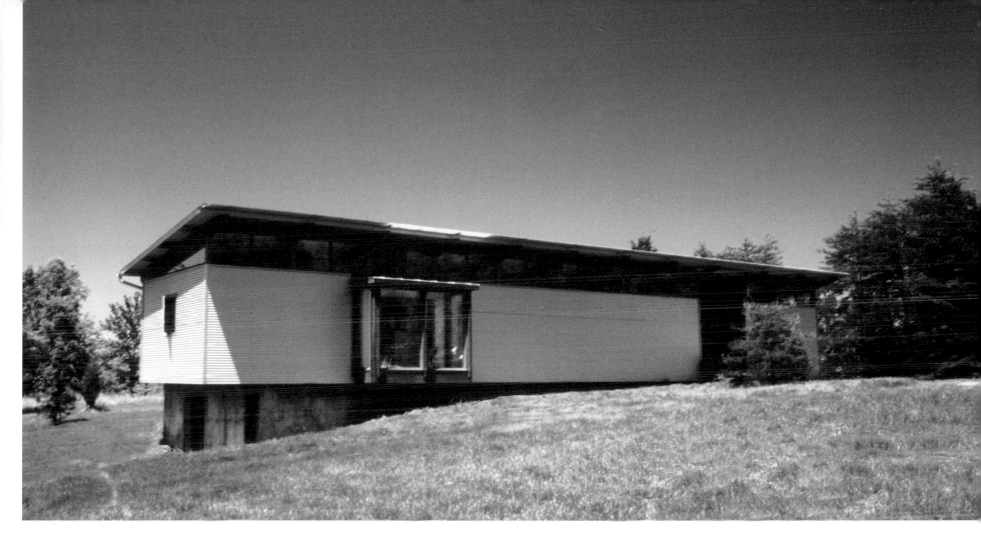

Above: South elevation
Left: Northeast corner

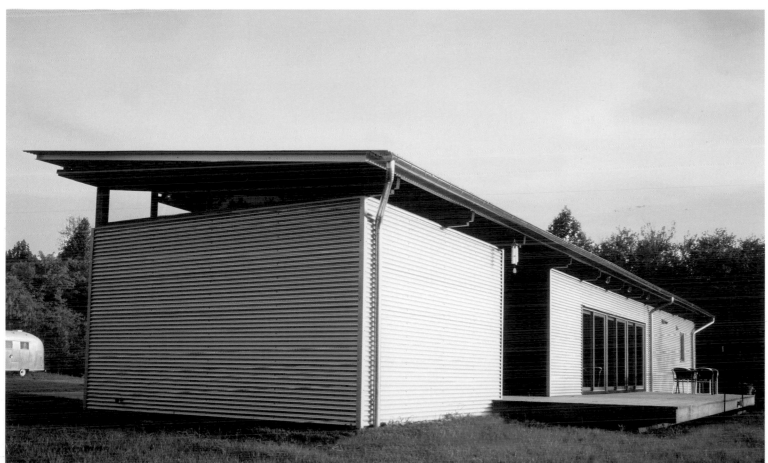

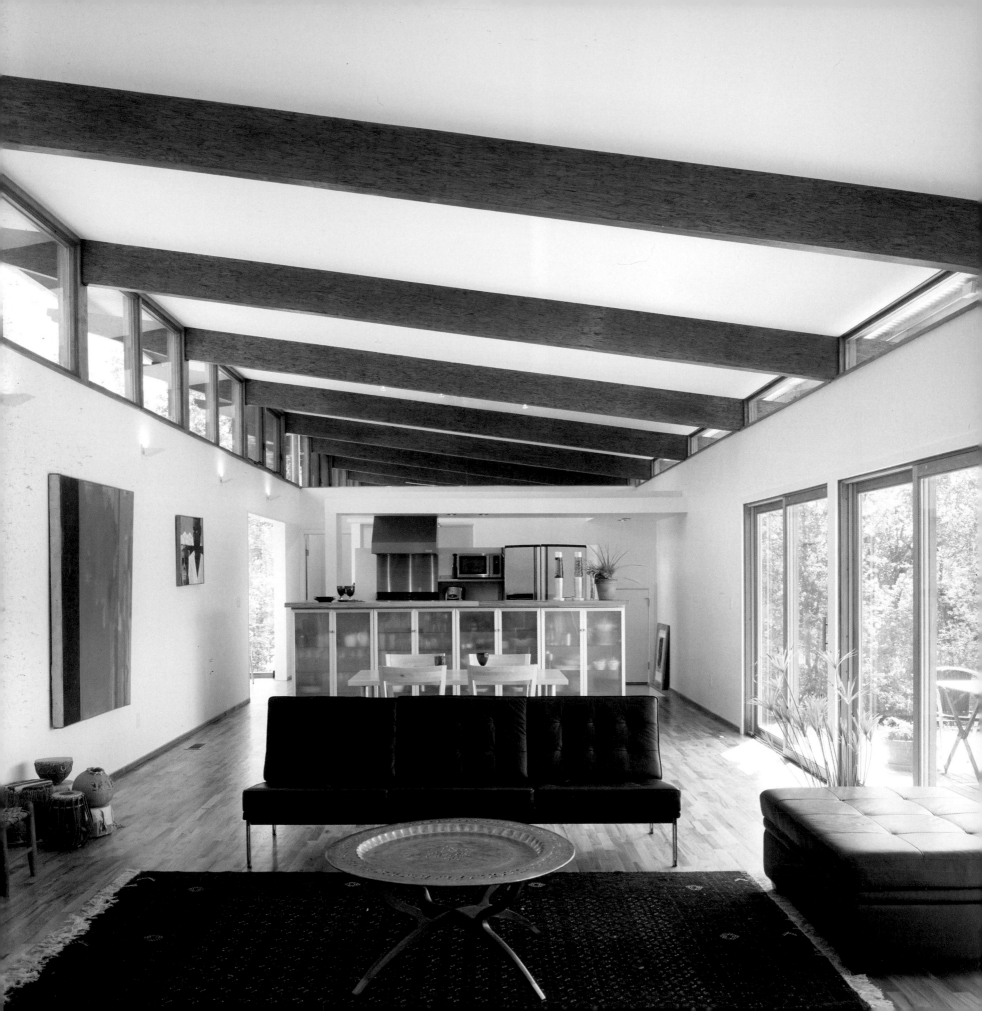

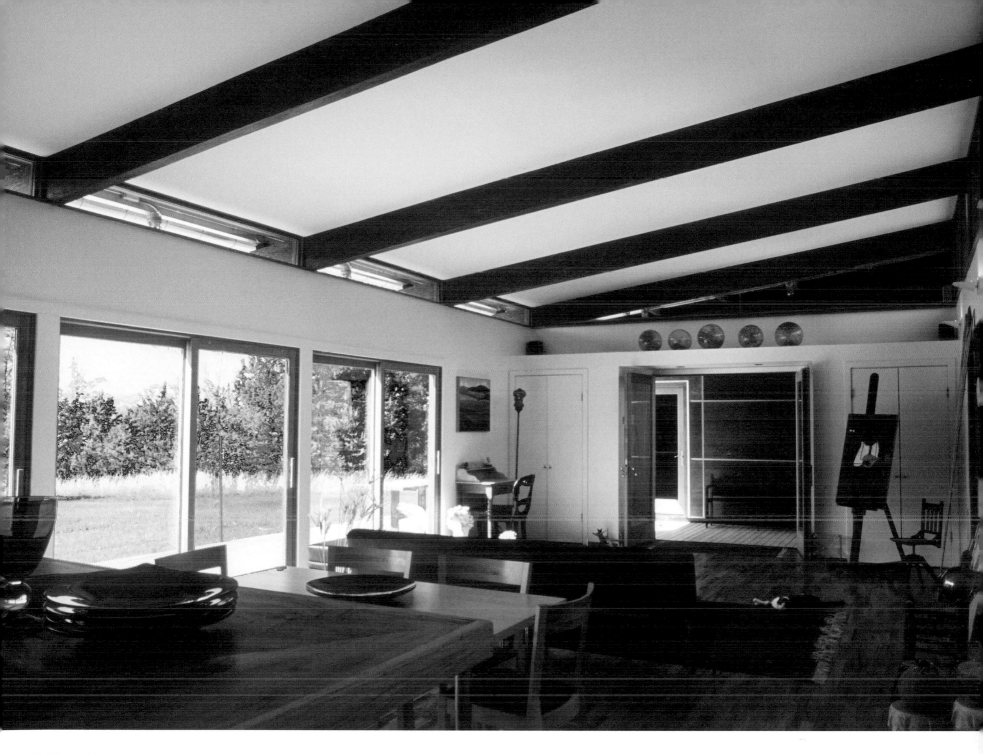

Left: View of the kitchen
from the living area
Above: View of the veranda
and guest bedroom from
the living area

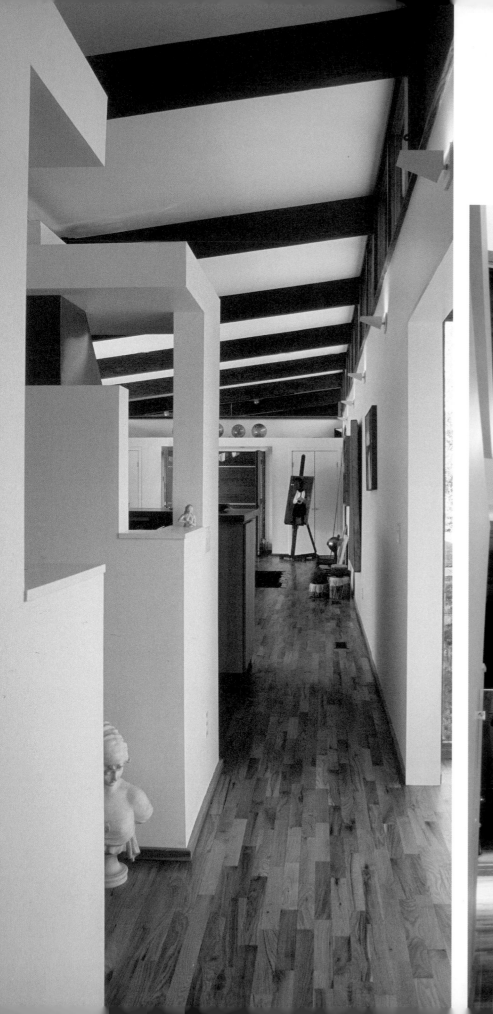

Left: View from the bed-
room of the kitchen and
living area beyond
Below: View of the vitrine
from the stairway
Right: The veranda with
the entry on the left

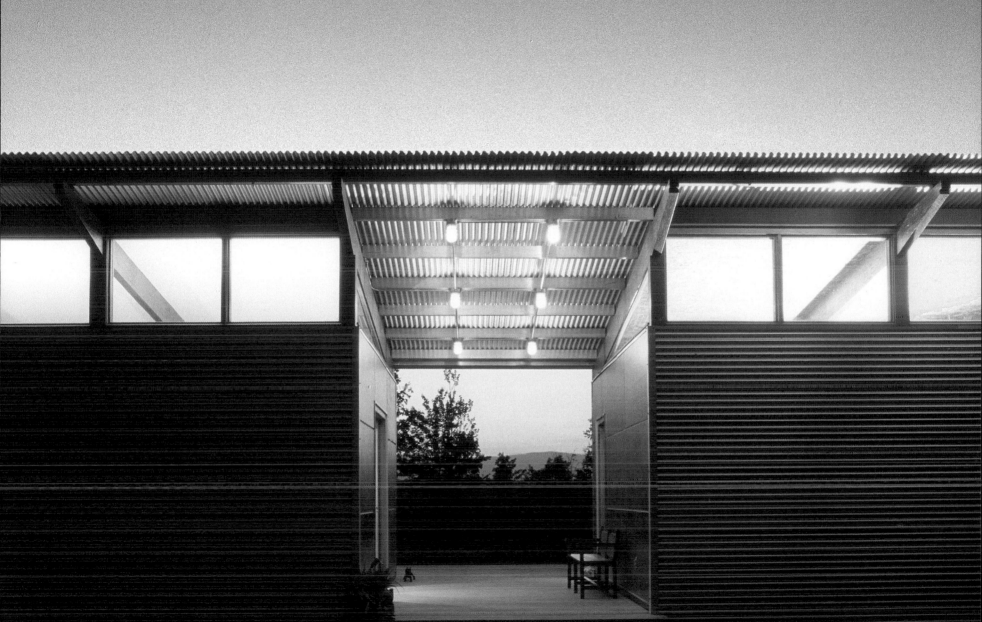

Carmel Guest House

1500 Square Feet

Archi-Tectonics
Photography: Winka Dubbeldam

A GARAGE CONSTRUCTED OF ROUGH STONE COLLECTED FROM THIS LAKESIDE SITE SUPPORTS A WOODEN, CANTILEVERED GUESTHOUSE, WHICH HOVERS FREE FROM THE GROUND.

THE LIVING, DINING, AND KITCHEN AREAS ARE LOCATED ON THE SECOND FLOOR WITH A STUNNING VIEW OF THE LAKE. THE DINING AND KITCHEN AREAS HAVE DOORS TO THE LARGE TERRACE ON THE GARAGE ROOF. THE DOUBLE-HEIGHT VOID TO BELOW CONNECTS TO THE SLEEPING AREA, WHERE SLIDING DOORS PROVIDE ACCESS TO A SMALL PORCH.

AT THE ENTRANCE ARE LAYERS OF WOOD SCREENS, LARGE GLASS SETBACKS, AND A DOUBLE-HEIGHT SPACE WITH FELT CURTAINS THAT CREATE A SOFT BOUNDARY BETWEEN THE INTERIOR AND THE EXTERIOR.

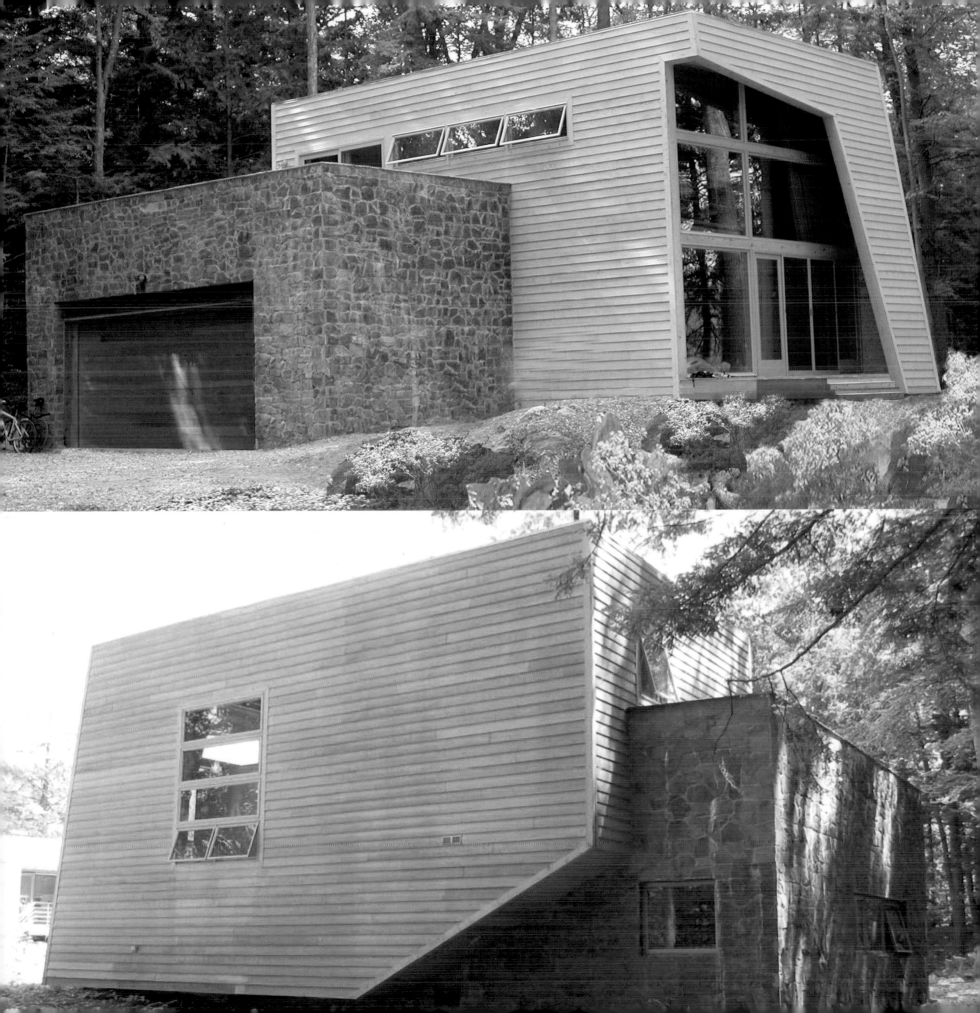

Elevation

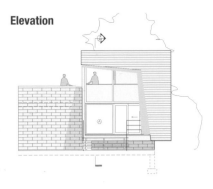

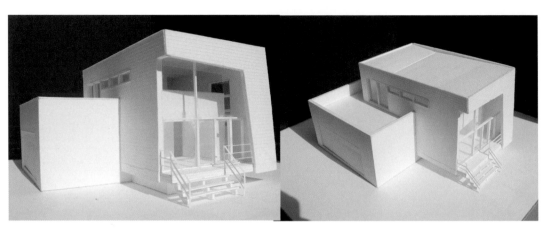

Previous Pages: View of guest house with attached garage; north façade
Left: Views of model
Below Left: Northeast façade
Below: Computer model of the interior
Right: Corner detail
Far Right: East façade

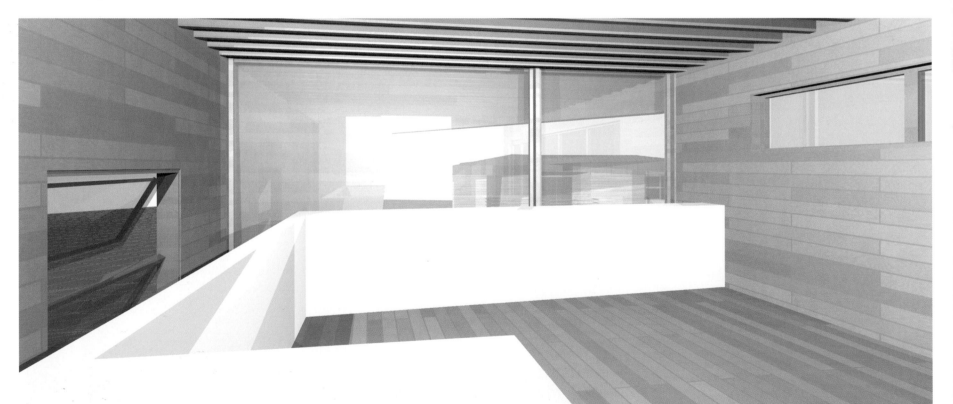

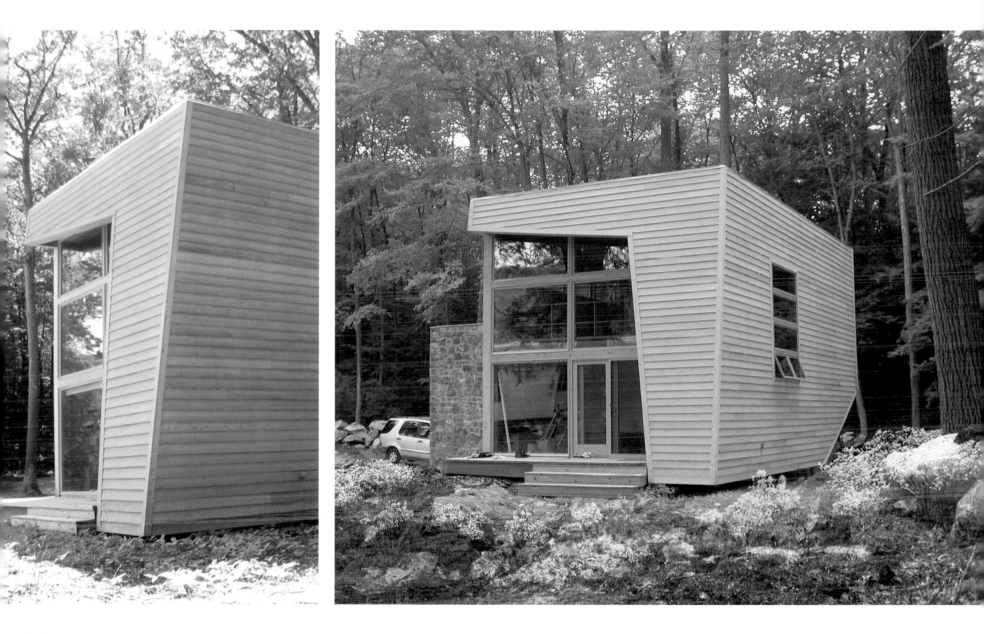

Sections

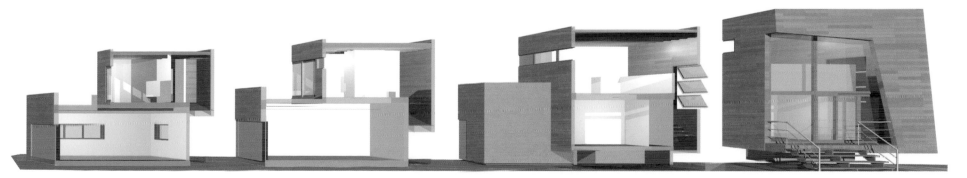

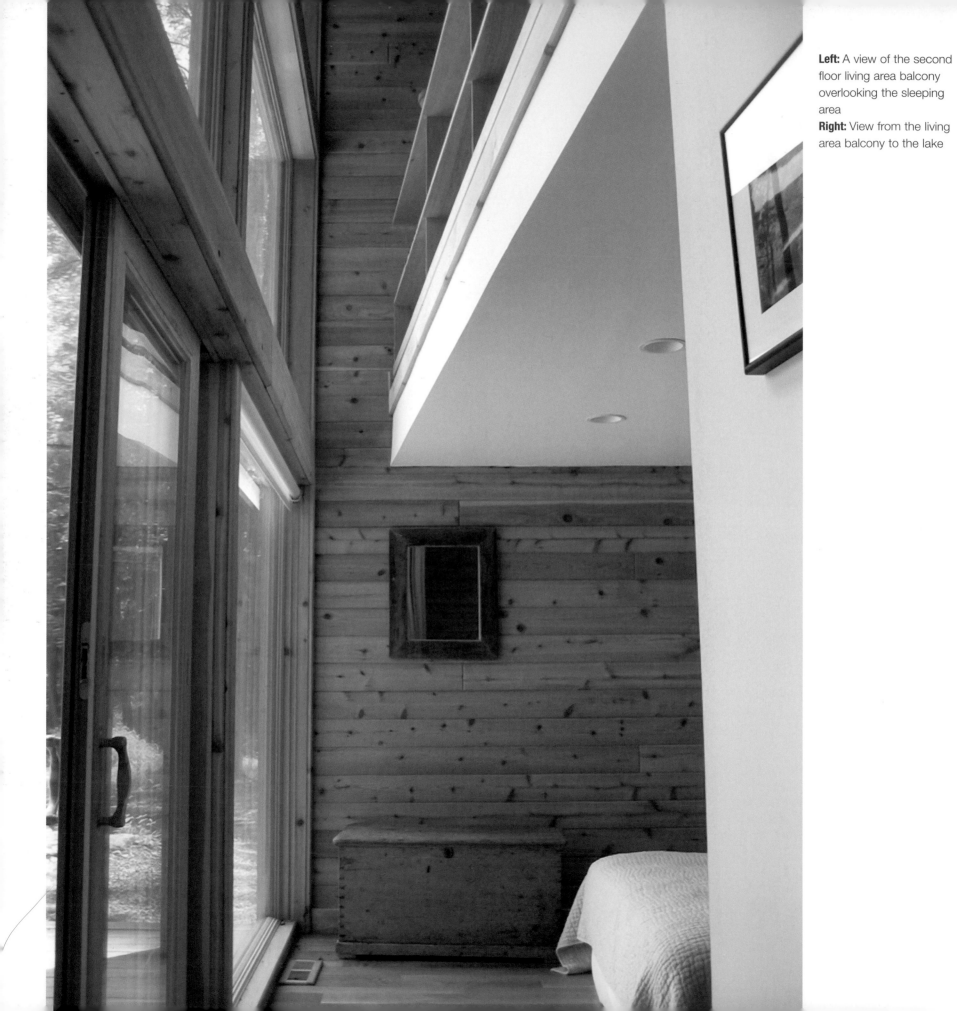

Left: A view of the second floor living area balcony overlooking the sleeping area

Right: View from the living area balcony to the lake

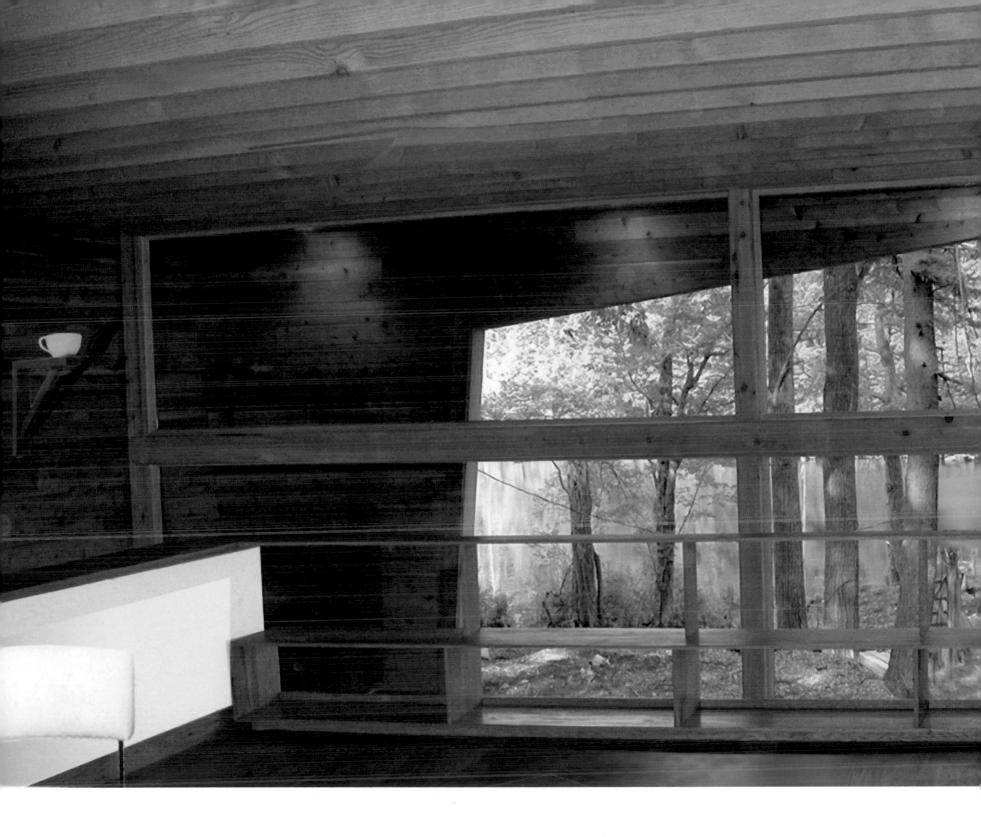

Honeymoon Cottage

1400 Square Feet

Tonic Design

Photography: JamesWest/WestProductions.com

The Honeymoon Cottage was designed and built by a young couple, a scientist and an architect, as their first home. It sits on the edge of a mature forest on a long, narrow site with a steep slope to a creek. It is accessed via an elevated walkway that leads to the first level, which is a loftlike space with the living, dining, and kitchen areas. An open stairway leads to the second floor master suite and a balcony, which overlooks the living area.

Windows are organized to take advantage of light, encourage views of nature and block less desirable views of neighboring properties. Standard building materials were used, and by participating in every phase of construction from digging footings to laying the recycled heart-of-pine floors, the couple was able to contain costs while creating a high quality, striking home.

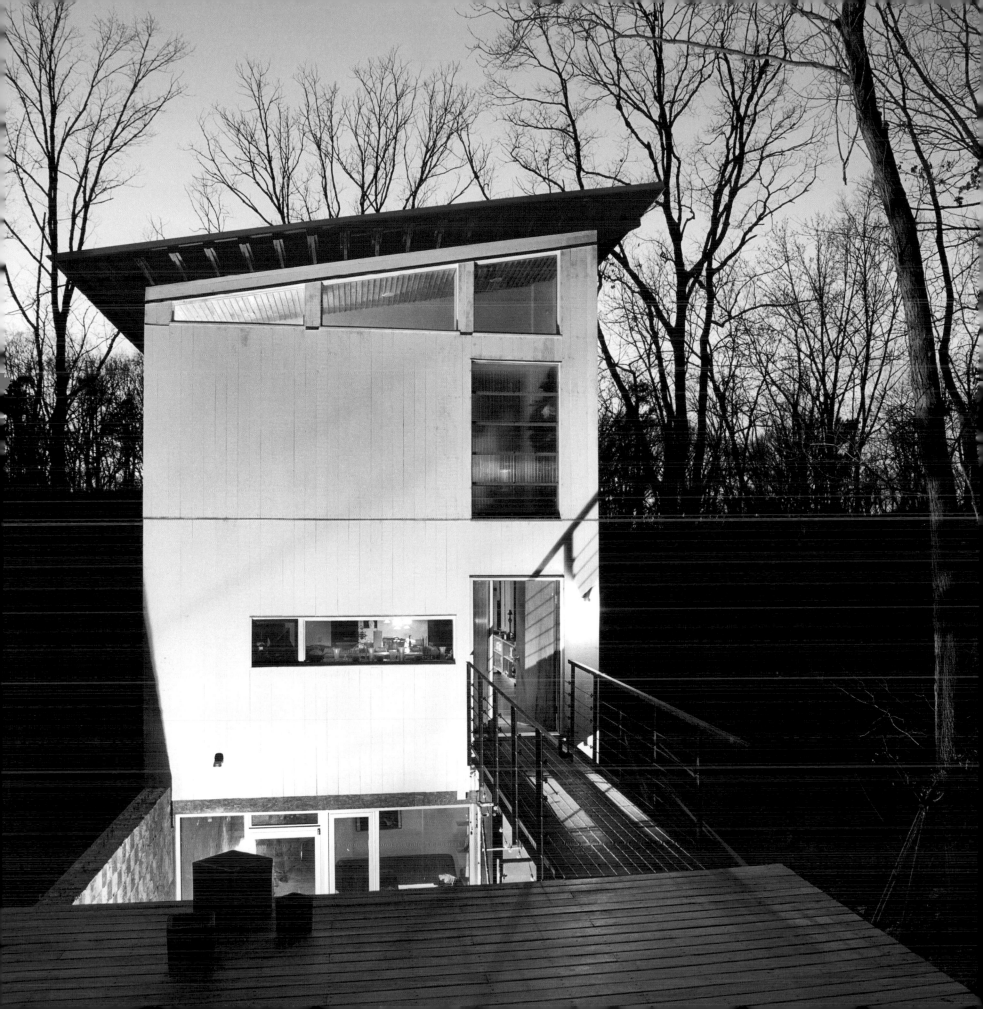

Site Plan

Elevation

Second Floor Plan

First Floor Plan

Ground Floor Plan

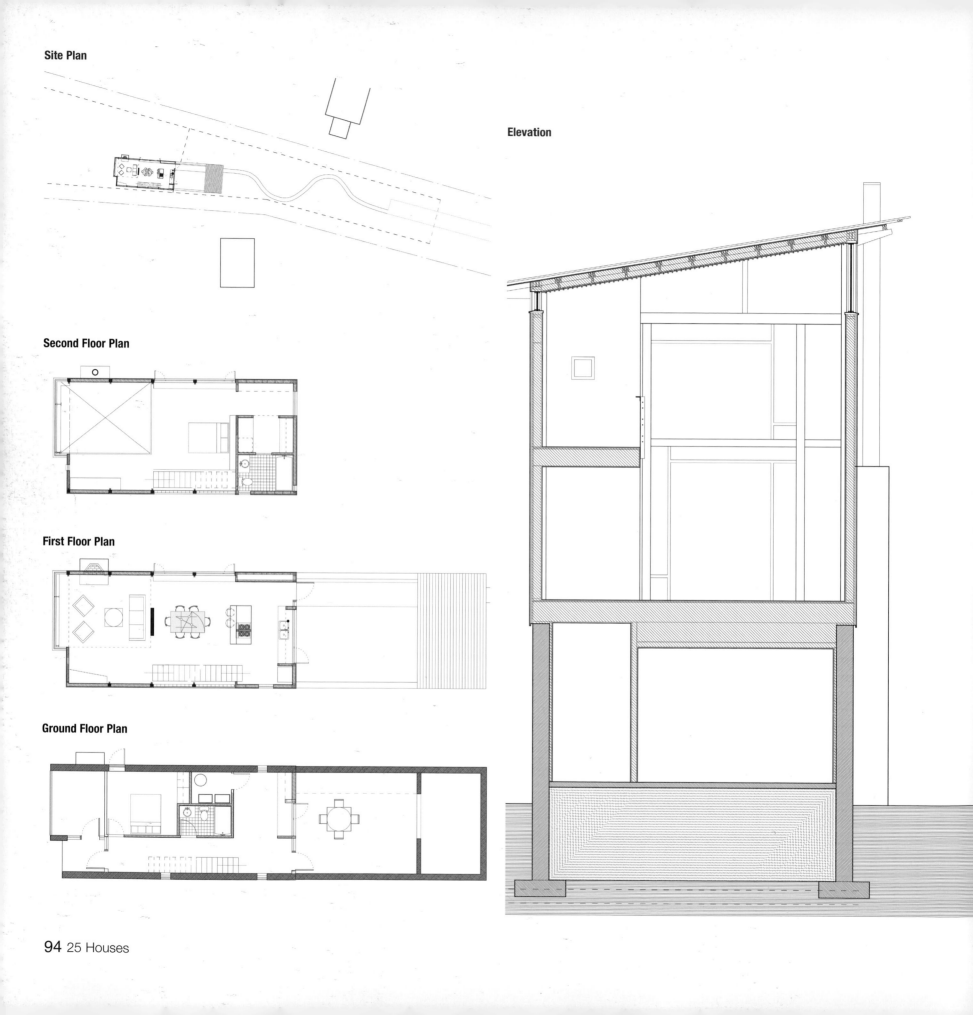

Previous Pages: Entry façade
Right: The house as seen
from the creek

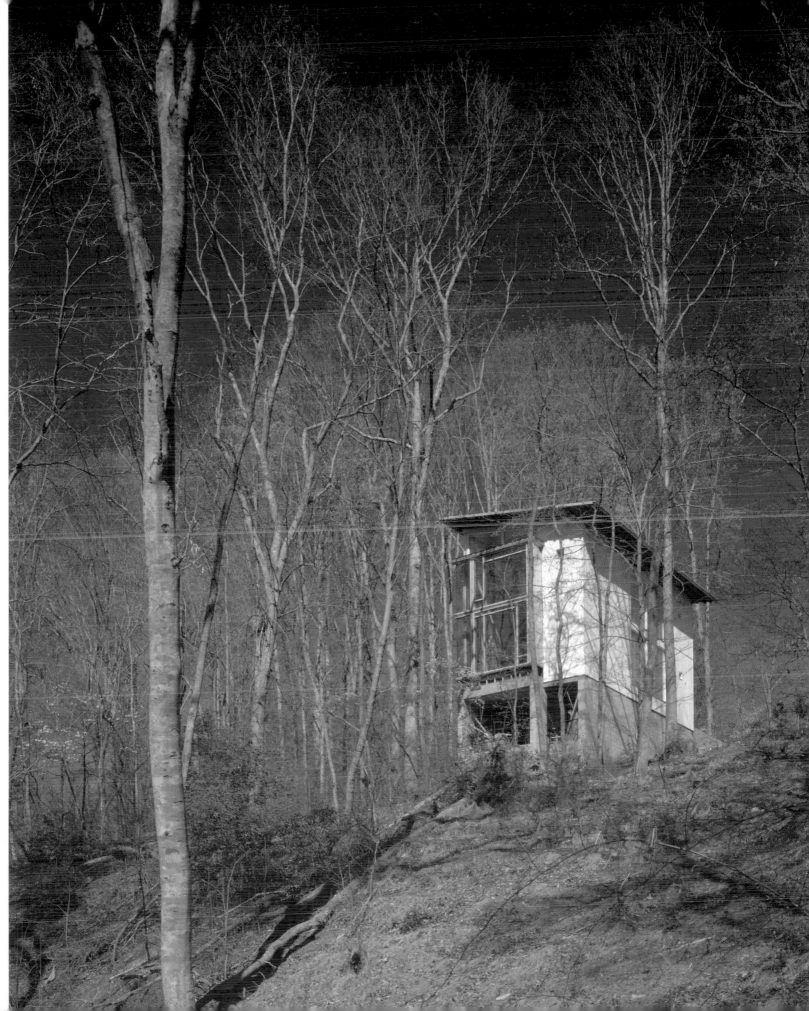

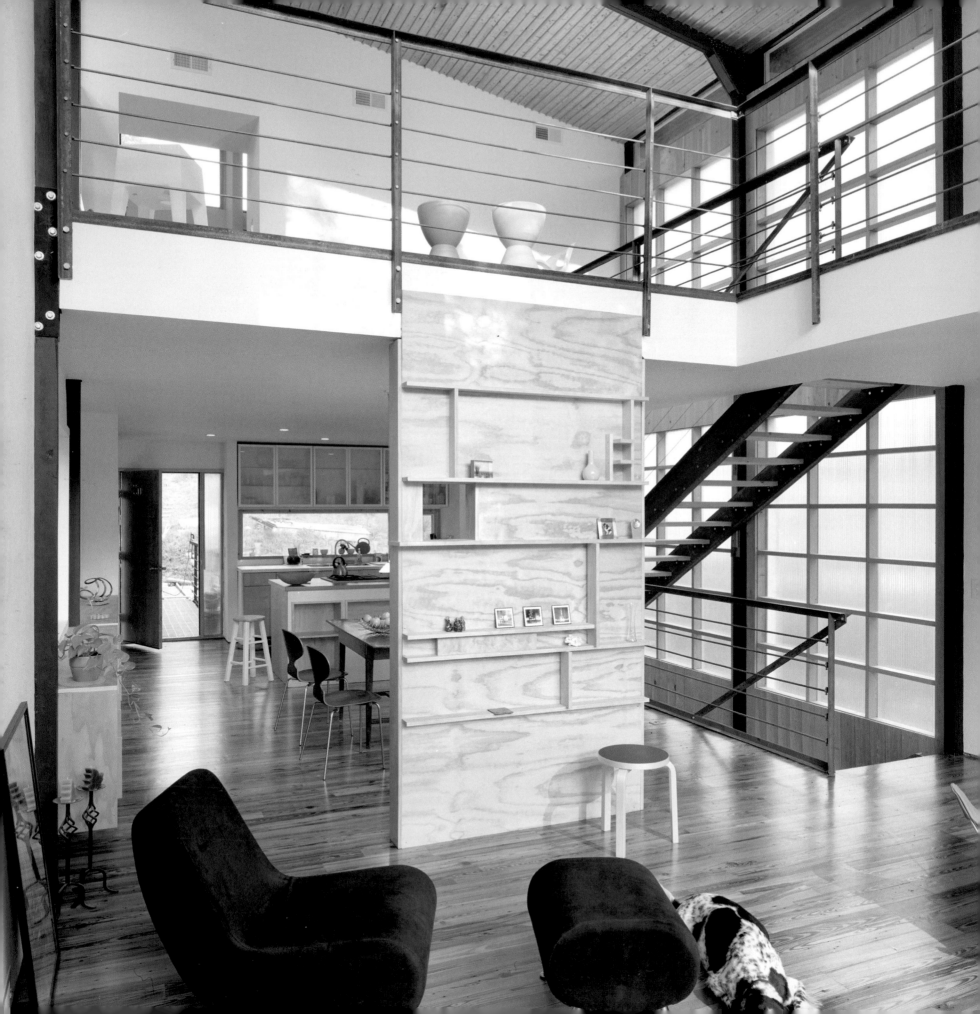

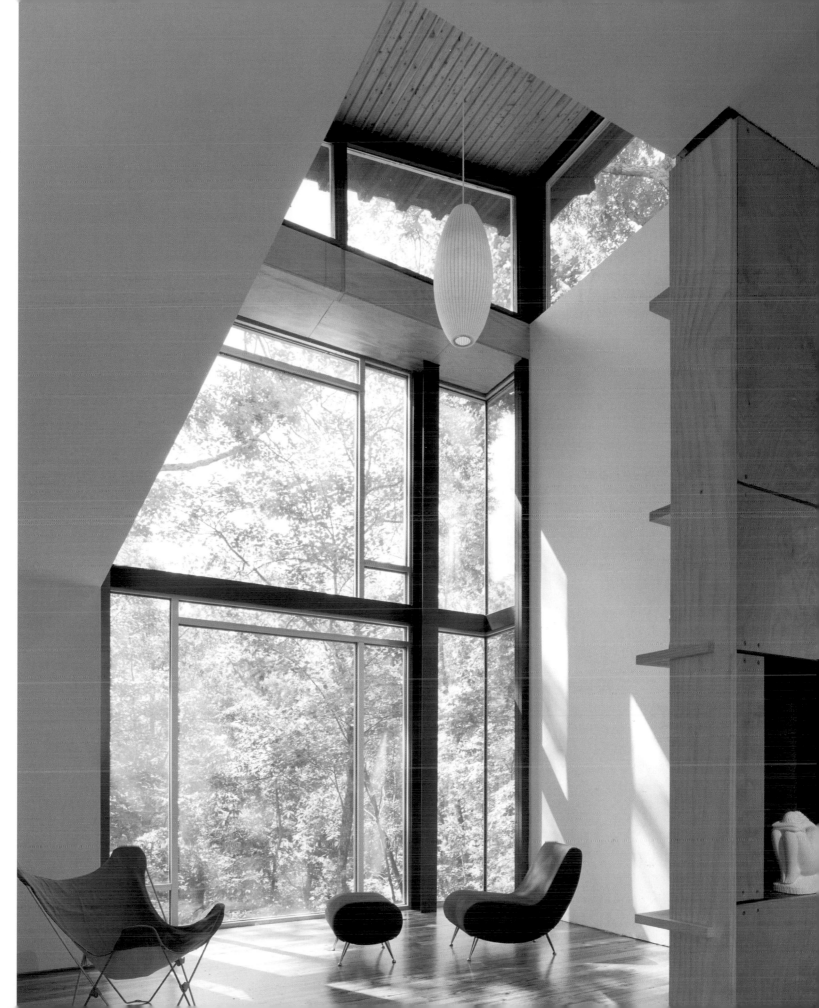

Left: View of the living room with the dining area and the kitchen beyond and master bedroom above
Right: The two-story living room

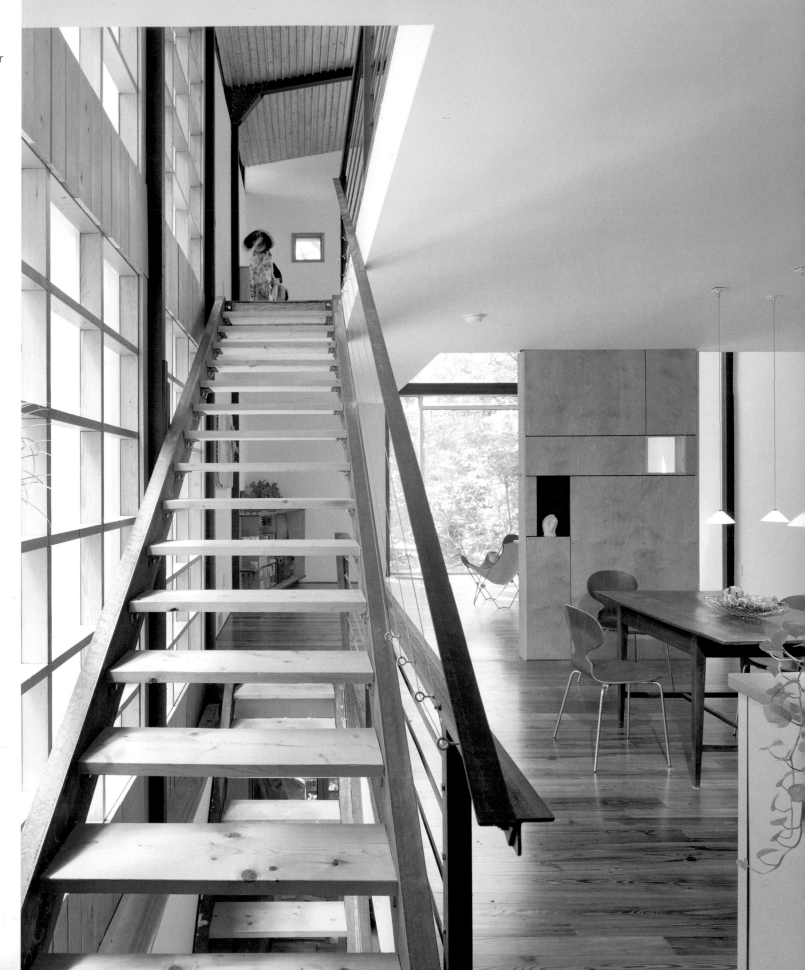

Right: The open stairs to
the second floor
Far Right: The second floor
balcony and study over-
look the living room.

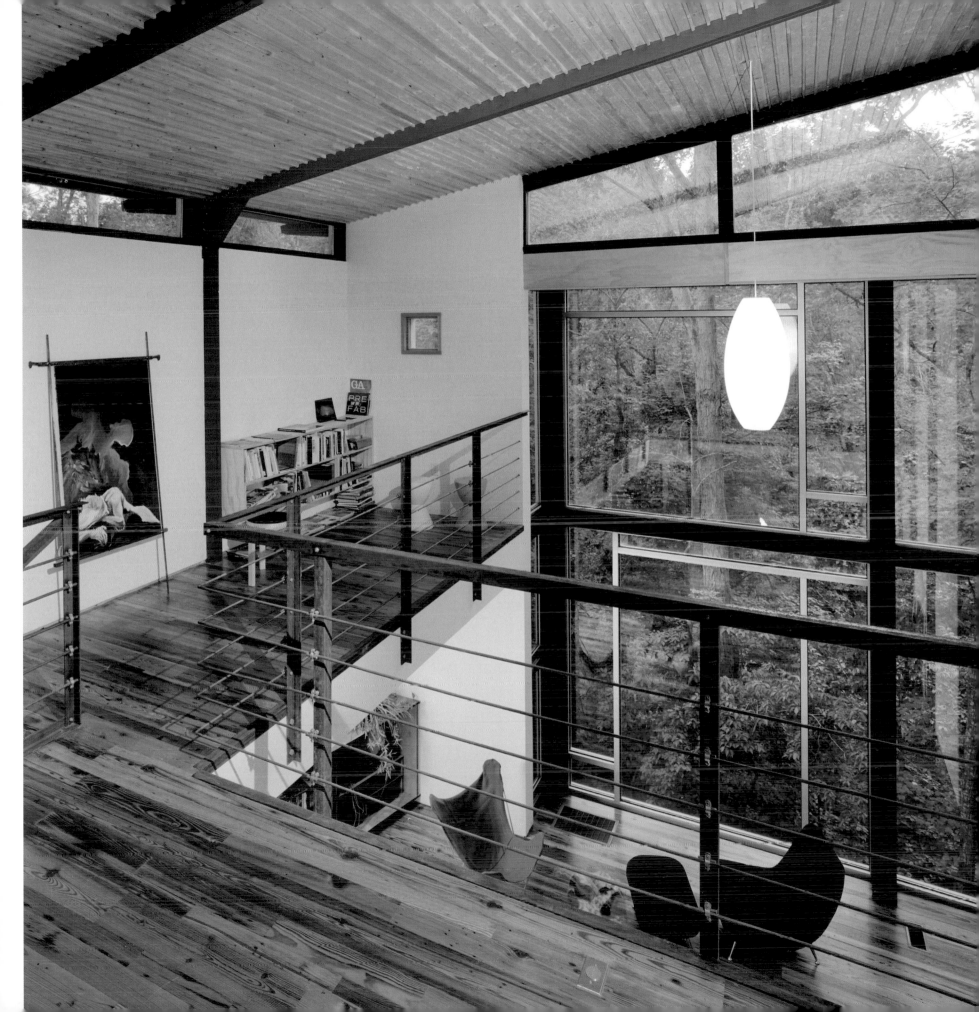

Cavehill Residence

1500 Square Feet

Eggleston Farkas Architects
Photography: Allan Farkas

For the renovation of this bungalow, the architect placed the main living space on the second floor to take advantage of impressive views of the Olympic Mountains and Seattle's Puget Sound. An elegant, open steel stair leads from the entry to the second level, where the space is divided into a living/dining area under an exposed butterfly roof, with the kitchen placed under a flat roof. The kitchen island serves as a guardrail for the stairs.

Downstairs, the master bedroom has a view of the back garden. A home office off the entry doubles as a guest room. A generous bathing room links the master bath and guest powder room, eliminating the need for a separate shower for the guest bedroom.

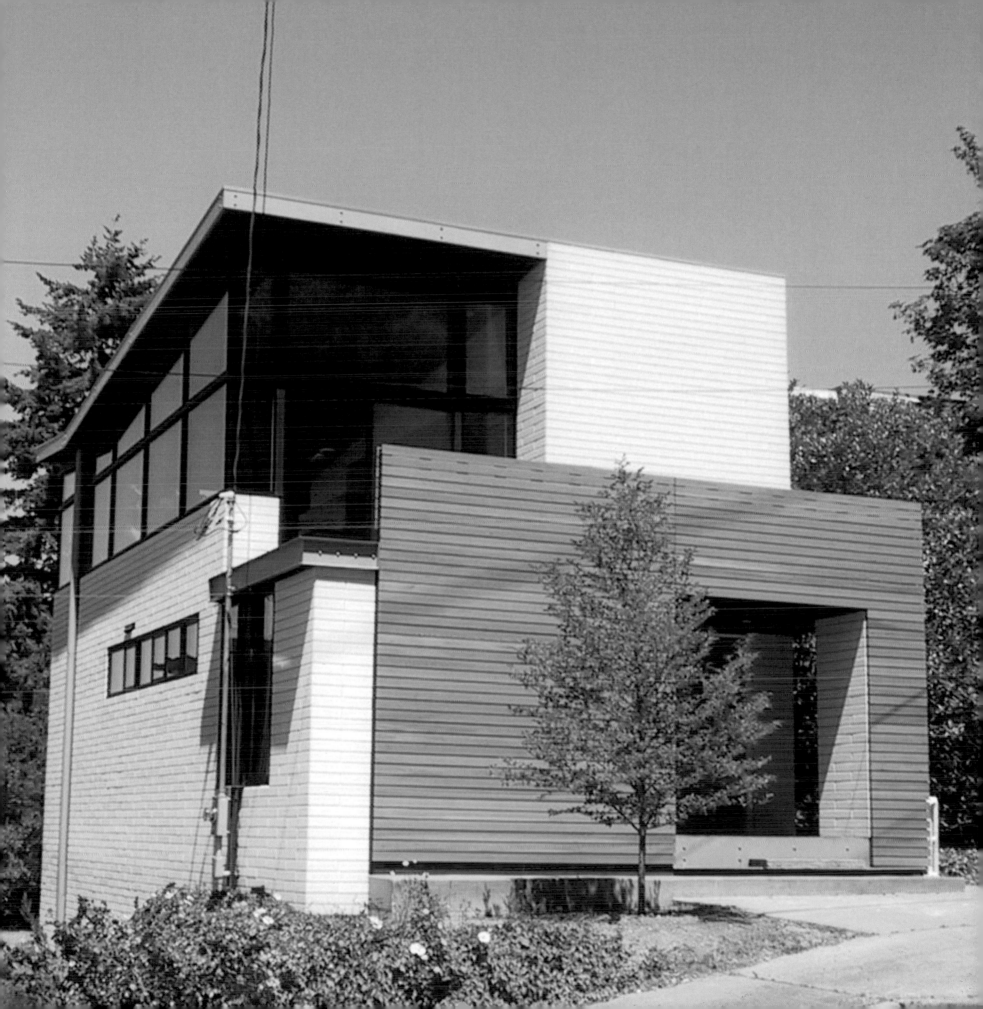

Section

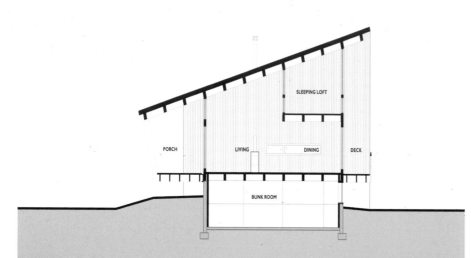

SLEEPING LOFT

PORCH LIVING DINING DECK

BUNK ROOM

Upper Level Plan

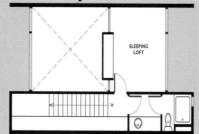

SLEEPING LOFT

Main Level Plan

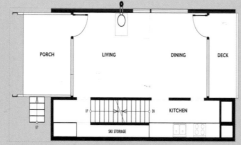

PORCH LIVING DINING DECK

KITCHEN

SKI STORAGE

Lower Level Plan

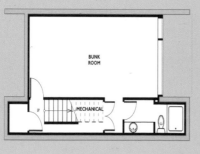

BUNK ROOM

MECHANICAL

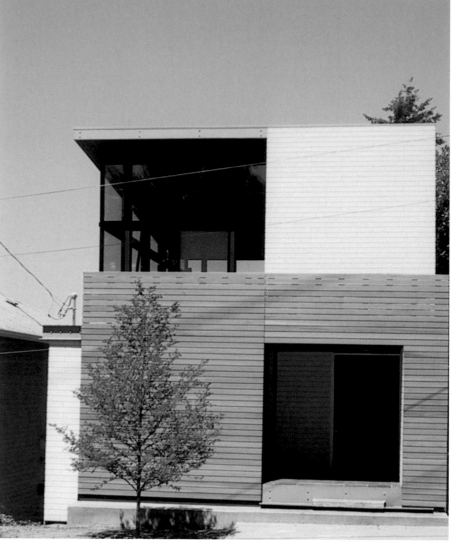

Previous Page and Above:
View of the house from
the street

Right: The open steel stair
to the upper level
Far Right: View of the living
area from the dining area

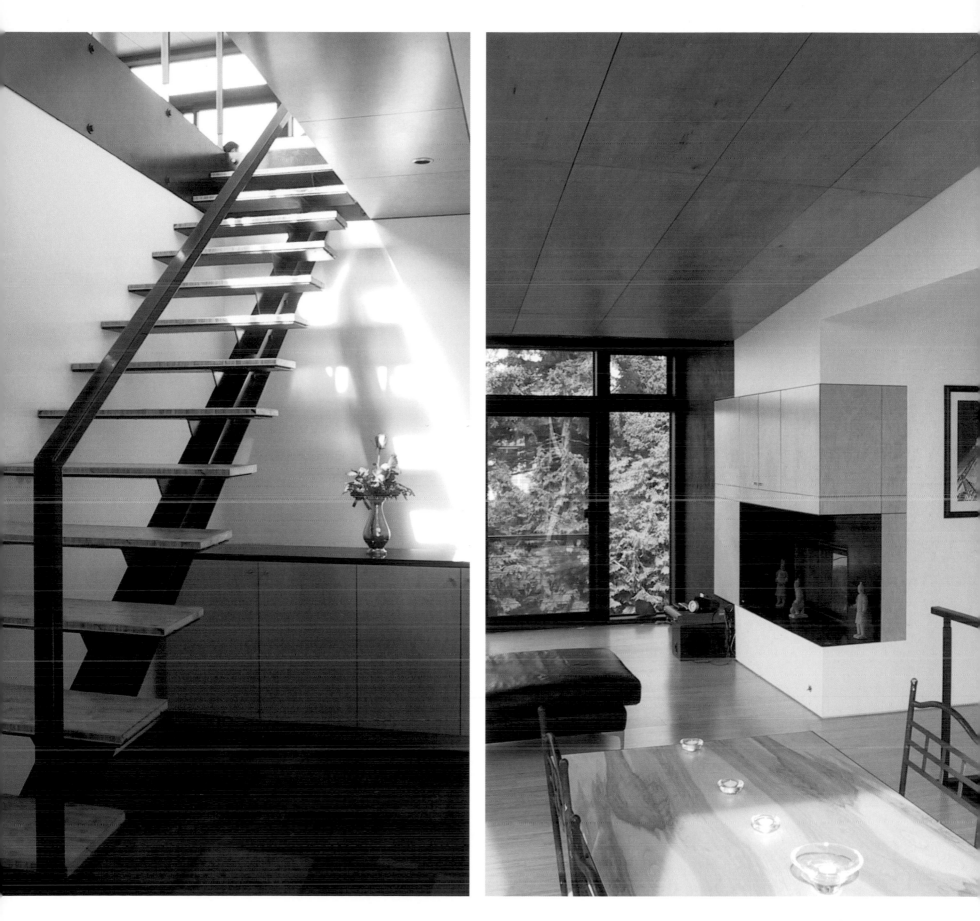

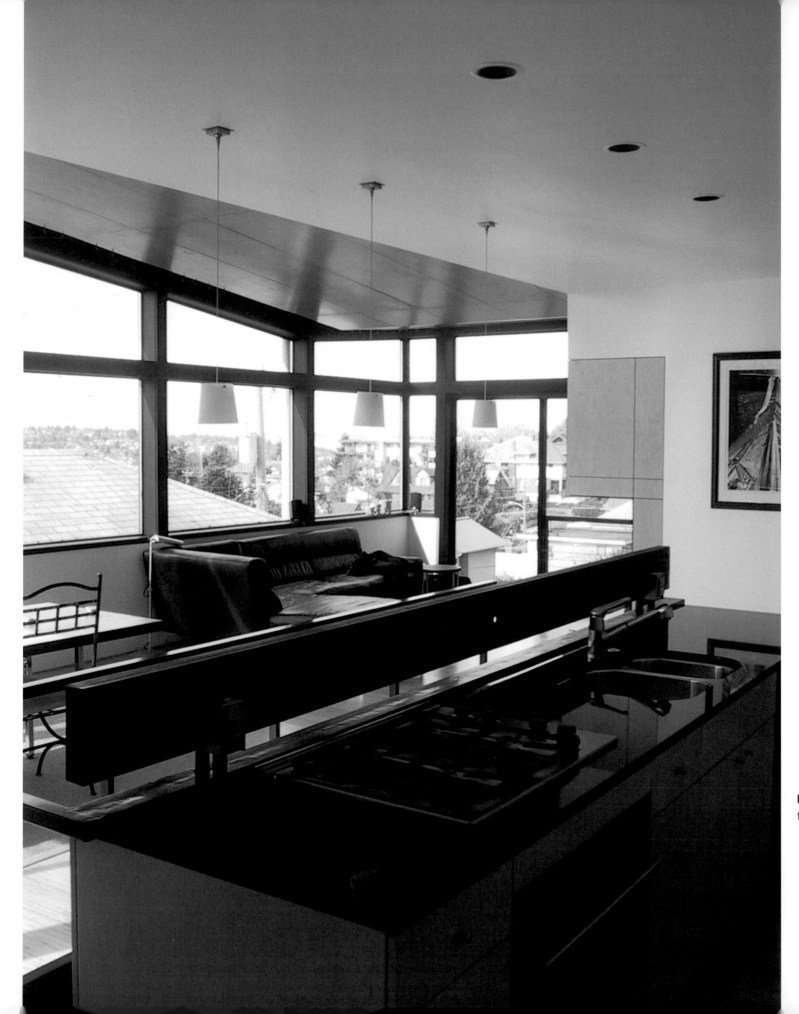

Left: View of the living area from the kitchen

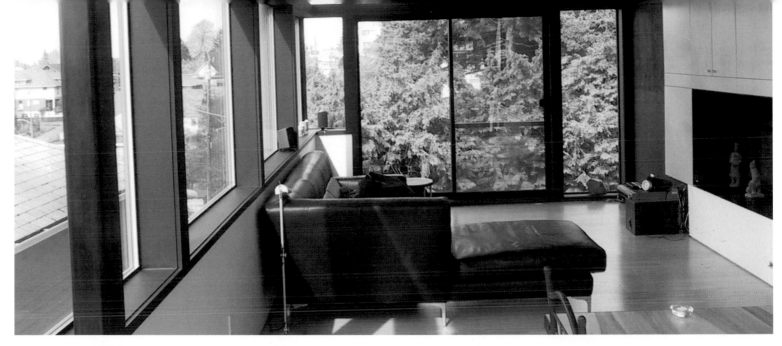

Right: View of the living area from the dining area
Below Right: View of the kitchen from the dining area

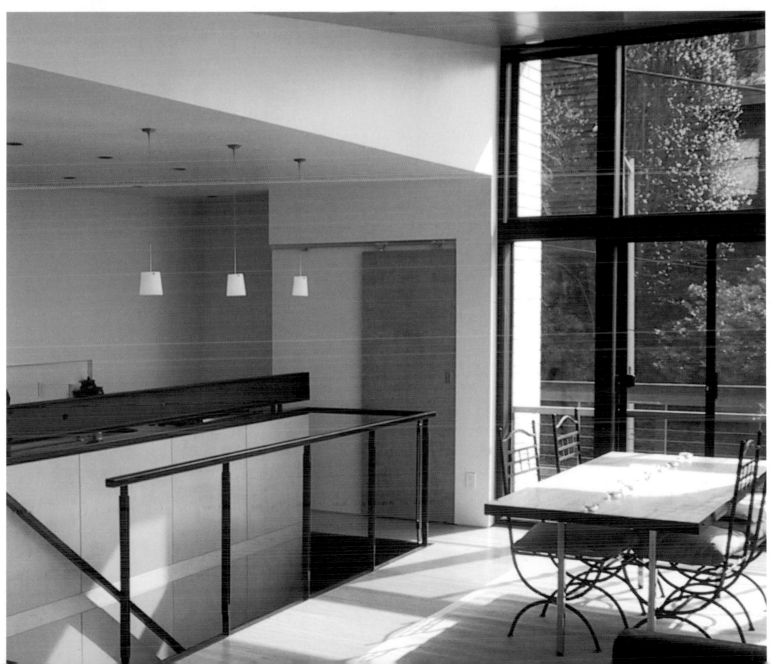

Killingworth Barn

1500 Square Feet

Centerbrook Architects and Planners

Photography: Jeff Goldberg/Esto

An existing livestock barn built in the 1800s had a strong timber frame and handsome proportions but was otherwise in poor condition. The design team, consisting of the owner, architect, and contractor, determined that the deteriorated siding could be removed and the structural frame moved onto a new foundation. Once that was accomplished, insulated panels were applied to the exterior and the original roof sheathing was reused and left visible inside.

The barn now contains three bedrooms, a kitchen, two baths, a living/dining area, and a two-vehicle carport. A partial basement houses the heating system and a small storage room.

A minimum of trim and simple details complete the economical but antique feeling of this recycled structure.

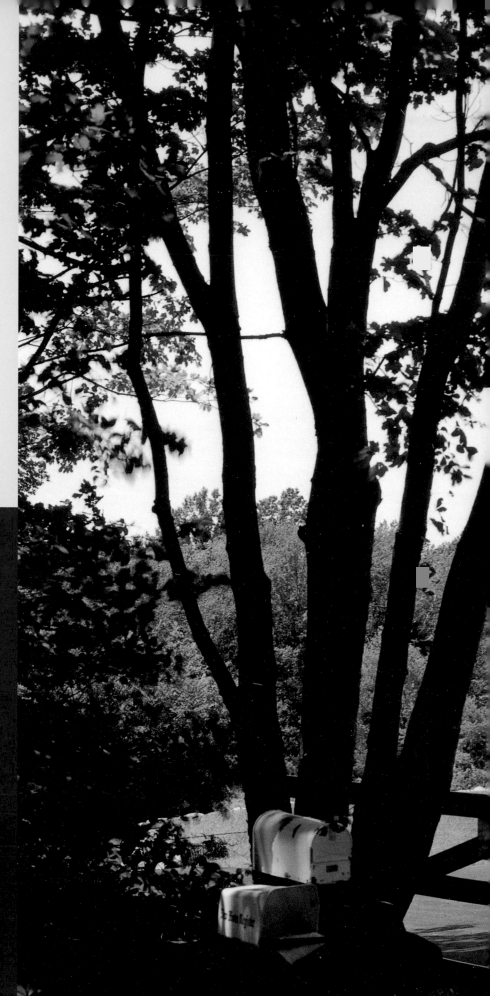

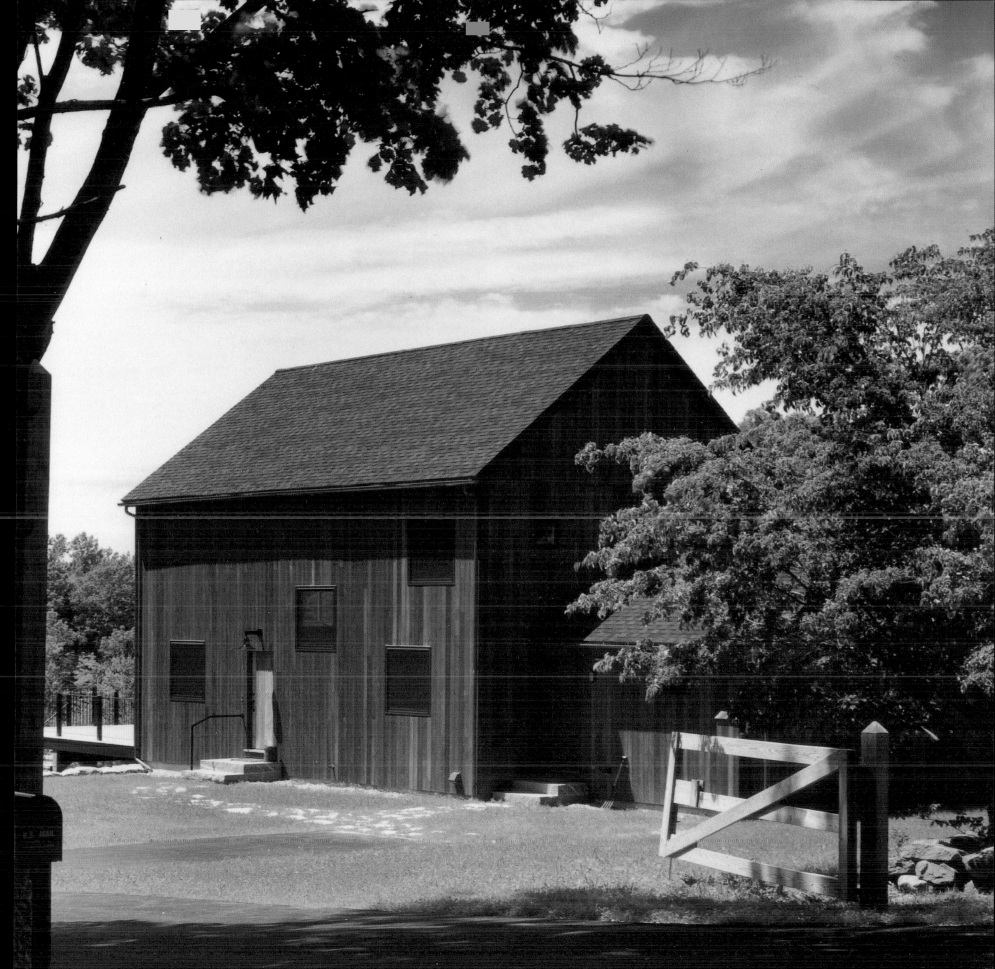

First Floor Plan

Attic Plan

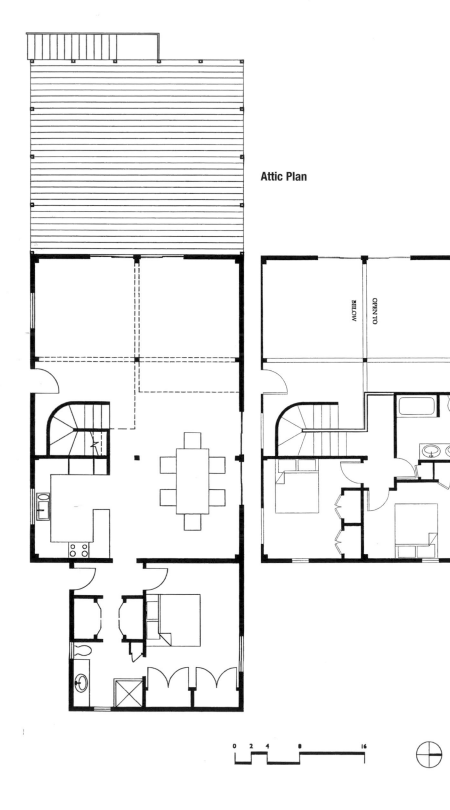

OPEN TO
BELOW

0 2 4 8 16

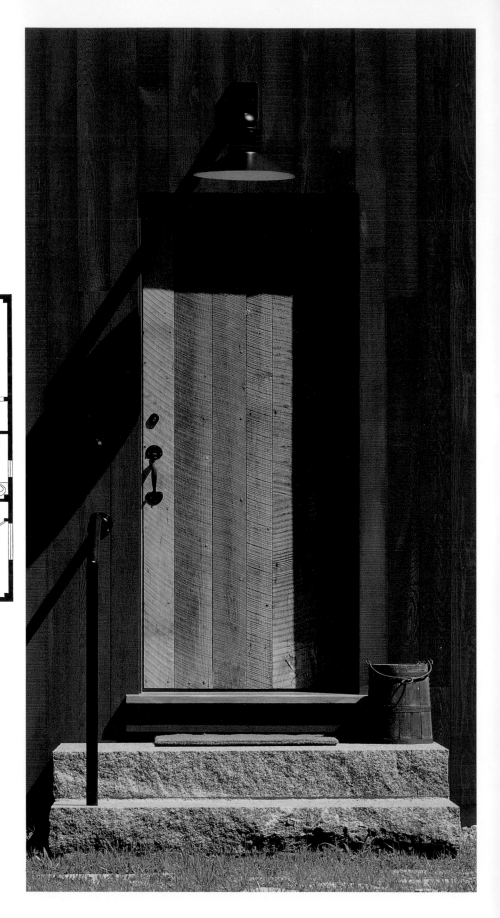

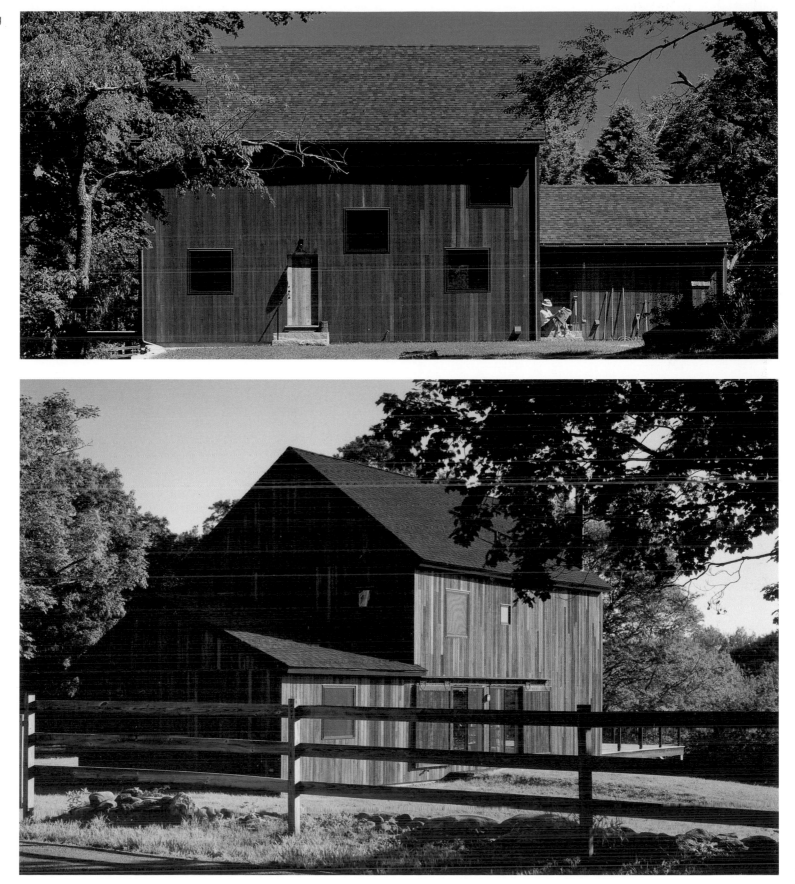

109

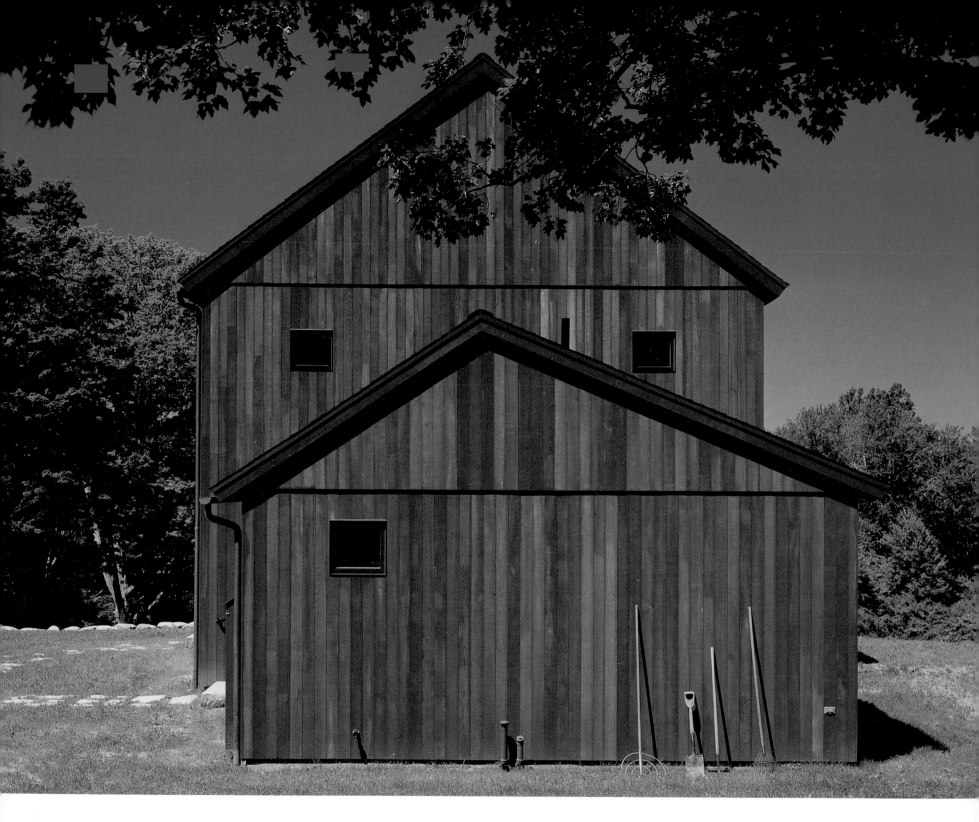

Above: East elevation
Above Right: West elevation

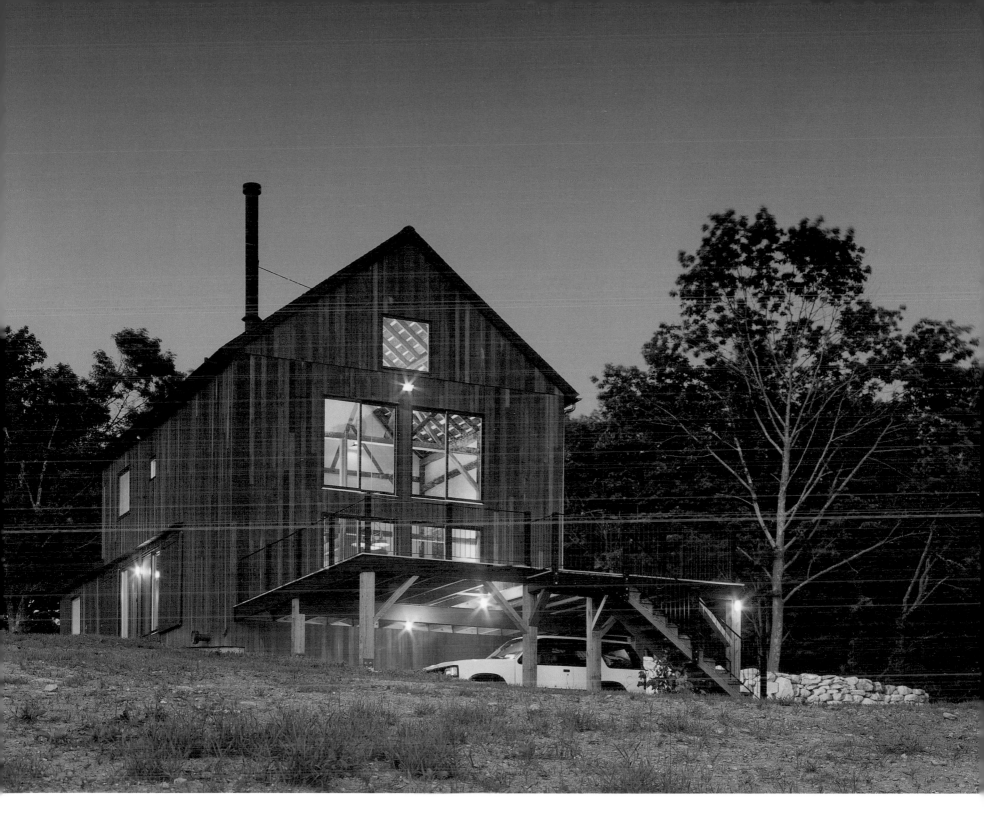

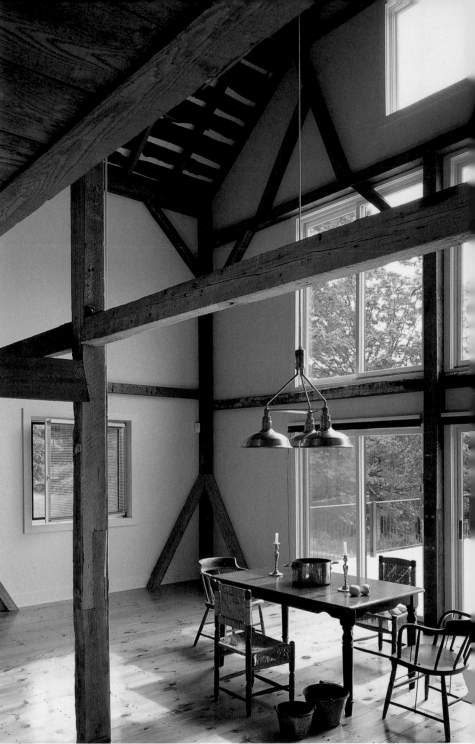

Above and Above Right:
Living and dining area
Right: View of the kitchen
from the dining area

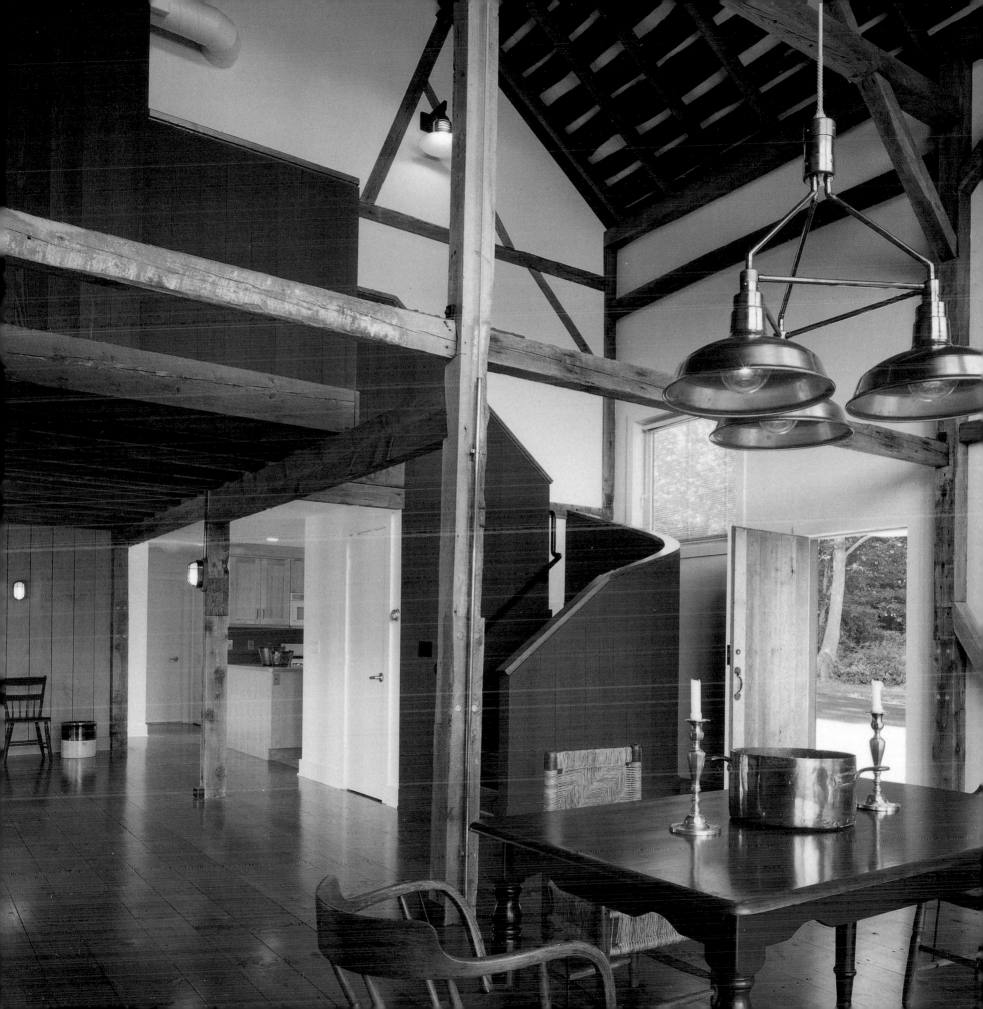

Orchard House

1100 Square Feet

Shim-Sutcliffe Architects
Photography: James Dow

ALTHOUGH THIS HOUSE IS SMALL IN AREA, IT PRO-VIDES ITS OWNER WITH A GREAT VARIETY OF SPACES, LIGHTING CONDITIONS, AND VIEWS ACROSS THE 30-YEAR-OLD APPLE ORCHARD THAT SURROUNDS IT. THE DWELLING CONSISTS OF TWO CLEARLY ARTICULATED PARTS. A LOW MASONRY BUILDING IS SET FIRMLY INTO THE GROUND AND IS SURROUNDED BY AN EARTH BERM. SOD-ROOFED AND CLAD WITH DRY-LAID LIMESTONE, IT APPEARS AS A SIMPLE EXTENSION OF THE EARTH. ENCLOSED HERE ARE THE LIVING, DINING, AND KITCHEN AREAS.

THE BEDROOM AND A PAINTING STUDIO ABOVE ARE CON-TAINED WITHIN AN ARTICULATED WOODEN TOWER WHOSE VERTICAL WINDOWS OPEN UP TO THE DISTANT VIEWS. AN EXTERIOR COURTYARD ENCLOSED BY A STONE WALL UNIFIES THE TOWER AND THE MASONRY BUILDING. WITHIN THE COURTYARD IS A SINGLE APPLE TREE.

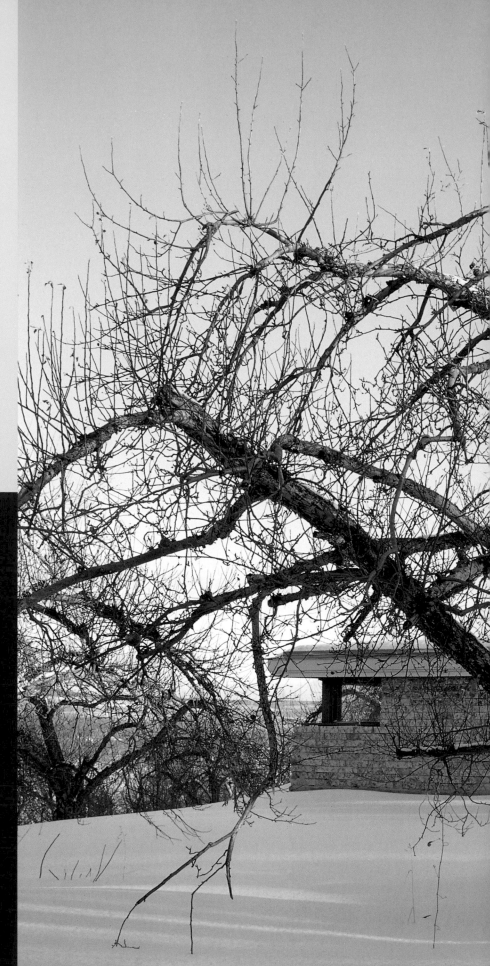

Second Floor Plan

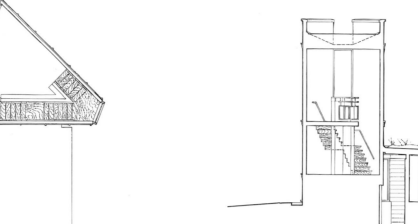

Section

First Floor Plan

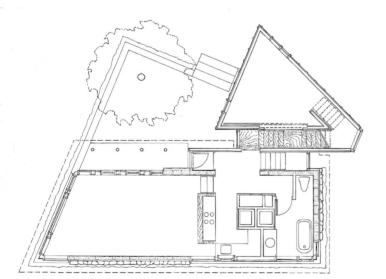

Elevations

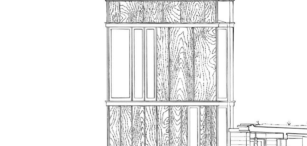

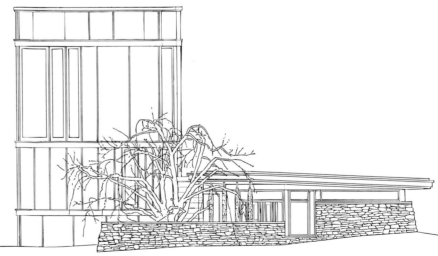

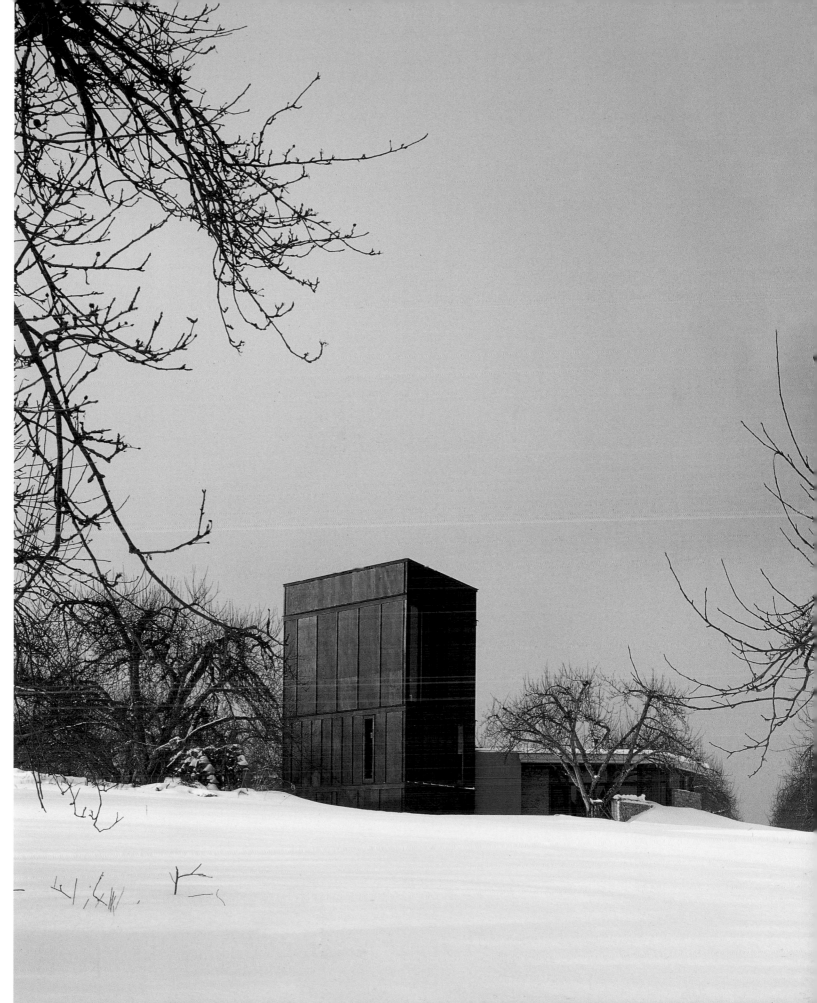

Previous Pages: The tower and adjoining masonry building
Below Left: The sod roof of the masonry building
Right: The vertical windows in the tower provide views of the surrounding apple orchard.

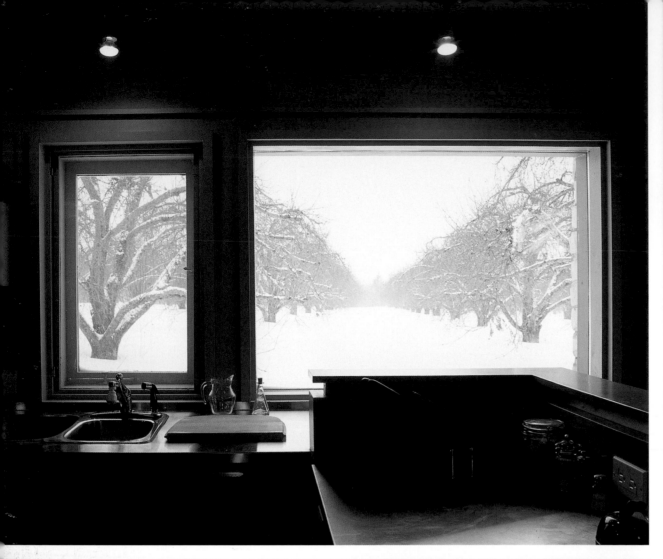

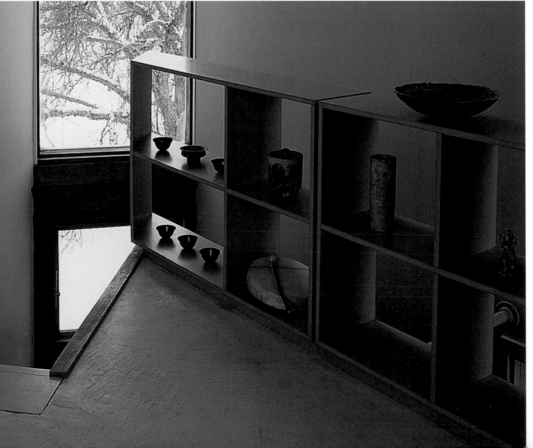

Above Left: A view across the kitchen to the orchard in winter
Above: The wooden staircase leading to the studio in the tower
Left: Vertical window in the tower
Right: In the winter, the tower becomes a beacon in the snow.

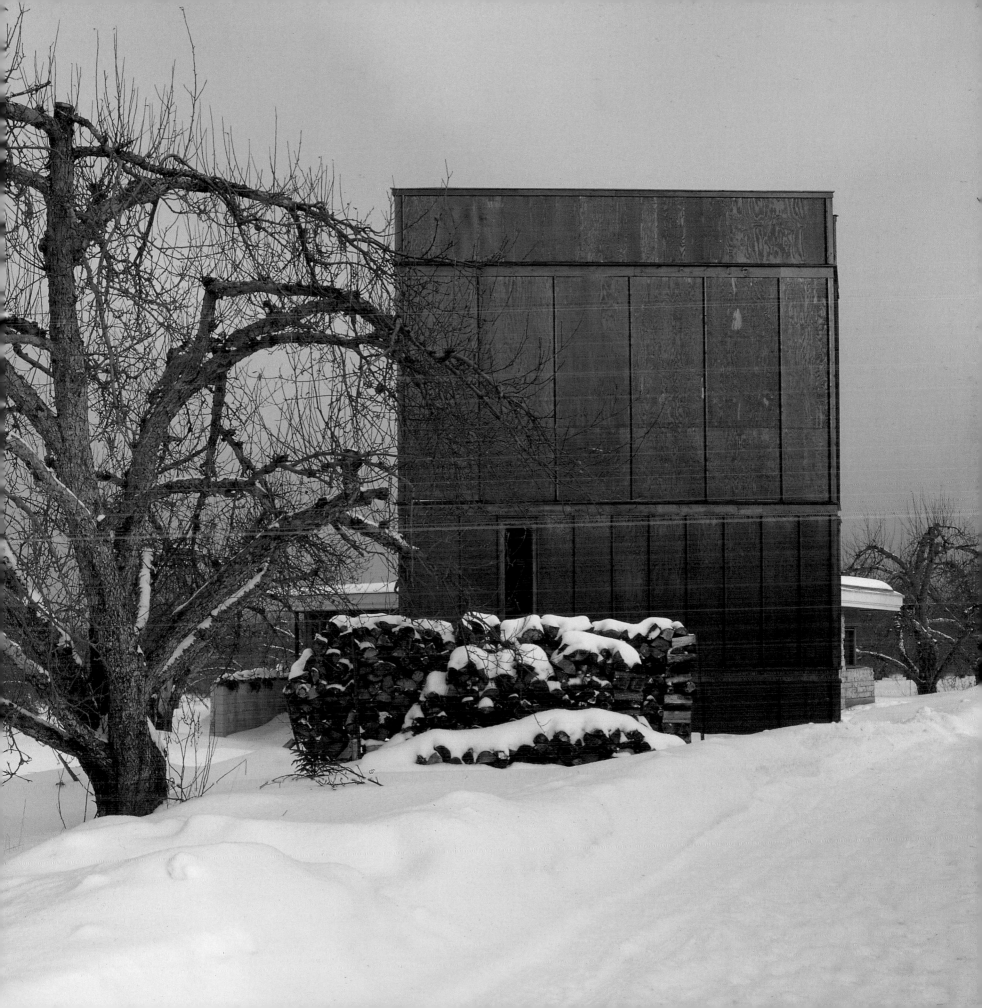

Ozark Cabin

1200 Square Feet

Joe Johnson, Architect

Photography: Richard Leo Johnson

DEVELOPING AN OZARK MOUNTAIN RETREAT PROVIDED
THE ARCHITECT WITH AN OPPORTUNITY TO DESIGN A
STRONG, SITE-SPECIFIC DWELLING. A 30-MILE VIEW
TO THE NORTH RESULTED IN A NORTH FAÇADE THAT IS MOSTLY
GLASS. A SOUTH-FACING MONITOR HELPS TO TAKE ADVANTAGE
OF PASSIVE SOLAR HEATING AND TO PROVIDE A BRIGHT, NATU-
RALLY LIGHTED INTERIOR. THE EXTERIOR COLORS OF GOLD
AND RED RECALL THE AUTUMN COLORS OF THE OZARK HARD-
WOOD FOREST.

THE KITCHEN, LIVING SPACE, AND DINING SUN PORCH ARE ON
THE UPPER LEVEL OF THE CABIN TO TAKE ADVANTAGE OF THE
VIEWS. BELOW ARE TWO SEPARATE BEDROOMS, A BUNKROOM,
A BATH, STORAGE, AND A SHOP. A PUTTING GREEN IS
ACCESSIBLE FROM THE LOWER LEVEL.

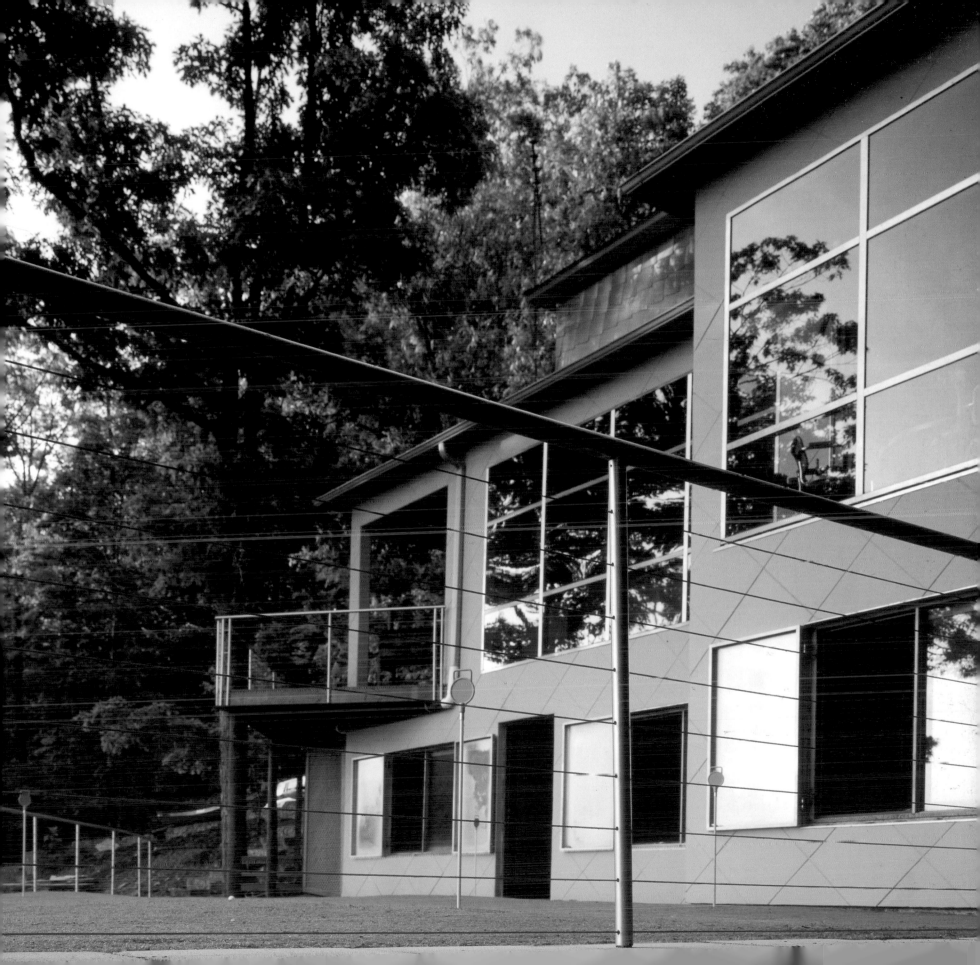

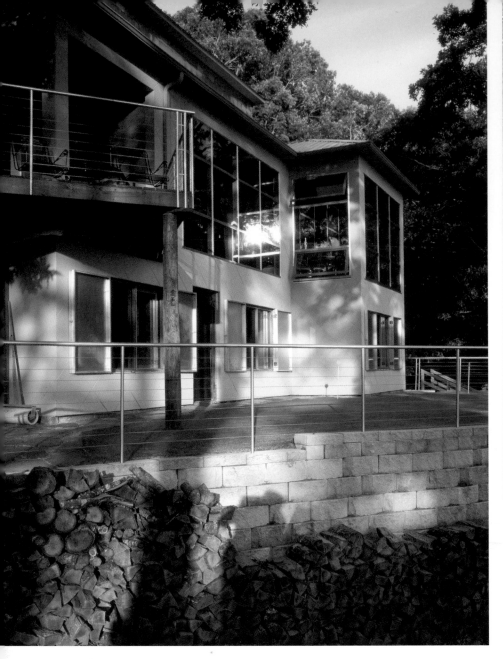

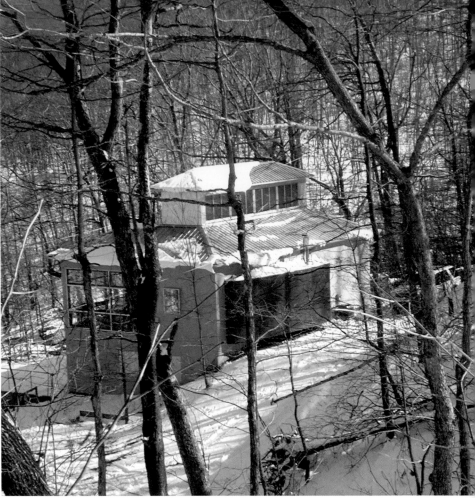

Previous Pages: The public spaces are on the upper level with the bedrooms below.
Left: East façade

Above: The cabin provides a cozy refuge.
Right: The dining area offers a panoramic view of the Ozark Mountains.

Lower Level Floor Plan

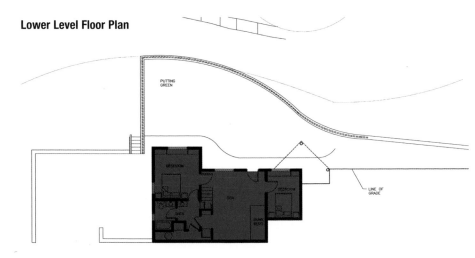

PUTTING GREEN

LINE OF GRADE

BEDROOM

DEN

BEDROOM

Upper Level Floor Plan

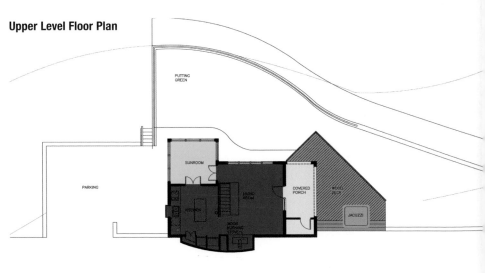

PUTTING GREEN

SUNROOM

PARKING

KITCHEN

LIVING ROOM

WOOD BURNING STOVE

COVERED PORCH

WOOD DECK

JACUZZI

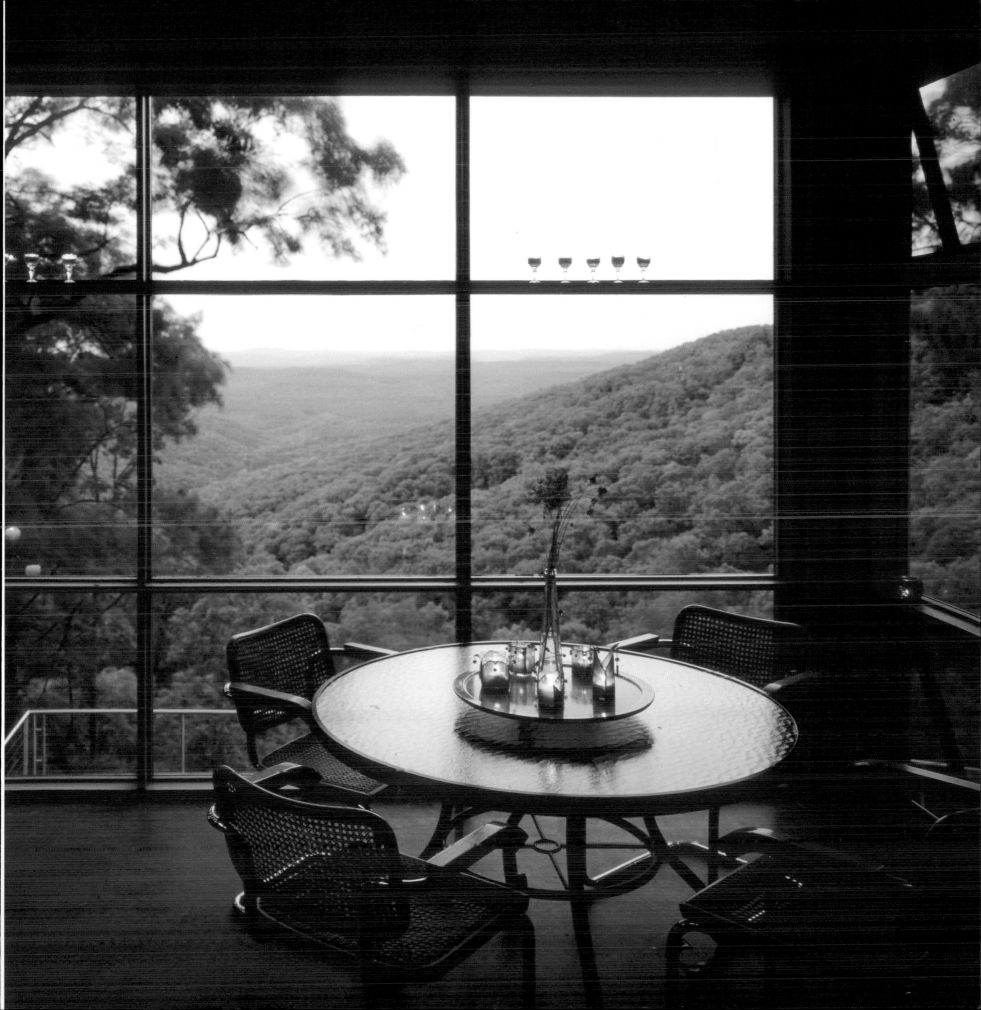

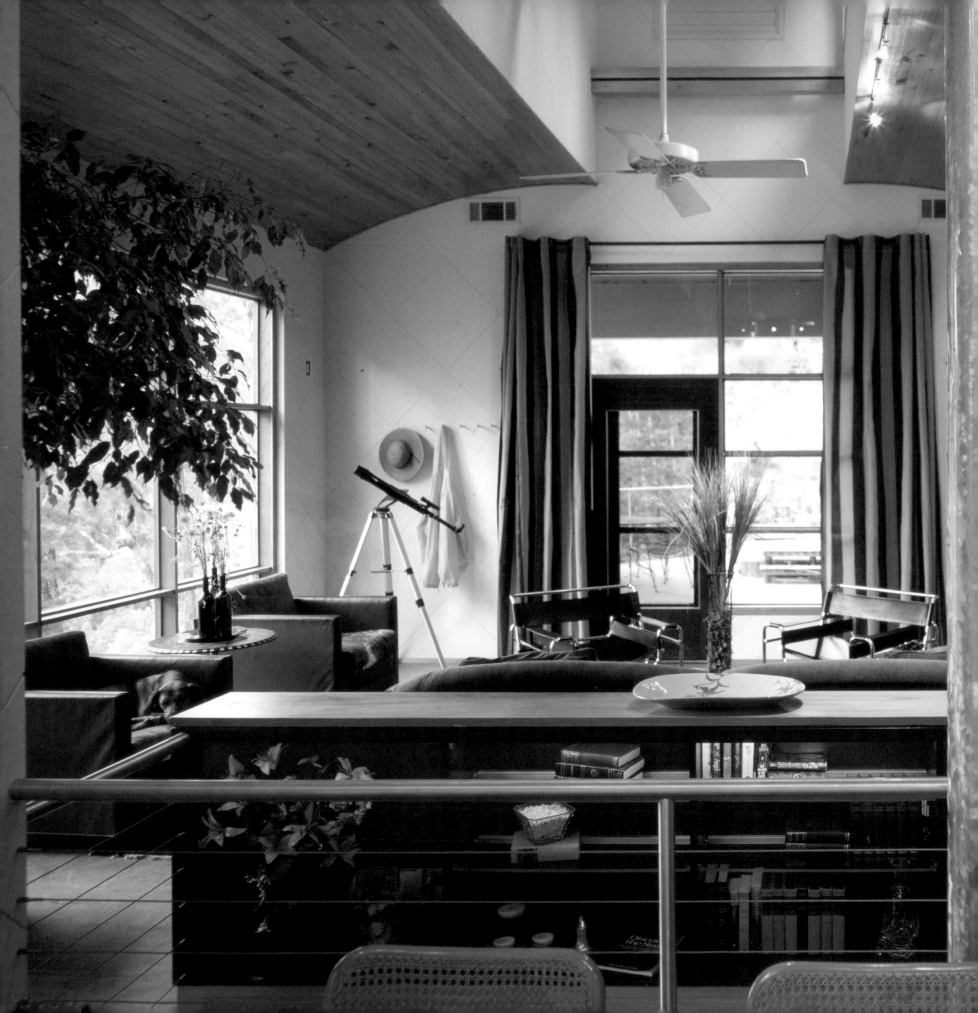

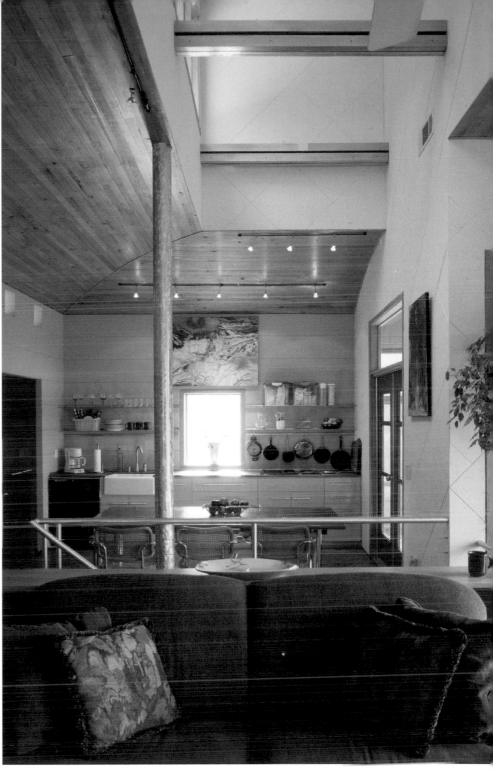

Left: The living area as seen from the kitchen
Above: The kitchen as seen from the living area

Canal House

1500 Square Feet

Sander Architects

Photography: Sharon Risedorph

THE CANAL HOUSE IS A LABORATORY FOR THE ARCHI-TECT'S EXPLORATION OF USING BUILDING MATERI-ALS—NEW AND TRADITIONAL—IN NEW AND UNCON-VENTIONAL WAYS. IN DESIGNING THE 1500-SQUARE-FOOT HOUSE AND 500-SQUARE-FOOT STUDIO, HE DREW FROM A BROAD PALETTE THAT INCLUDED MASONITE FOR THE CABI-NETS IN THE KITCHEN AND THE BATHROOMS, PAINTED STEEL PLATE FOR THE STAIR TREADS, AND RAW STEEL FOR THE FIREPLACE. CAST RESIN SINKS, OF HIS OWN DESIGN AND FABRICATION, ARE USED IN THE BATHROOMS. ACID-ETCHED CONCRETE FLOORS ARE DARKENED WITH TWO COATS OF A COMMERCIAL STAIN. THE KITCHEN ISLAND CONSISTS OF CAN-TILEVERED SHEETS OF WAVECORE PANELITE, FOLDED INTO AN "L" SECTION. PARACHUTE NYLON WRAPS THE FIRST FLOOR LIVING AND DINING AREAS. THE EXTERIOR FAÇADE INCLUDES A GLASS CURTAIN WALL AND PERFORATED ALU-MINUM CLADDING.

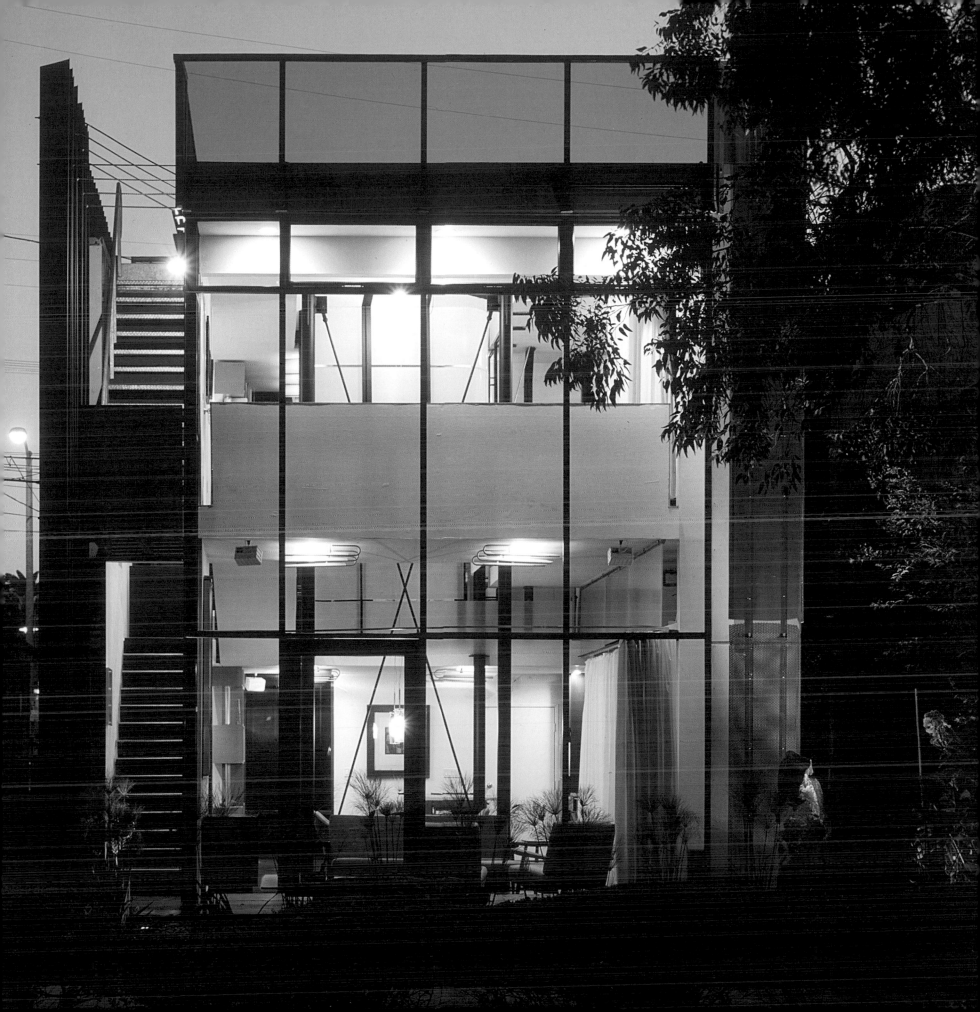

Lower Level

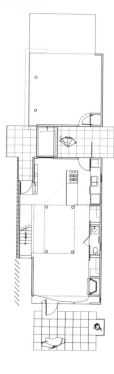

Middle Level

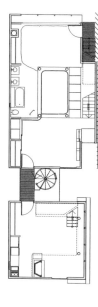

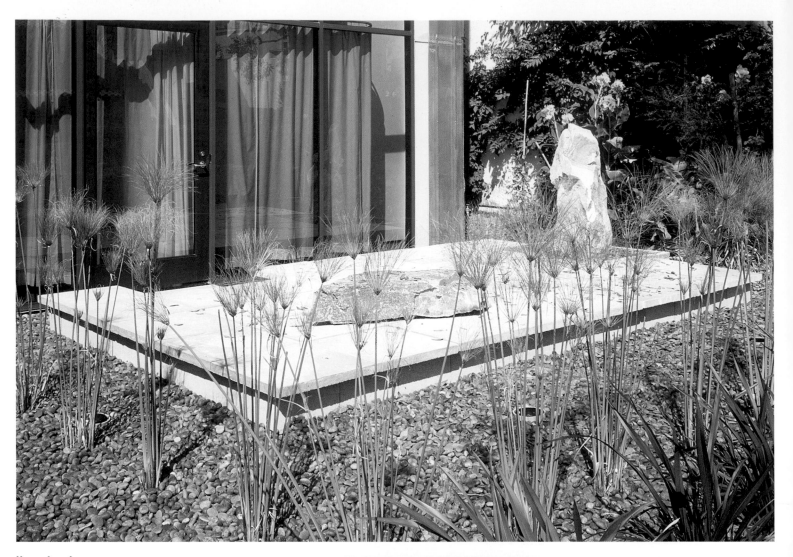

Upper Level

Previous Page: Canal side view showing the glass curtain wall and perforated aluminum cladding
Above: Noguchi inspired patio adjacent to the living area
Right: The entrance

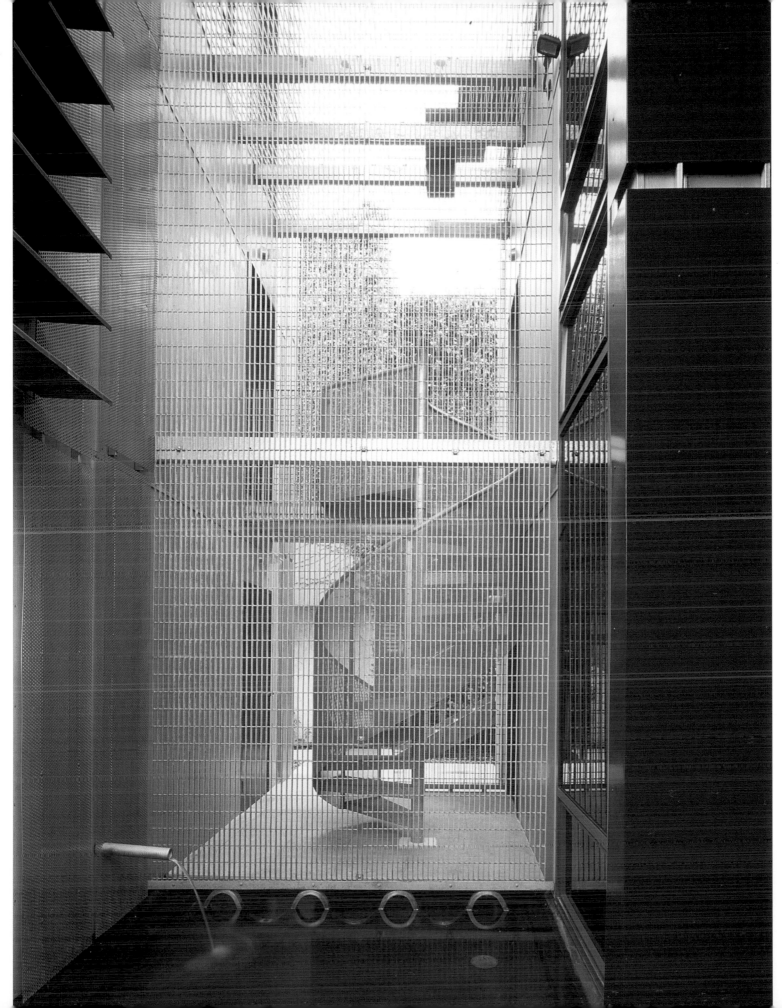

Left: The connecting space between the main house and the studio.

129

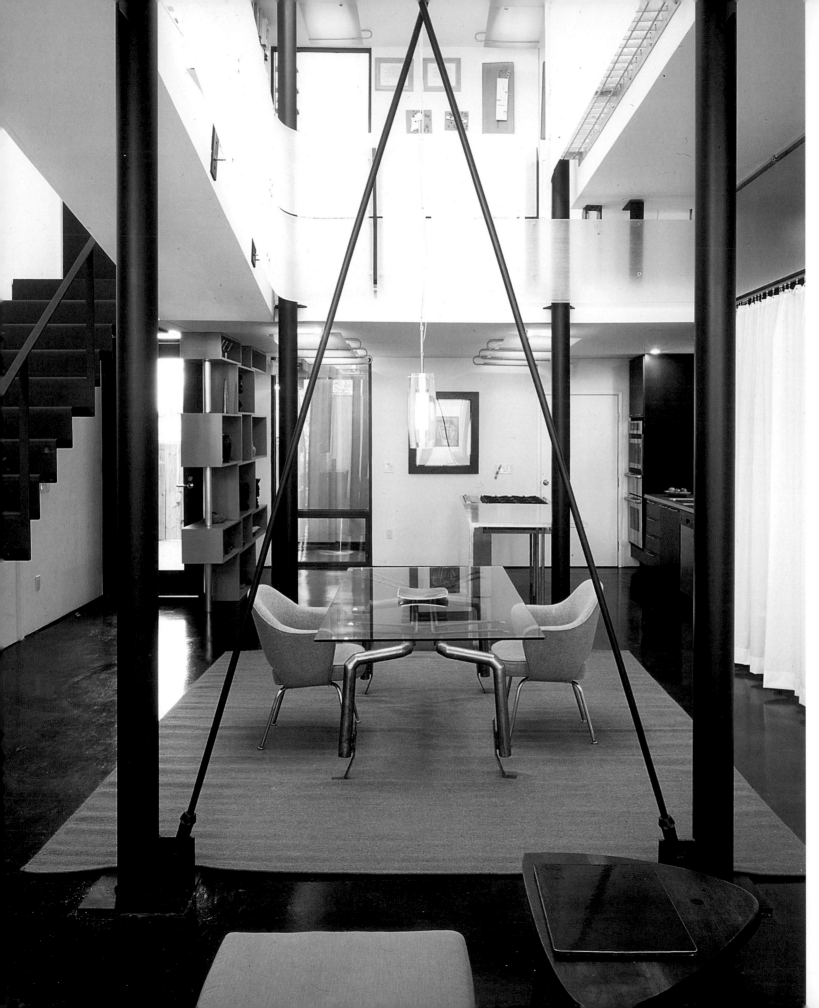

Left: A view of the dining room from the living room, with the kitchen on the far right

Right: The stairs to the master bedroom are made of vertical grain bamboo.

Far Right: The main stairway is constructed of 1-inch-thick painted steel.

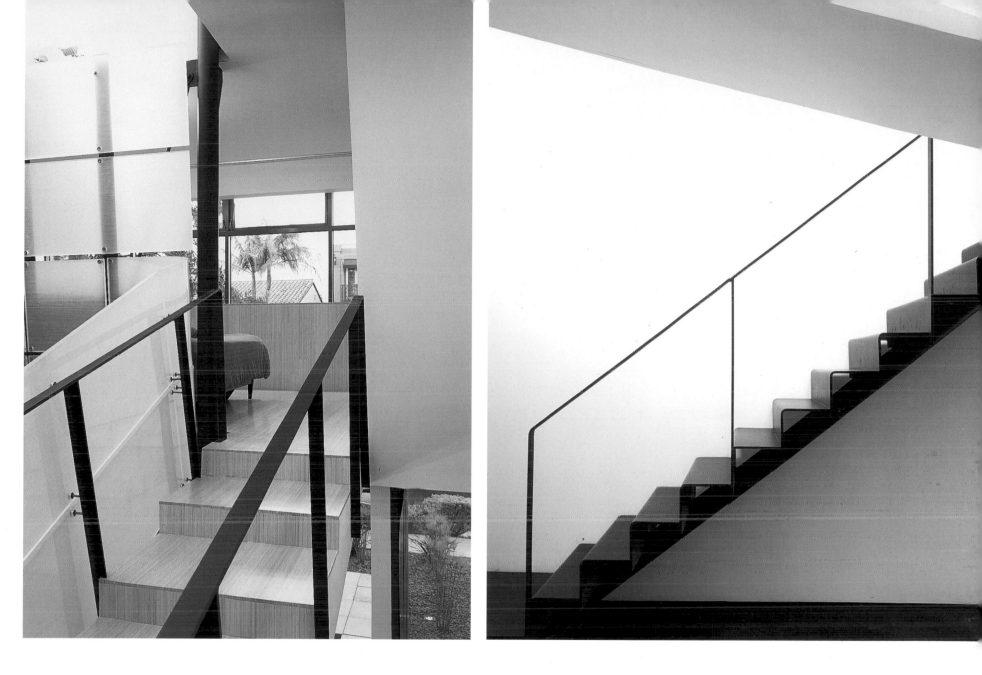

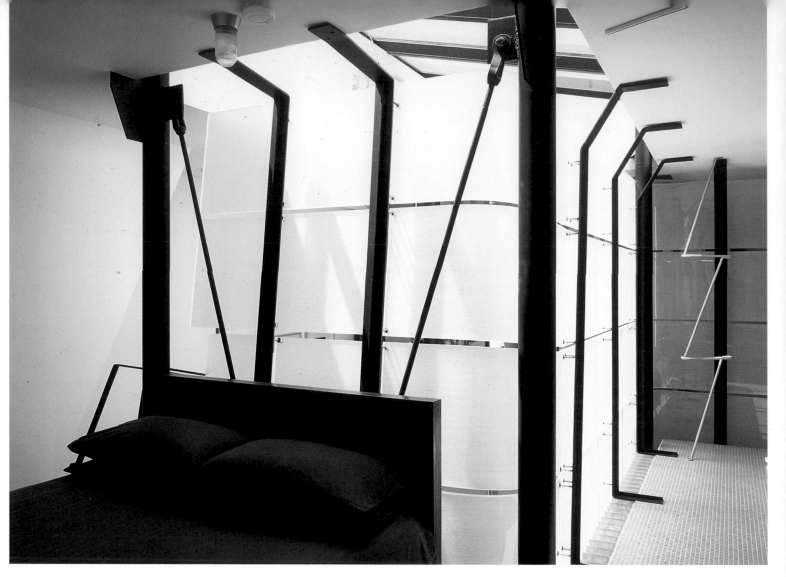

Above: Master bedroom with acrylic paneling that wraps the atrium and bathroom
Right: Master bathroom with a resin sink designed by the architect
Far Right: View of the studio at dusk

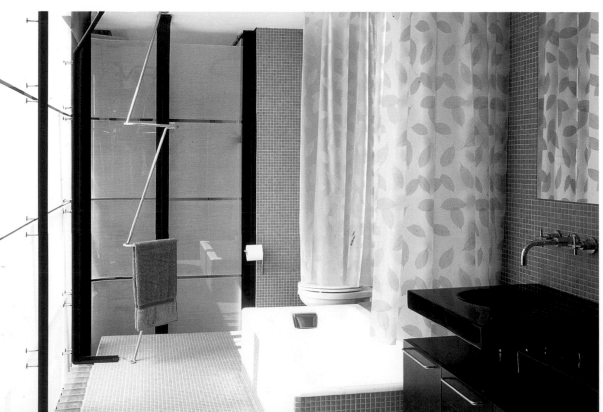

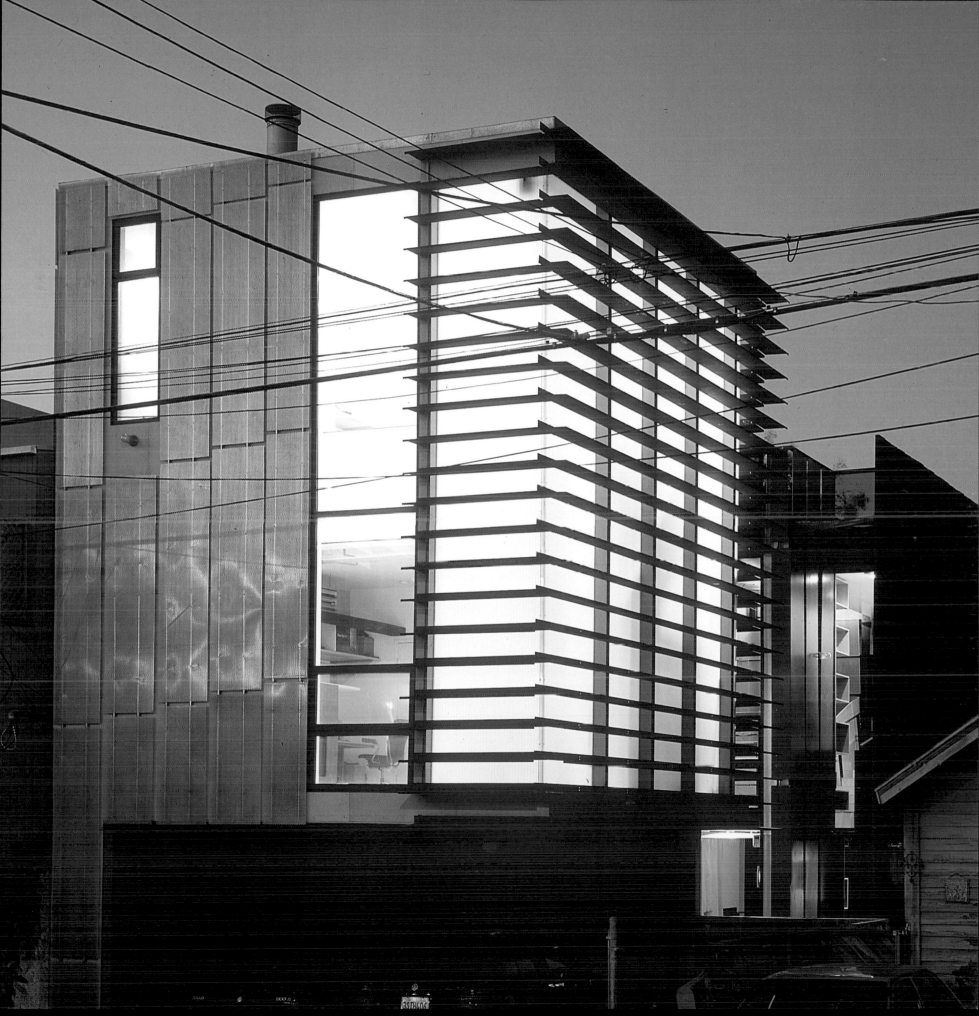

Teviot Springs

640 Square Feet

Turnbull Griffin & Haesloop Architects
Photography: Mark Darley

THIS DECEPTIVELY SIMPLE LITTLE HOUSE COMBINES ARCHITECTURE AND LANDSCAPE TO MAKE LARGE ROOMS OUT-OF-DOORS. IT IS SITED ON THE ONLY FLAT AREA IN A ROLLING 20-ACRE HILLSIDE VINEYARD THAT OVER-LOOKS MOUNT ST. HELENA.

THE HOUSE, ONLY TEN FEET WIDE, AND ITS COMPANION BUILDING, A WASH HOUSE, FLANK TWO OPPOSITE ENDS OF AN 80-SQUARE-FOOT CARPET OF GRASS.

IT IS A NARROW, GABLED-ROOF BUILDING PUNCTUATED IN THE MIDDLE BY A PASS-THROUGH, COVERED PORCH. IN THE SUMMER, WITH THE SLIDING DOORS OPEN, THE PORCH SERVES AS A BREEZEWAY AND DINING ROOM. IN WINTER, WITH THE DOORS CLOSED, THE PORCH BECOMES A MUD ROOM AND SUN ROOM. THE LUMBER USED TO CONSTRUCT THE HOUSE IS FROM WIND-FELLED TREES CUT ON THE PROPERTY AND LOCALLY MILLED, MAKING THE HOUSE TRULY WEDDED TO ITS ENVIRONMENT.

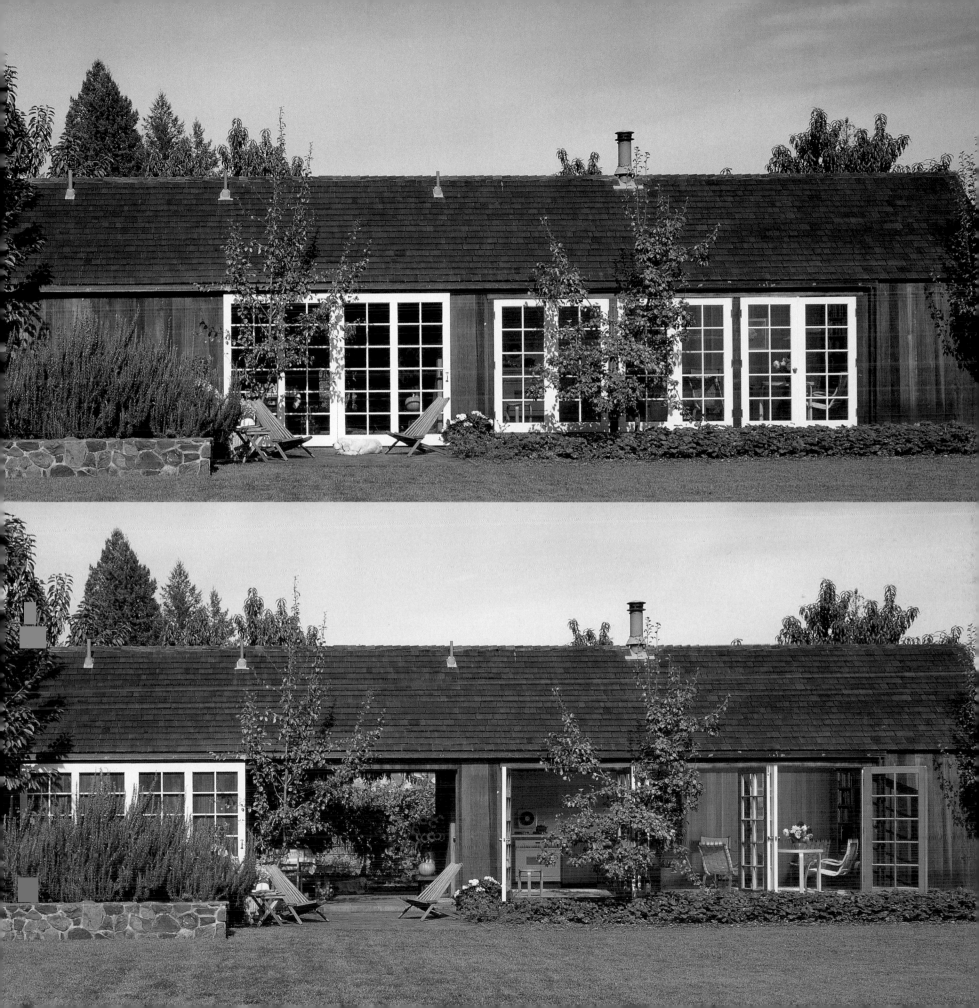

Previous Page: The porch (shown closed and open) functions as a breezeway and dining room in the summer.
Below: The house enjoys spectacular views over the valley.
Right: The house is only 10 feet wide.

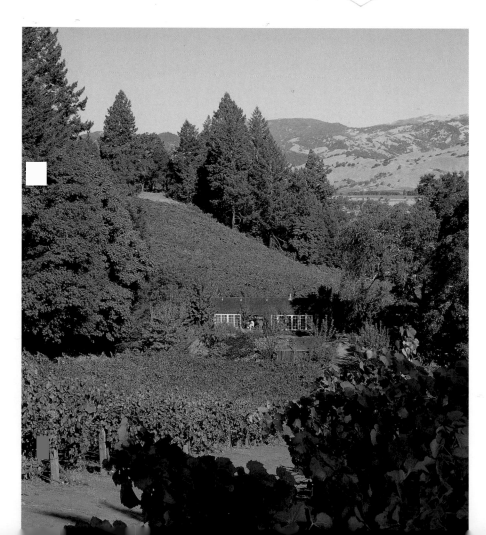

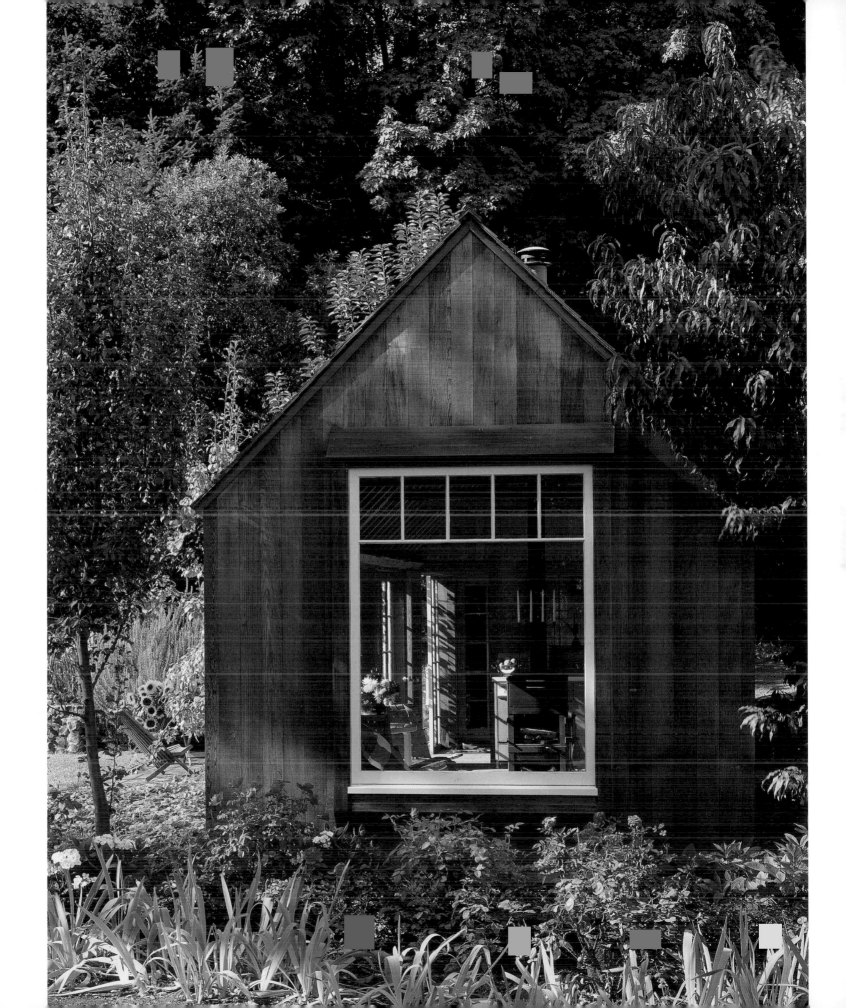

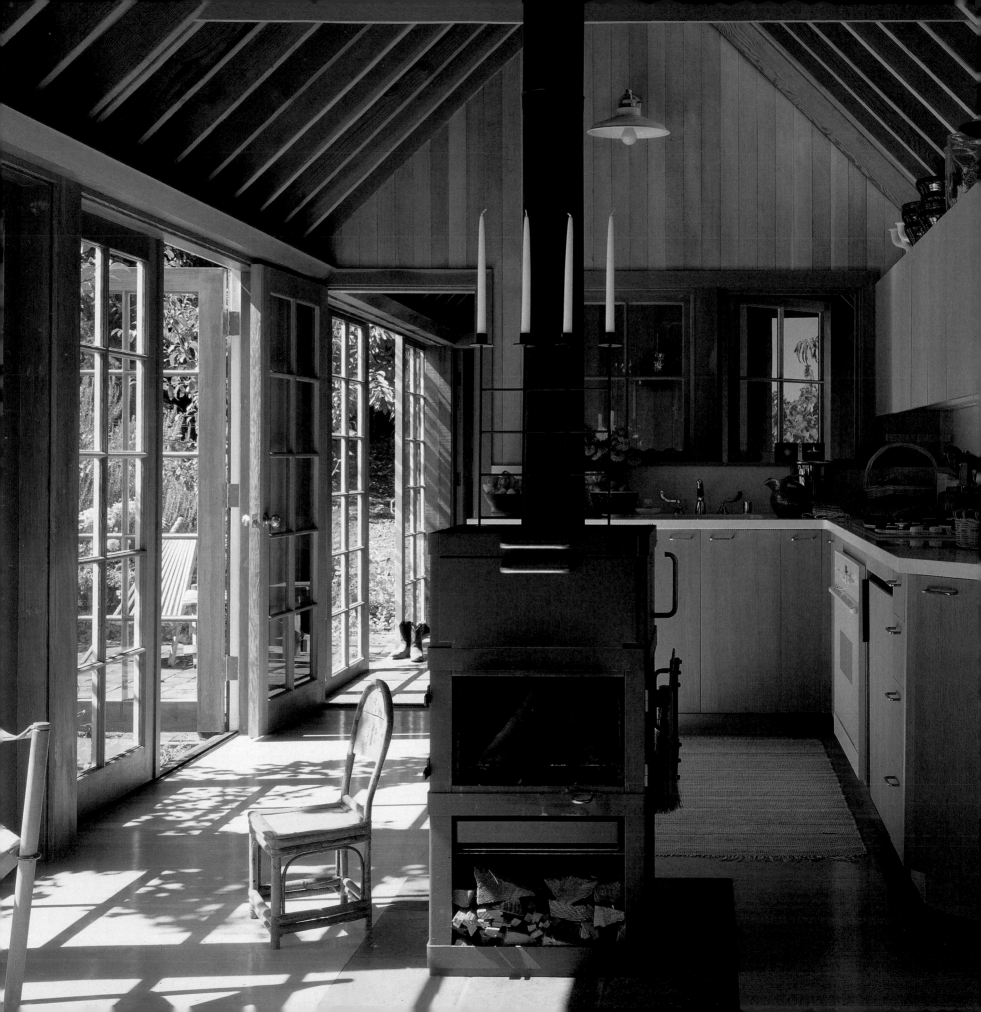

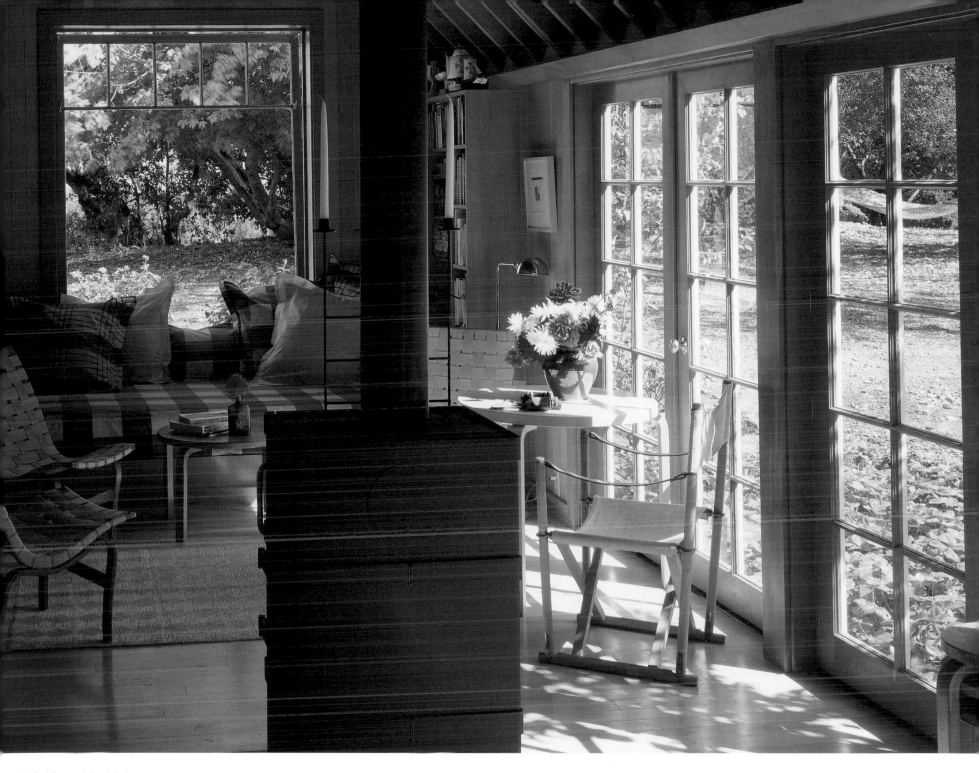

Left: View of the kitchen
from the living area
Above: View of the living
area from the kitchen

Right: A corner of the kitchen

Far Right: A ladder leads to a sleeping loft.

McAdams Cottage

1300 Square Feet

Suyama Peterson Deguchi Architects

Photography: Paul Warchol

INSPIRED BY THE ROCK CLIFF AND TOPOGRAPHY OF THE SITE, THE HOUSE IS BURIED BEHIND A CONCRETE RETAINING WALL, WHICH PROVIDES A SENSE OF PROTECTION AND REFUGE FROM THE WEATHER WHILE SCREENING THE NEIGHBORING HOUSES. FLOATING ABOVE THIS WALL, A VAULTED ROOF ECHOES THE TOPOGRAPHY AND BECOMES PART OF THE ROLLING SITE. AN ELEMENTAL PALATE OF BUILDING MATERIALS CONSISTING OF CONCRETE, RAW STEEL, AND WOOD HELPS ANCHOR THE HOUSE TO ITS RUGGED SURROUNDINGS.

A SEPARATE GUEST ROOM IS PERCHED ON THE RIM OF THE COVE AND PARTIALLY BURIED IN THE GROUND. IT IS LINKED TO THE MAIN HOUSE BY A SIMPLE CONCRETE WALK AND STAIR. THE VOID OF A REFLECTING POOL IN THE CONCRETE TERRACE ADJOINING THE MAIN HOUSE REFERENCES THE FOOTPRINT OF THE GUESTHOUSE, WHICH CONNECTS THE SITE TO THE COVE BEYOND.

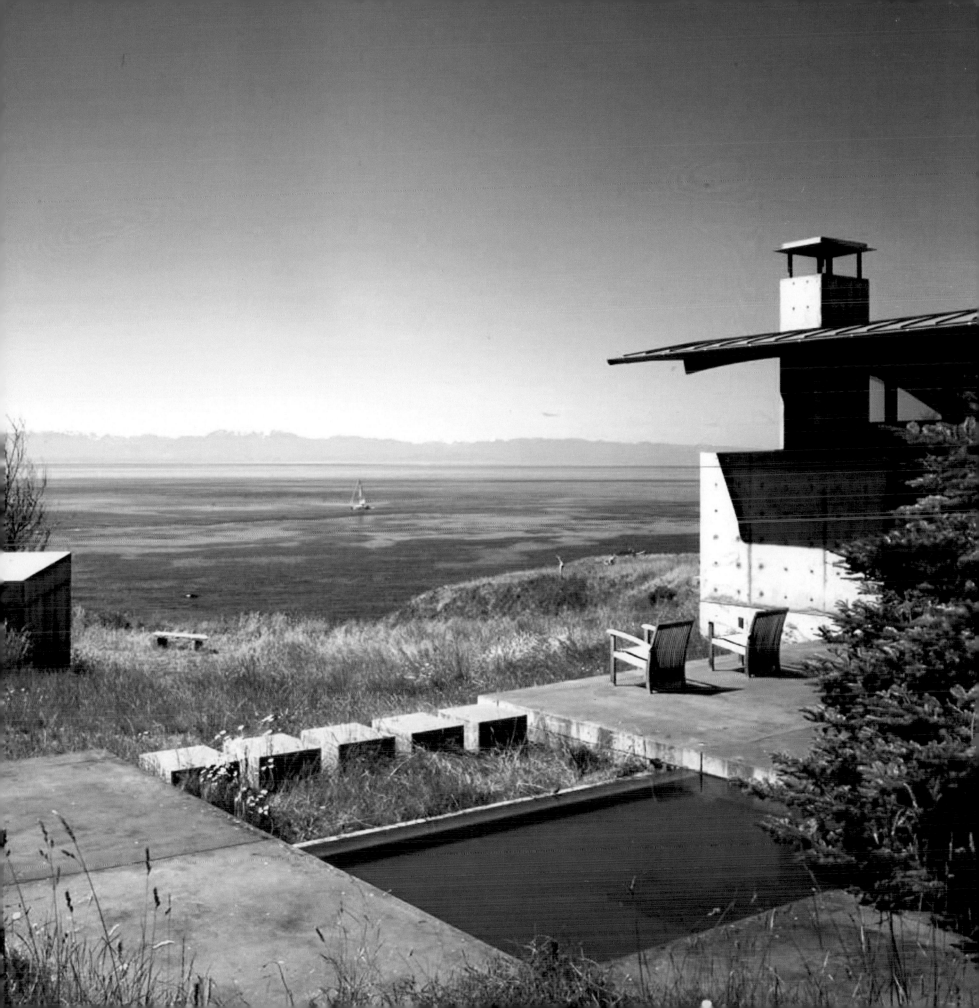

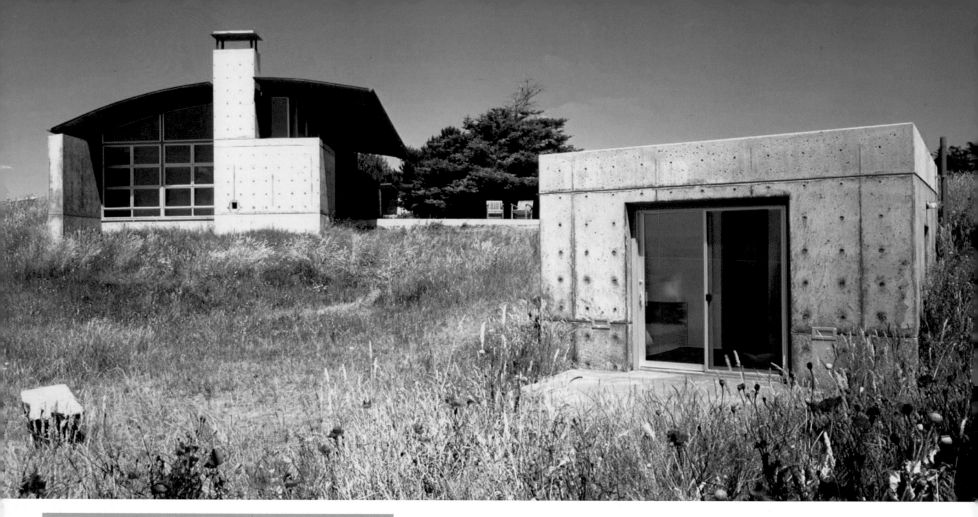

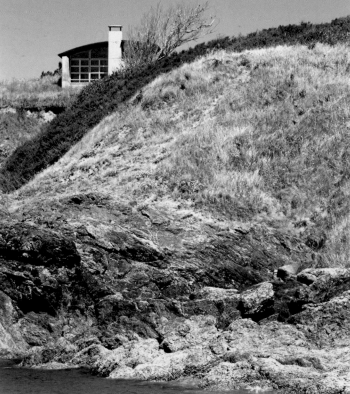

Previous Pages: A view from the terrace to the guest bedroom on the left and the water beyond
Above: The separate guest room
Left: The house as seen from the water

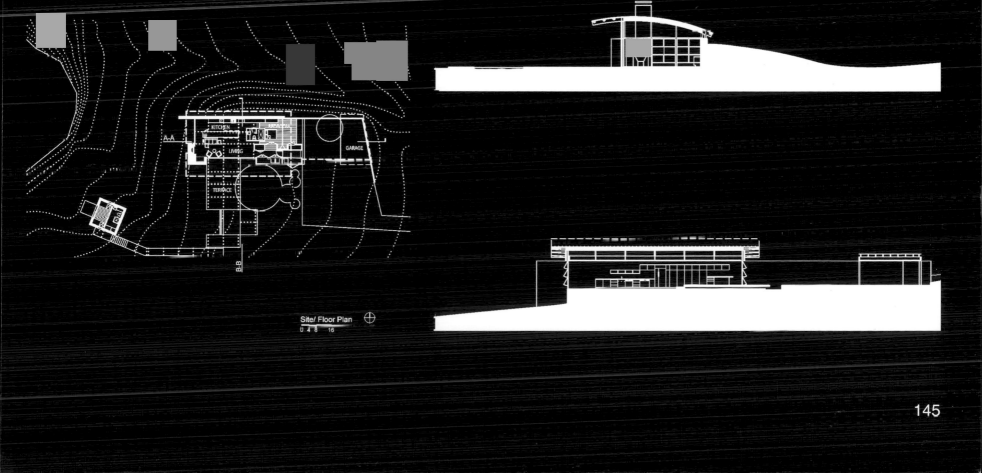

Site/ Floor Plan

0 4 8 16

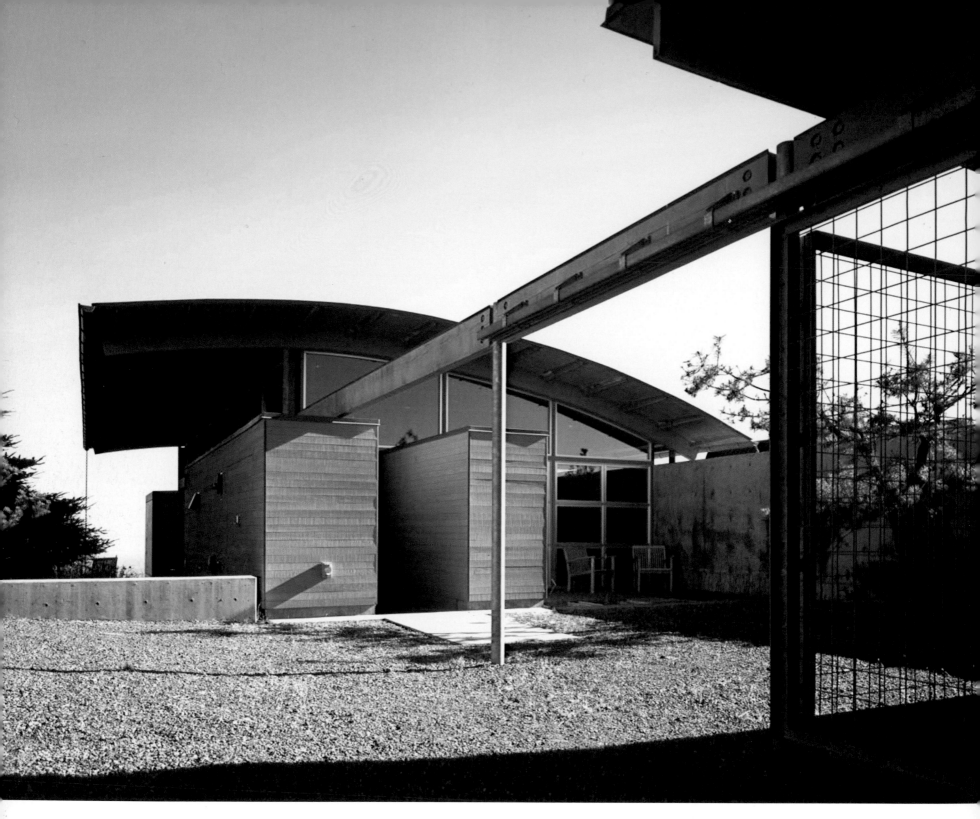

Above: A view of the entry from the garage
Right: View into the living area from atop the garage at dusk

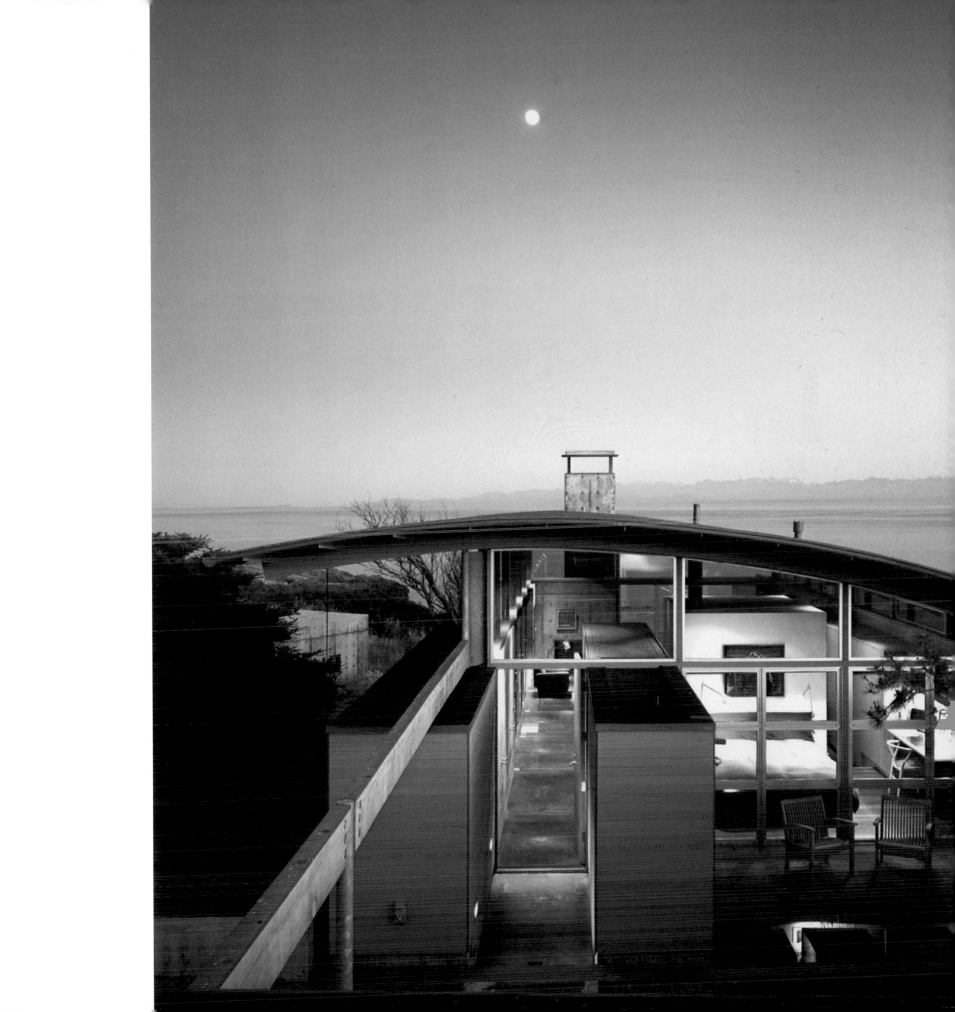

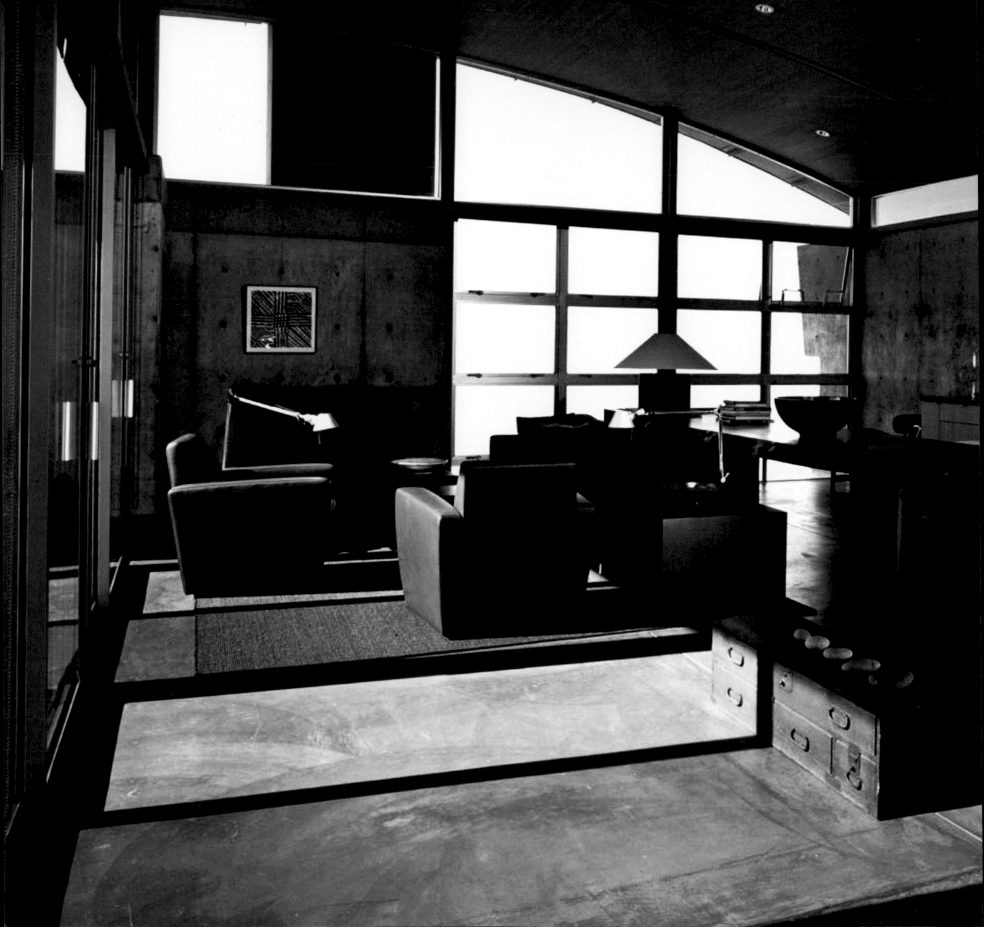

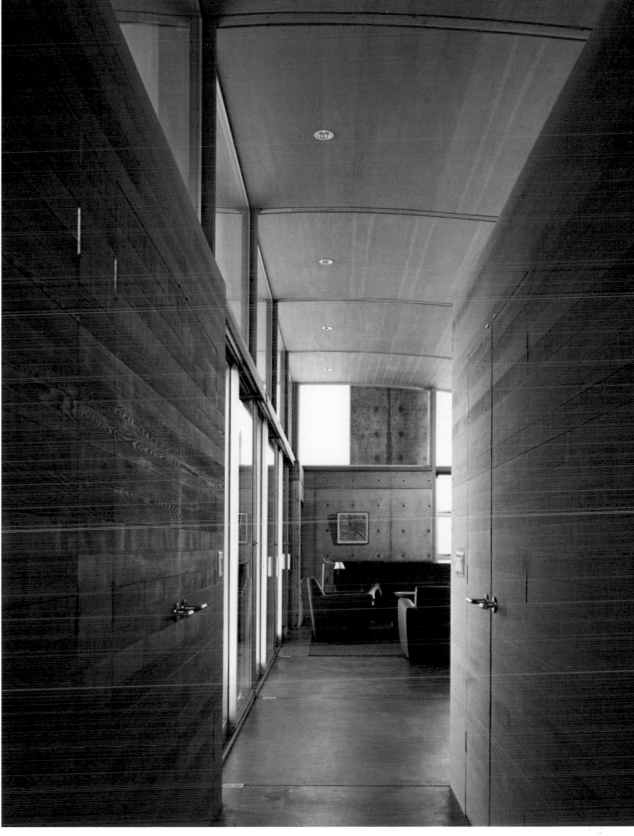

Left: Living, dining, and kitchen areas
Above: View of the living area from the entry

149

Vineyard Grove Tent

1500 Square Feet

Residential Design Systems

Photography: Carter Berg

VINEYARD GROVE IS A NEW COTTAGE COMMUNITY IN HISTORIC IRVINGTON, VIRGINIA. IT REPLICATES COTTAGE COMMUNITIES POPULAR IN THE MID-1800S THAT WERE SITES FOR RELIGIOUS REVIVALS. THESE CAMPS WERE REFERRED TO AS "GROVES," AND THE EARLIEST CONSISTED ONLY OF TENTS. OVER THE YEARS THEY EVOLVED INTO WOODEN-SIDED TENTS WITH CANVAS TOPS, AND FINALLY INTO PERMANENT WOODEN COTTAGES IN VICTORIAN OR CARPENTER GOTHIC STYLES. THESE COTTAGES WERE STILL REFERRED TO AS TENTS.

THIS TENT FEATURES OVERSIZED GOTHIC DOORS AND WINDOWS, AND THE TRIM IS BOLD CARPENTER GOTHIC, THE HISTORICAL RESULT OF EARLY CARPENTERS AND FAMILIES COMPETING FOR BRAGGING RIGHTS WITHIN THE CAMP. THE EXTERIOR FINISH IS BOARD AND BATTEN, WITH TURNED POSTS ON THE PORCH. ROOFS ARE METAL TO BETTER HEAR THE RAIN. WITHIN THE COMPACT TENT ARE THREE BEDROOMS, THREE BATHS, AND A LIVING/DINING/KITCHEN AREA.

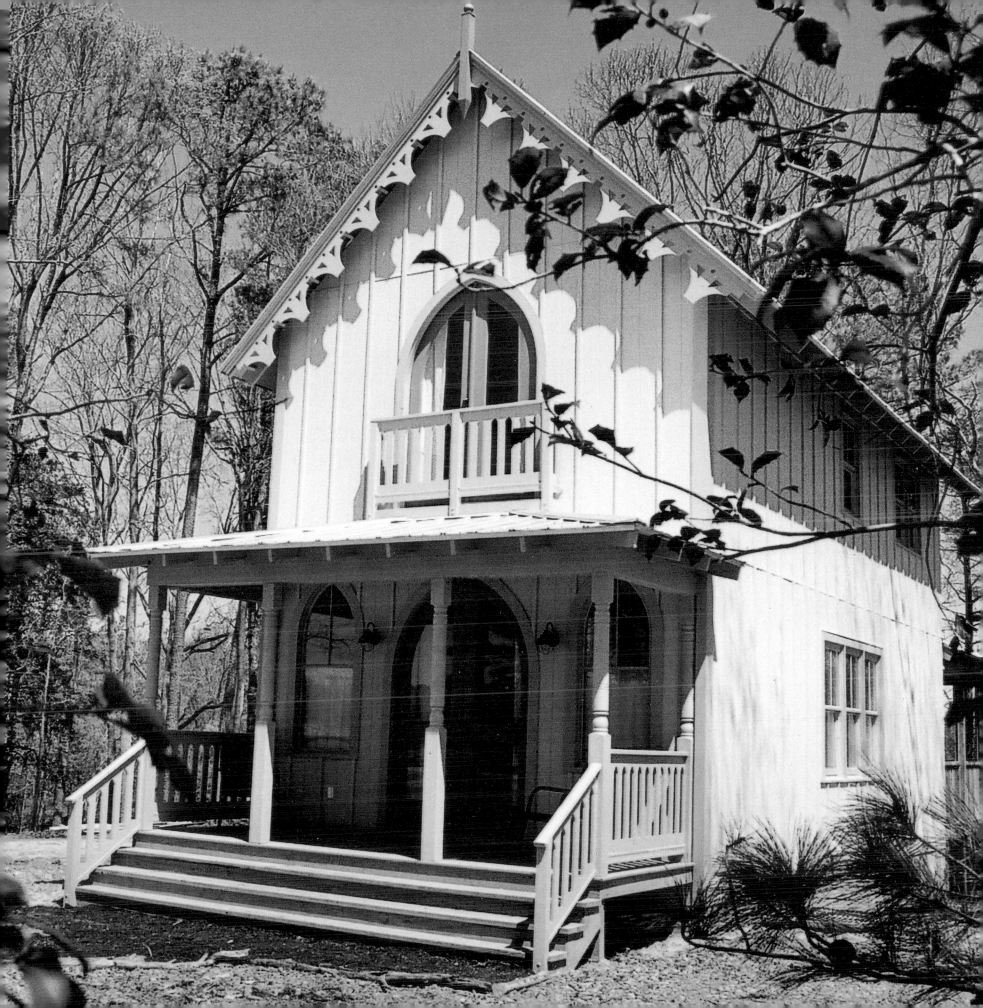

Elevations

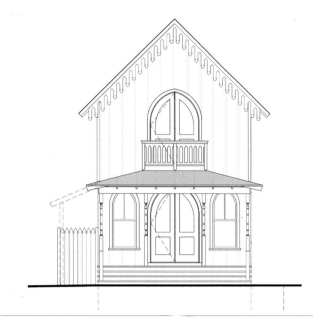

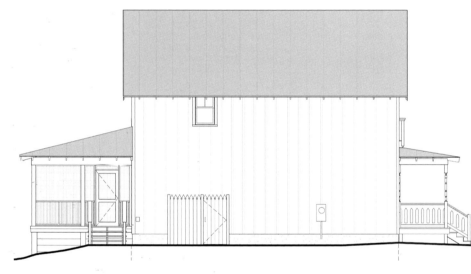

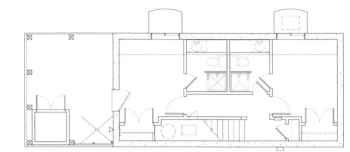

Lower Floor Plan

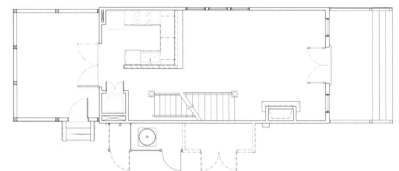

Main Floor Plan

Upper Floor Plan

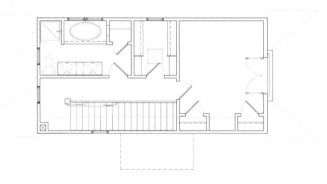

Previous Pages: The over sized windows and doors give the cottage a facelike expression, typical of this style.

Right and Below: The rear façade features porches with views of a creek.

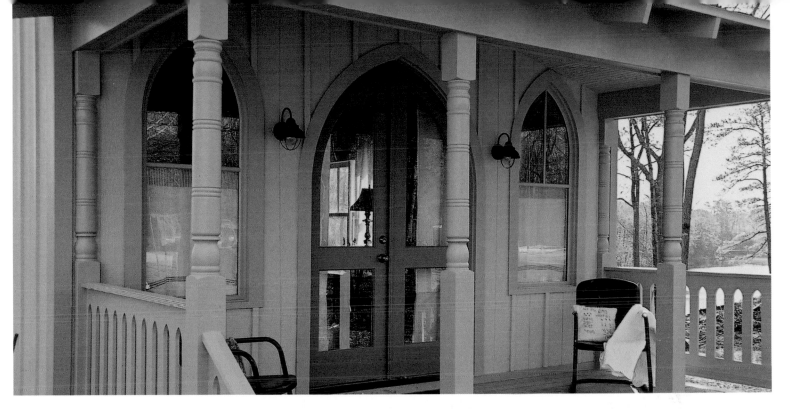

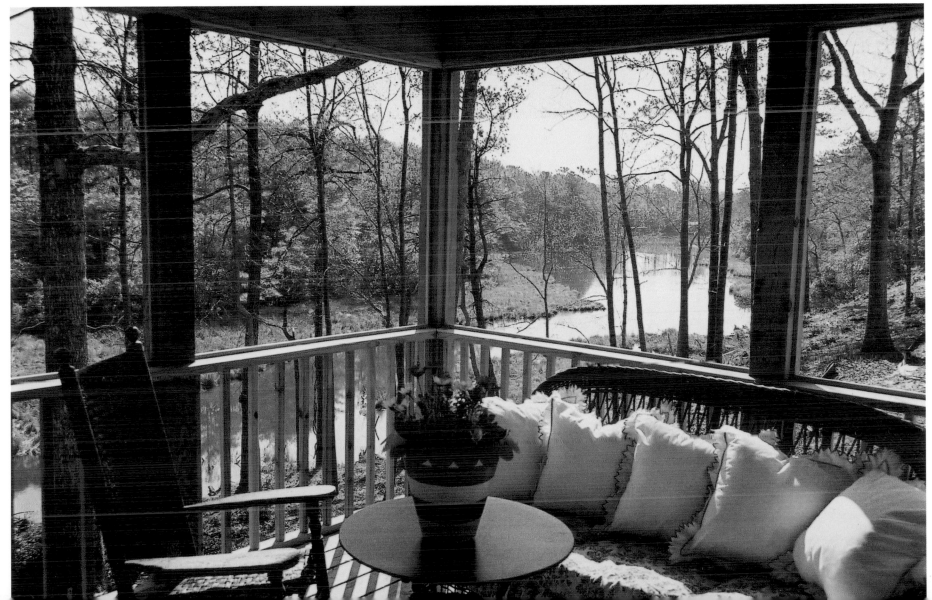

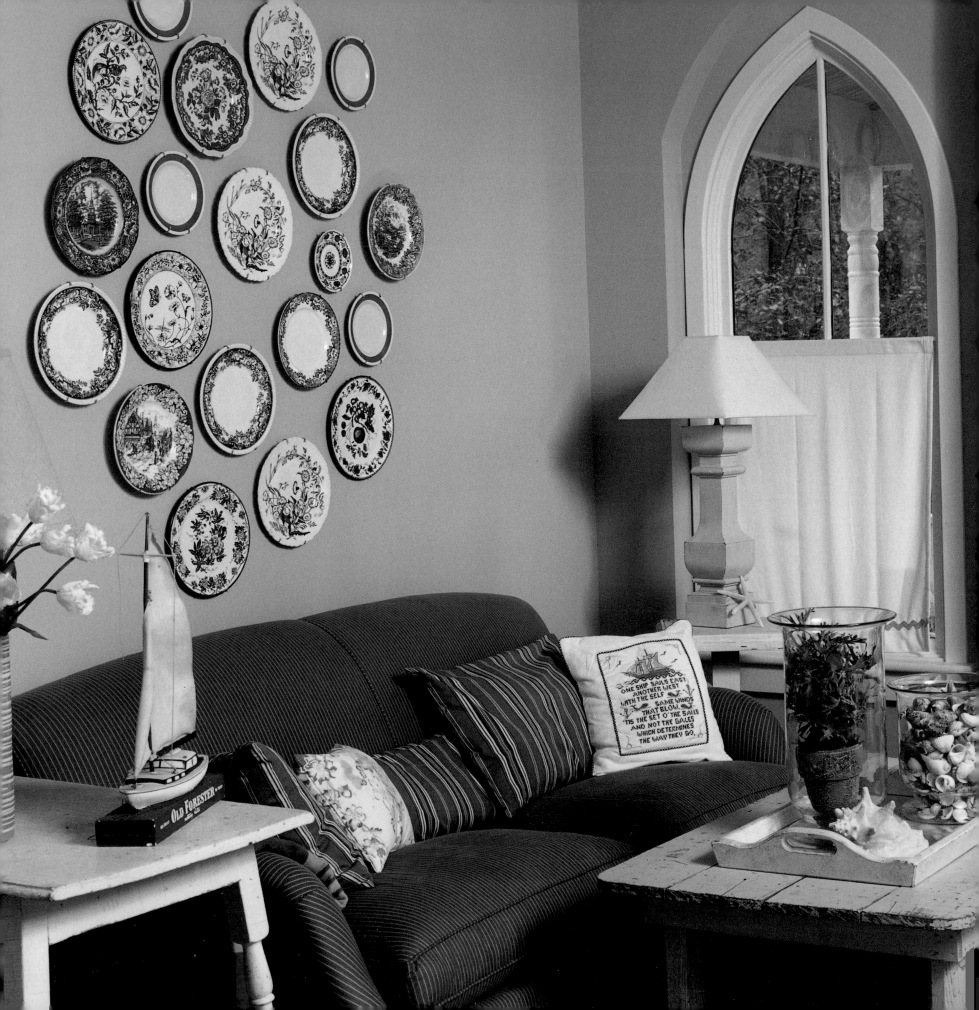

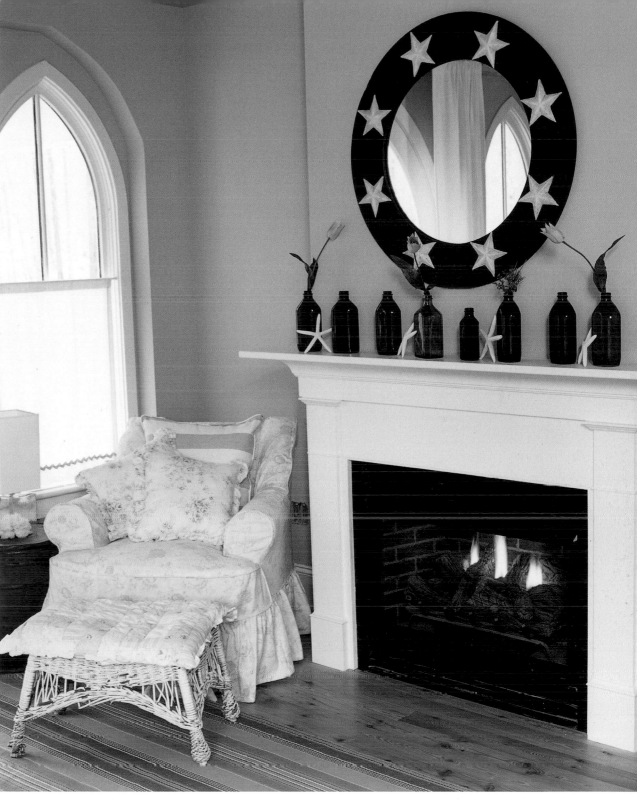

Left: The living area as seen from the kitchen
Above: View from the second floor to the living area

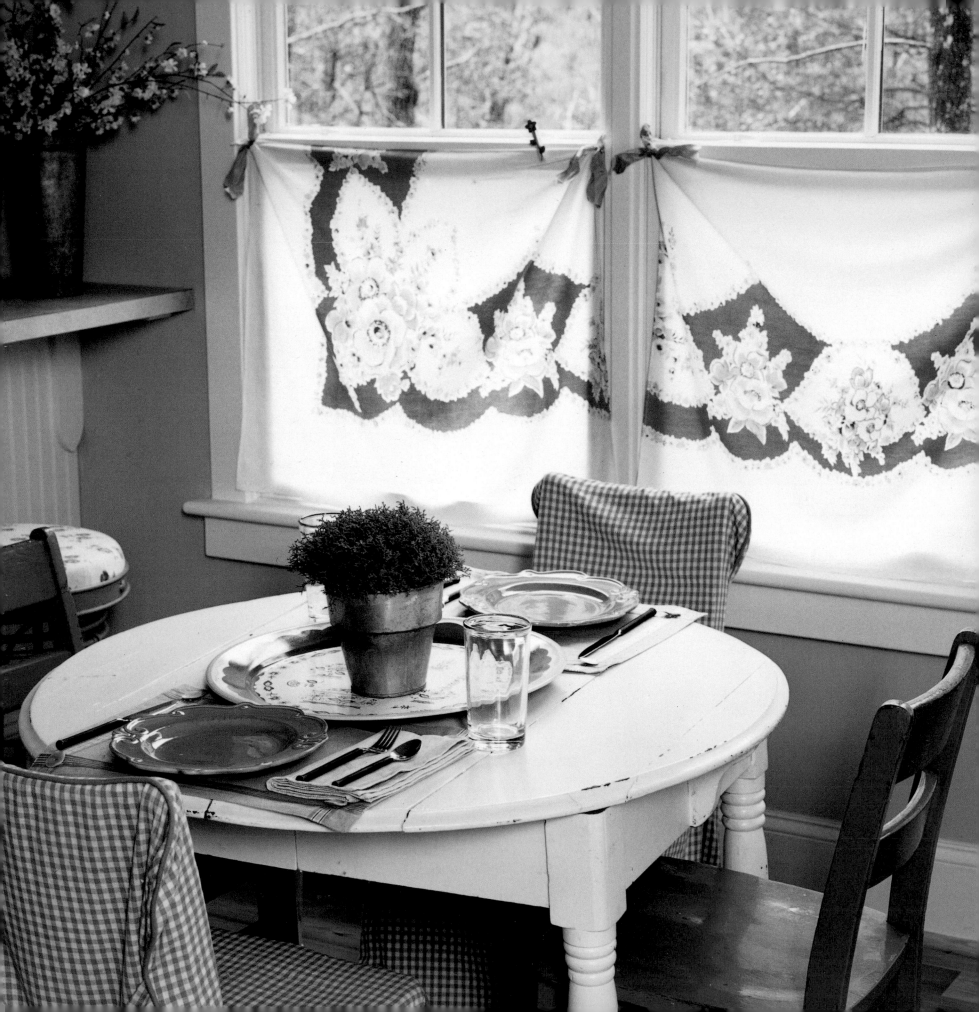

Methow Cabin

1313 Square Feet

Eggleston Farkas Architects
Photography: Jim Van Gundy

L OCATED ON A SPARSE MEADOW ADJACENT TO A NET-
WORK OF CROSS-COUNTRY SKIING TRAILS, THIS SMALL
RETREAT SERVES AS A BASE FOR CROSS-COUNTRY SKI-
ING AND MOUNTAIN BIKING. IT CAN ACCOMMODATE SIX TO
EIGHT PEOPLE WITH A COMMUNAL AREA FOR SOCIALIZING
AND DINING. THE BUILDING IS ALIGNED WITH THE VALLEY,
OPENING AT THE ENDS TO FOCUS ON THE VIEWS UP AND
DOWN THE VALLEY. THE SERVICE ZONE SHIELDS THE LIVING
SPACES FROM THE ROAD. A SLOT WINDOW, POSITIONED FOR
SEATED VIEWING, FRAMES SKIERS GLIDING BY.

THE EXTERIOR CEDAR SIDING IS CONTINUED THROUGH THE
LIVING SPACES TO CREATE A CONTINUUM OF INTERIOR AND
EXTERIOR SPACE. THE SHED ROOF ECHOES THE SLOPE OF THE
HILLS BEYOND, WHILE ALLOWING SNOW TO SLIDE OFF EASI-
LY. THE SHED CREATES A PROTECTED ENTRY PORCH AT THE
LOW END AND A SLEEPING LOFT AT THE HIGH END. ACCESSED
FROM THE SIDE, THE ENTRY STAIR REMAINS SNOW FREE EVEN
AS SNOW AVALANCHES DRAMATICALLY OFF THE END.

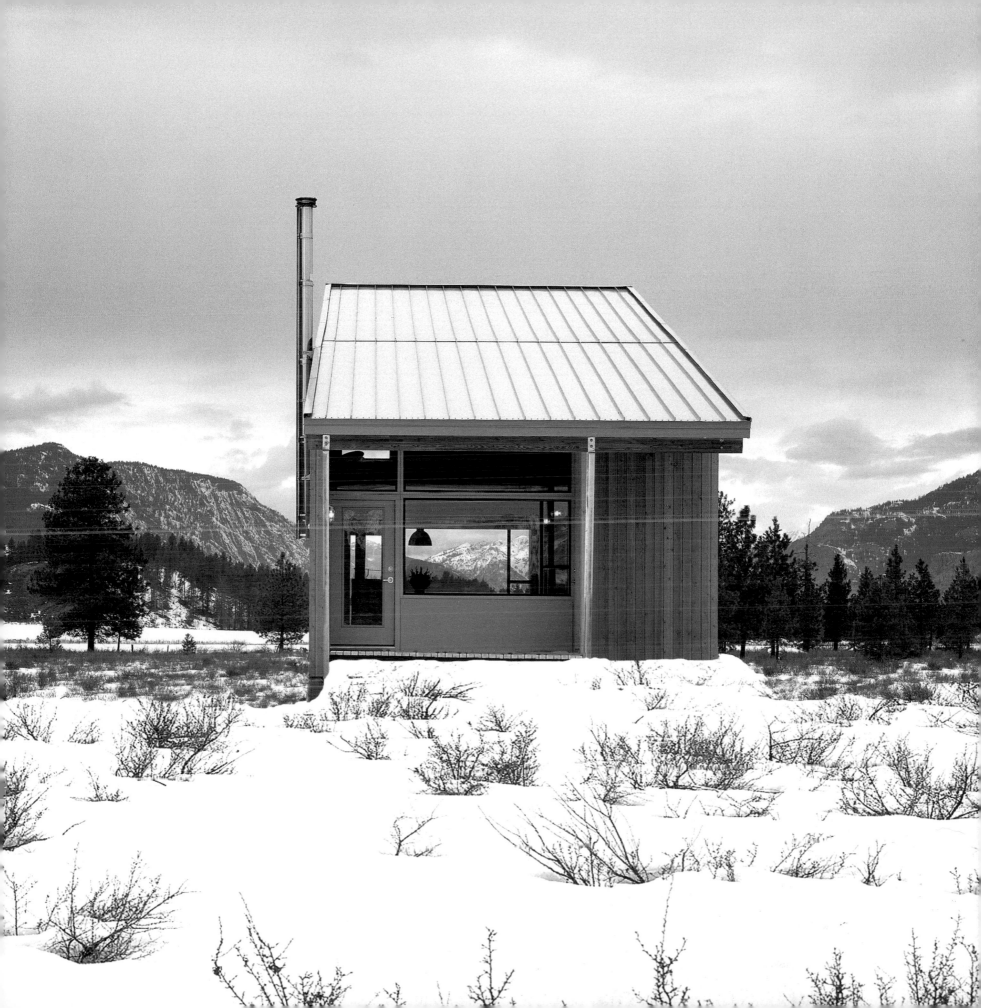

Section

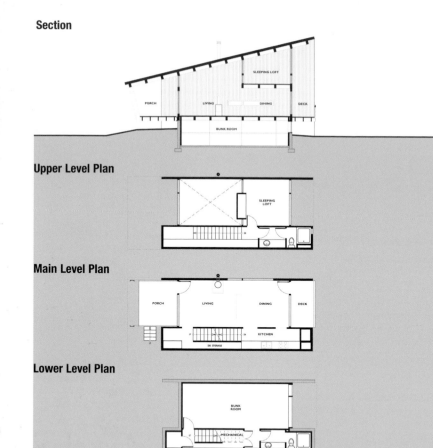

Upper Level Plan

Main Level Plan

Lower Level Plan

Site Sketch

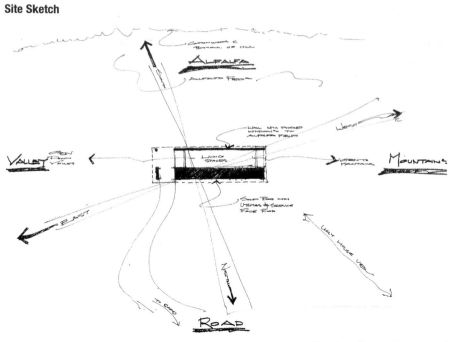

Previous Pages: The retreat is located on a sparse meadow adjacent to a network of cross-country skiing trails.

Below: The roofline echoes the slopes of the hills.

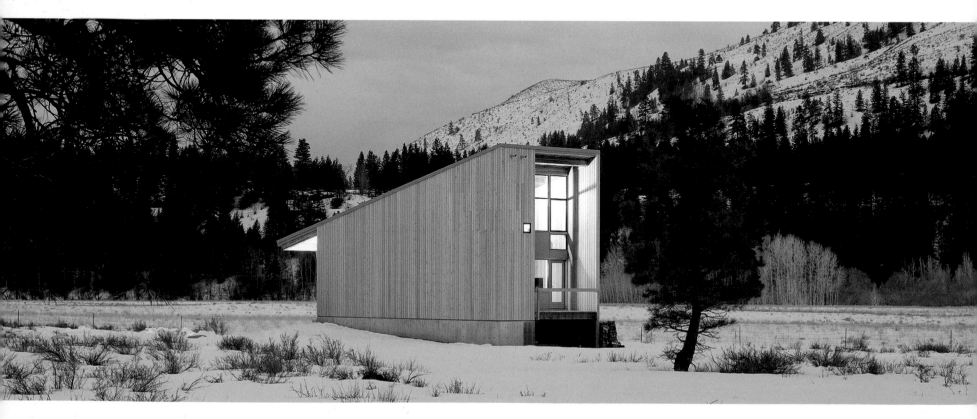

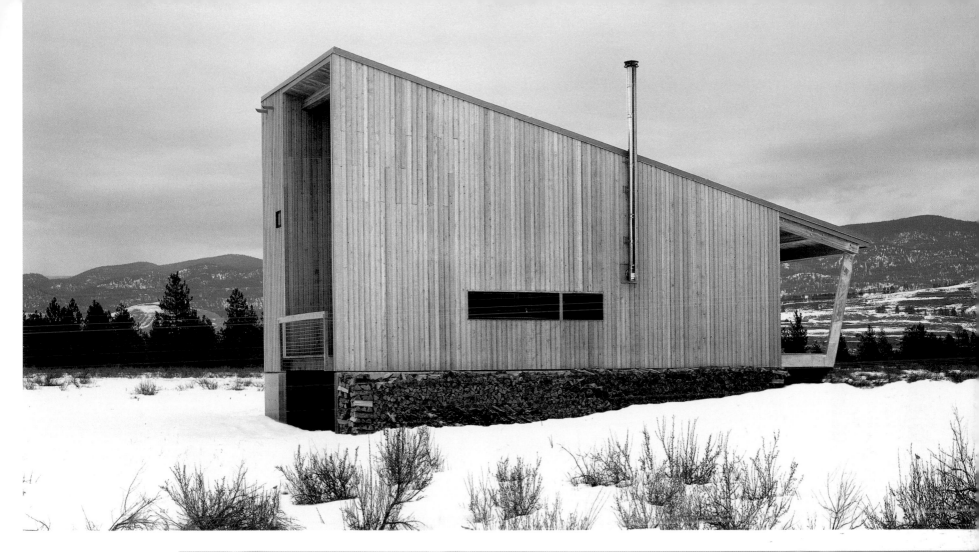

Above: The slot window frames skiers going by.
Right: Entry

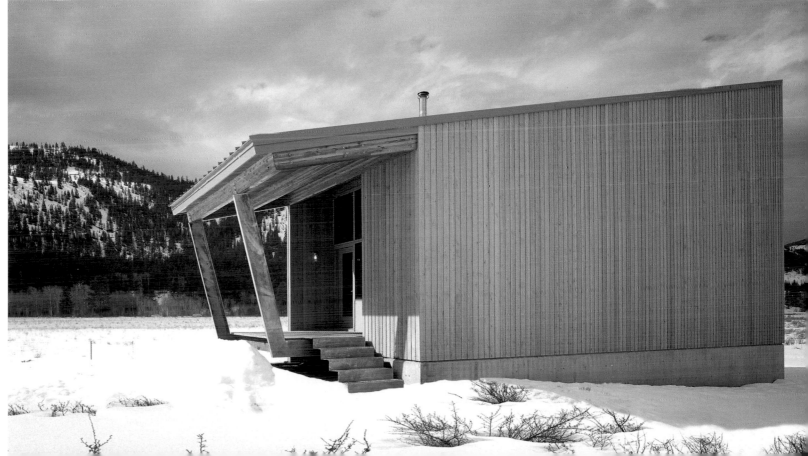

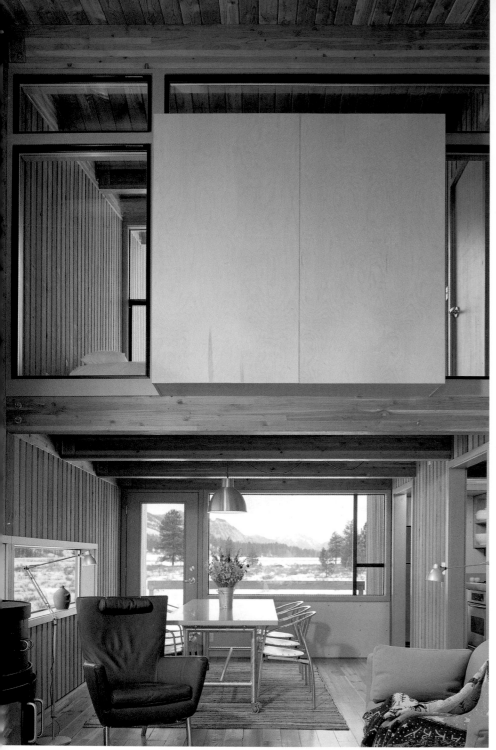

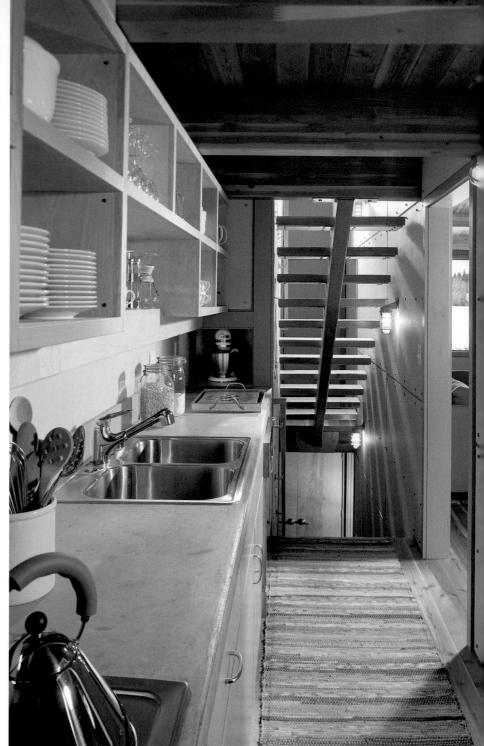

Above Left: Living area
Above: The kitchen and stairs to the master bedroom
Above Right: Dining area with the slot window
Right: Bedroom

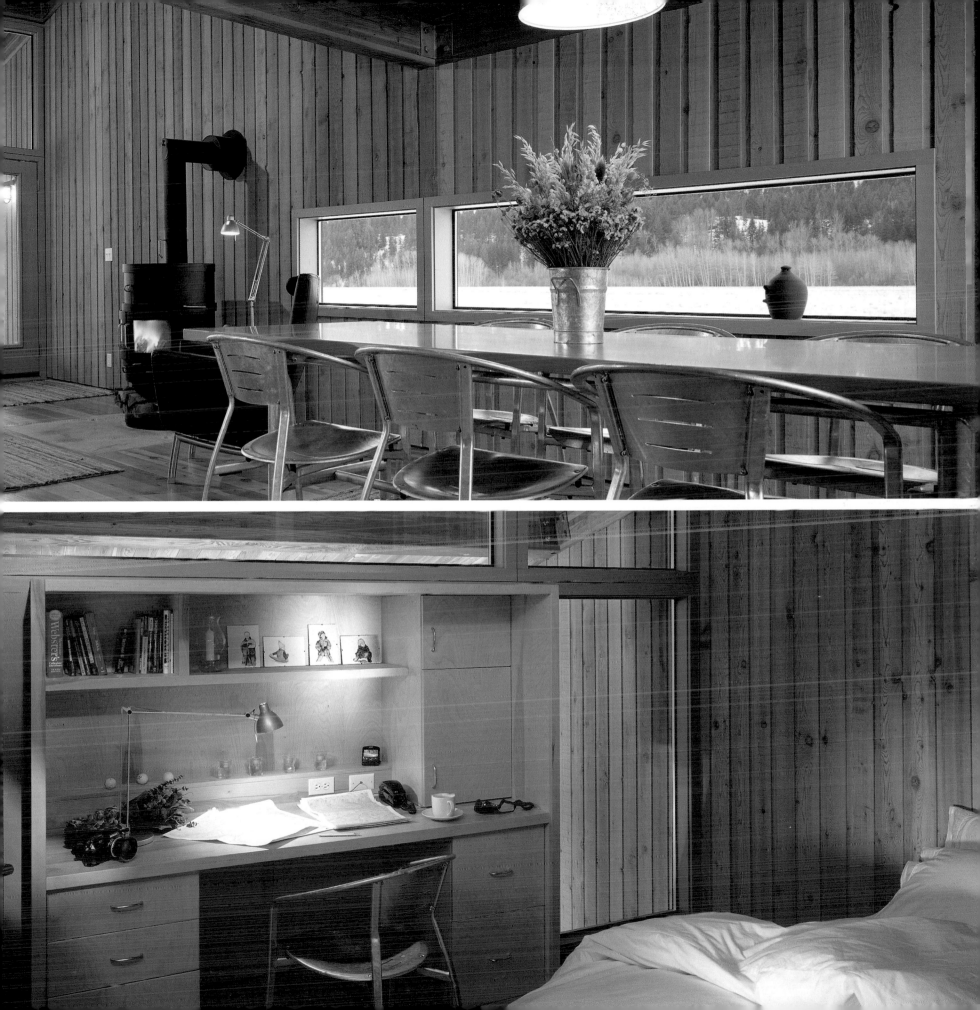

Barn at Bonny Shore

900 Square Feet

Historical Concepts
Photography: Richard Leo Johnson

THE DESIGN BEGAN AS A BARN AND EVOLVED TO ITS PRESENT USE AS A GUESTHOUSE WITH ENTERTAINING ON THE FIRST LEVEL AND LIVING QUARTERS ABOVE. THE BARN IS CONSTRUCTED ENTIRELY OF RECLAIMED LUMBER; EVEN THE WORN STEP TREADS RECALL AN EARLIER LIFE. EVERY EFFORT WAS MADE TO UTILIZE EVERY INCH OF THE COMPACT SPACE, WHICH CAN COMFORTABLY SLEEP EIGHT.

THE UPPER LEVEL CONSISTS OF A DINING, SEATING, AND KITCHEN AREA. A BATHROOM WRAPS ONE SIDE OF THE STRUCTURE AROUND THE KITCHEN WALL. A LOFT ABOVE THE KITCHEN OFFERS A BIRDS-EYE VIEW OF THE ROOM AND PROVIDES ADDITIONAL SLEEPING QUARTERS. A BUNK ROOM WITH TWO BUILT-IN BEDS IS SEPARATED FROM THE FIRST FLOOR ENTERTAINING AREA BY A SLIDING BARN DOOR.

THE GALVANIZED METAL ROOF HAS LONG OVERHANGS TO PROVIDE COOLING SHADE. A TIMBER-FRAMED, REAR UPPER-LEVEL SCREENED PORCH, COMPLETE WITH ROCKING CHAIRS, PROVIDES VIEWS OF THE DISTANT MARSHES.

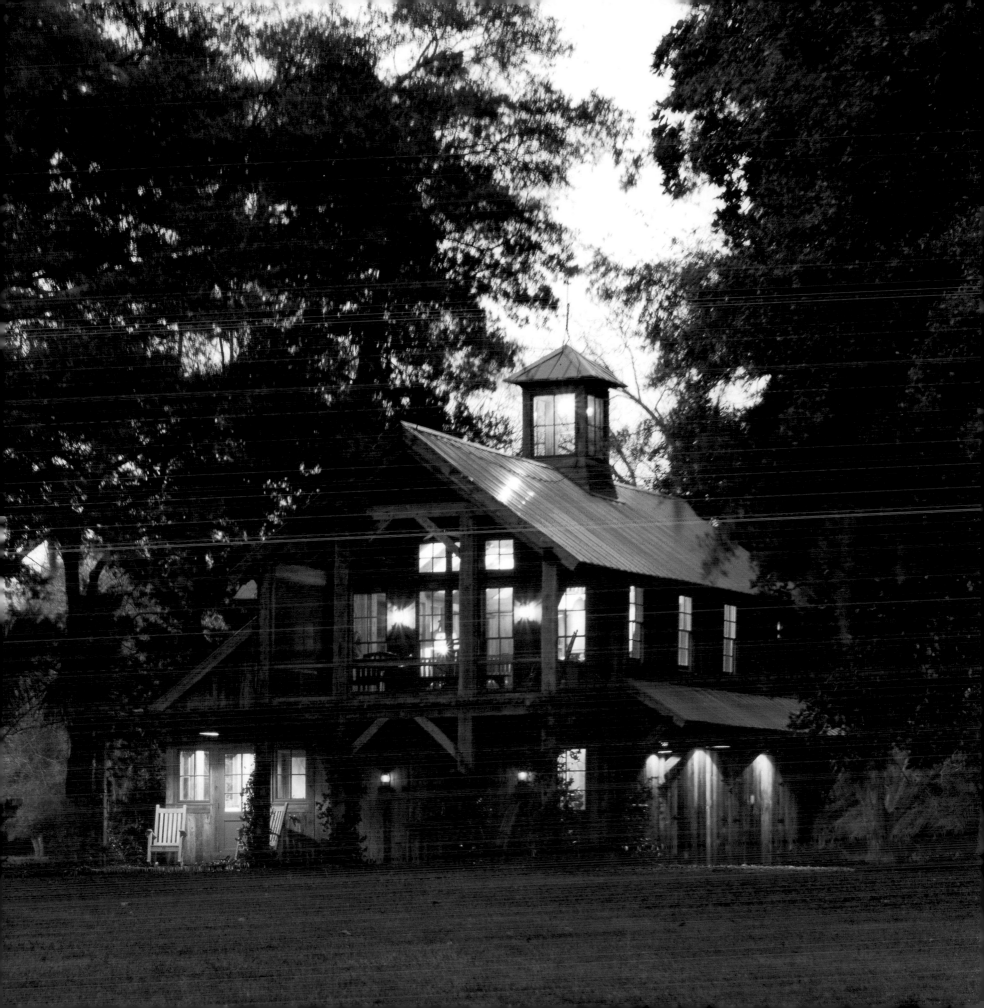

First Floor Plan

Second Floor Plan

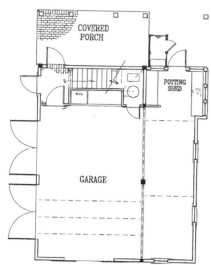

Previous Pages: The small barn glows from its cupola to its base.

Below Left and Right: The upper-level screened porch

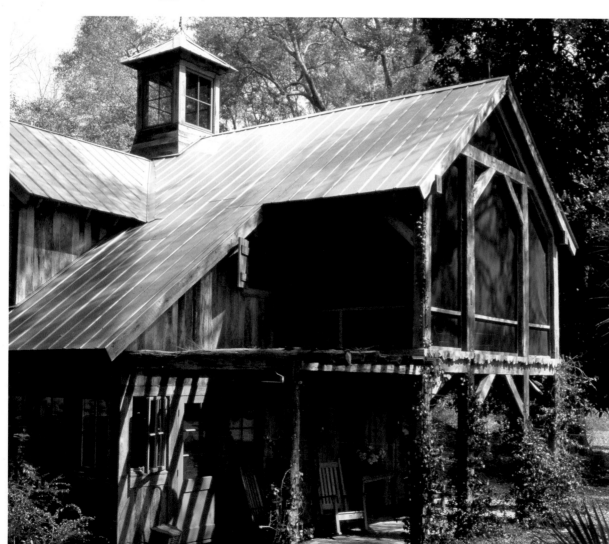

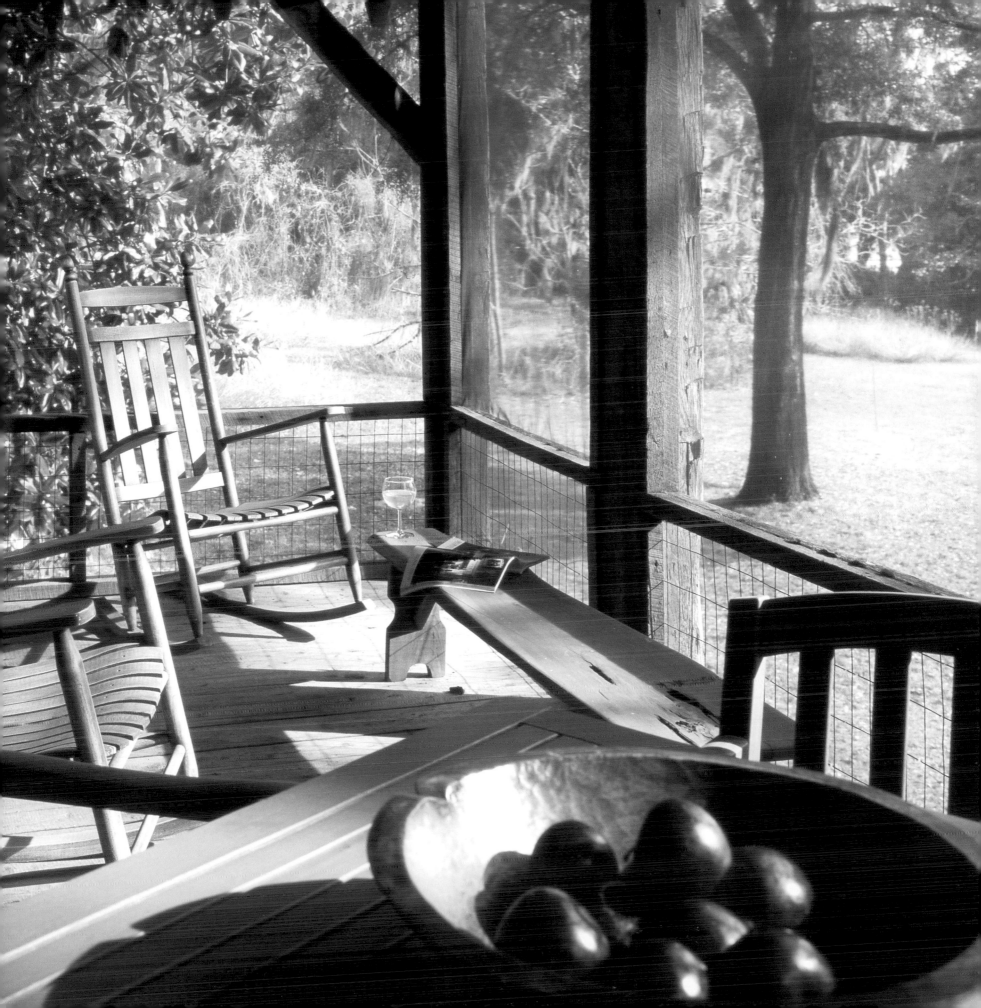

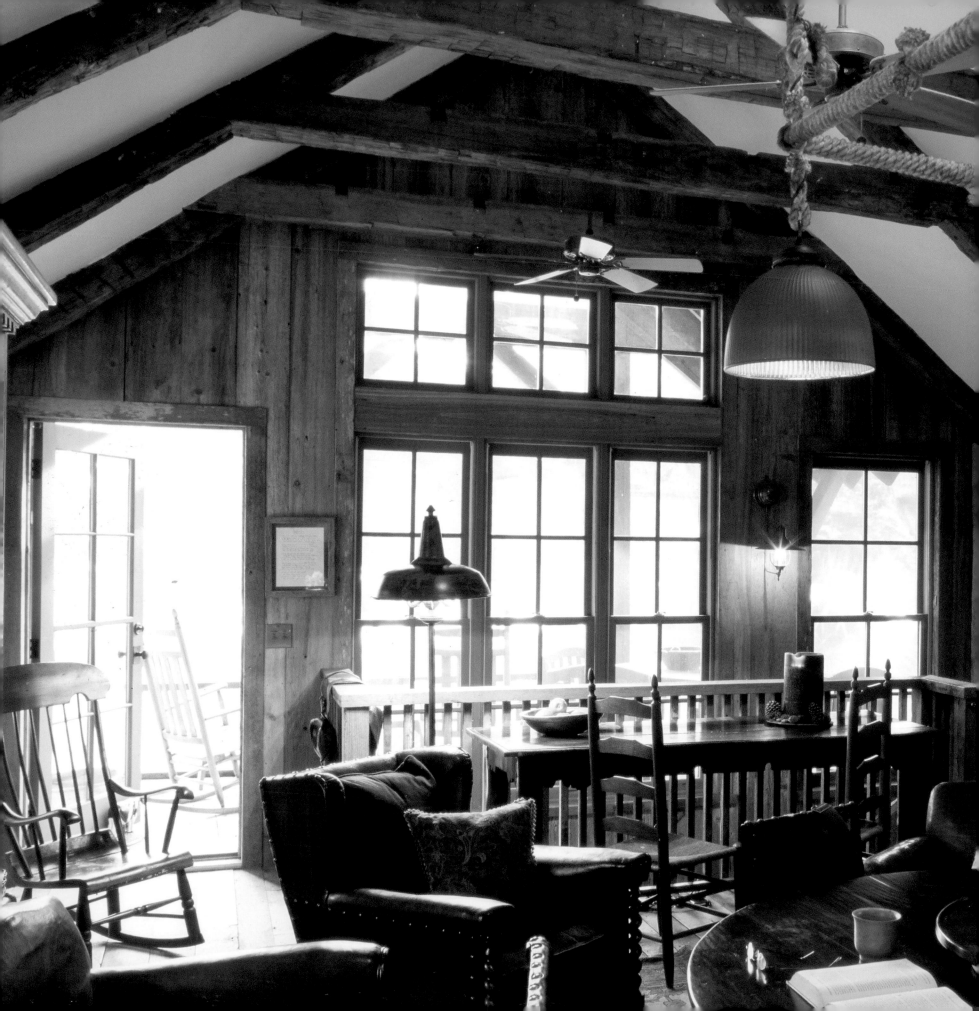

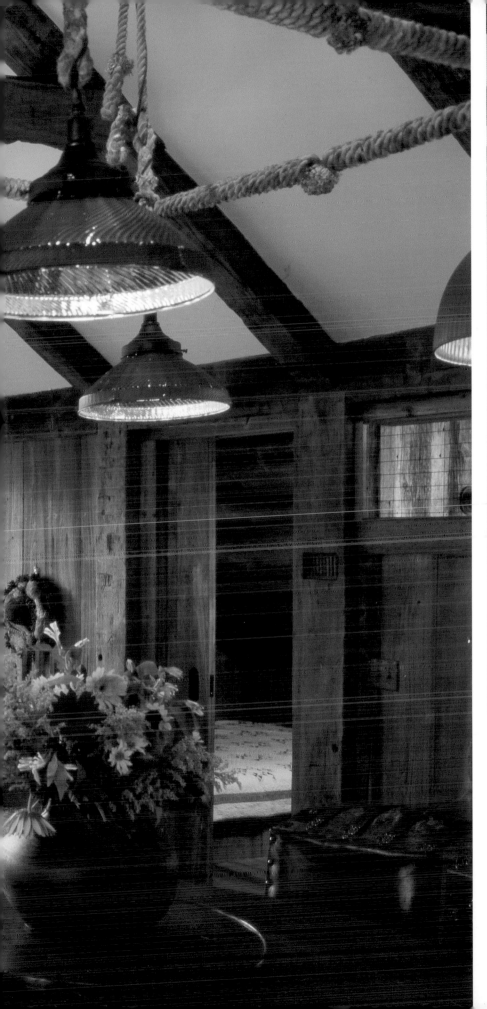

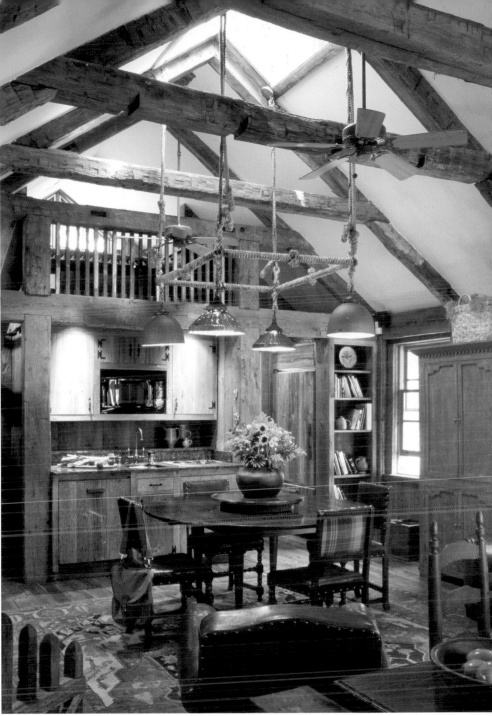

Left and Above: The entertaining area is complete with a custom-made light fixture crafted of old rope and four antique globes.

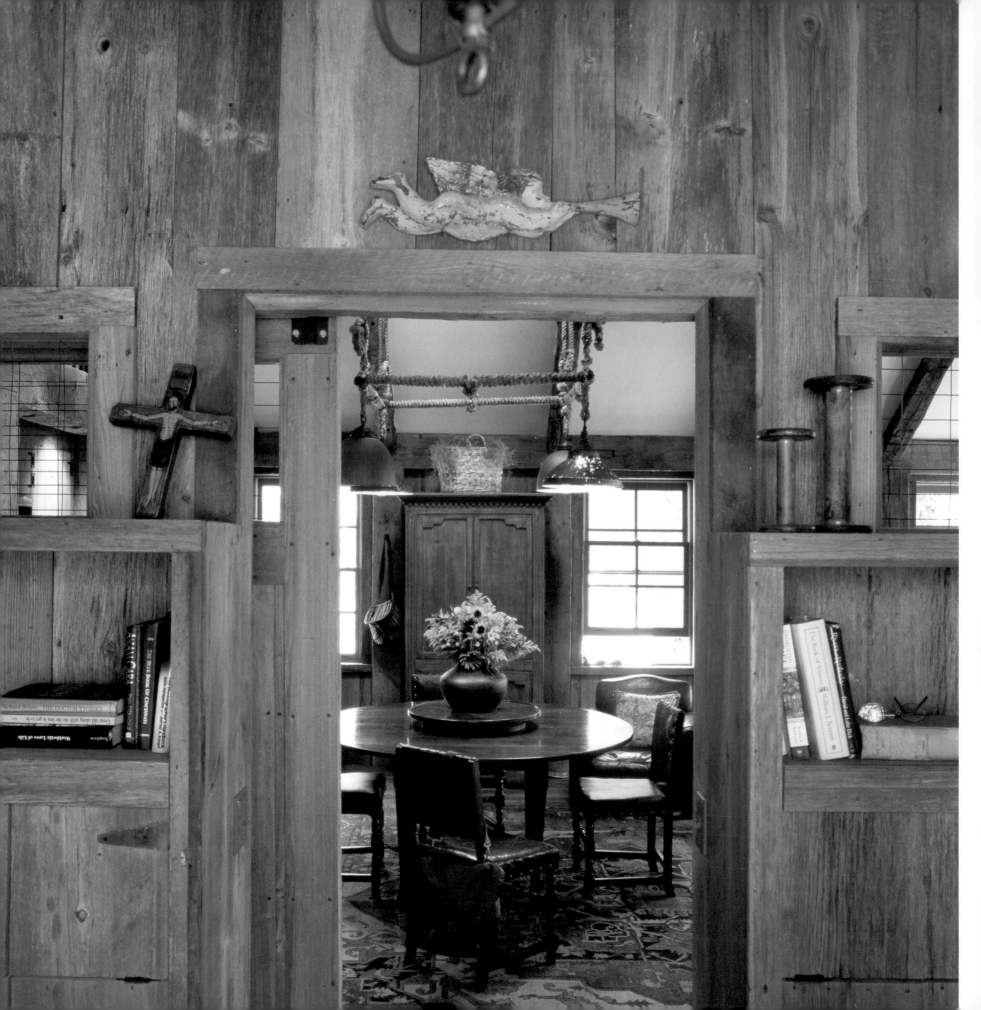

Left: View of the entertaining area from the bunk bedroom

Above: View into the bunk bedroom

Above Right: The bathroom sink is made from a galvanized wash bucket set in a wood frame.

Mathieson Residence

1500 Square Feet

Eggleston Farkas Architects
Photography: Jim Van Gundy

THE SITE ORIGINALLY HOUSED A FLOWER SHOP FOR THE NEIGHBORING CEMETERY. IN REBUILDING THE STRUCTURE, THE OWNERS WANTED AN OPEN LOFT PLAN WITH AN INTERIOR COURTYARD SHIELDED FROM THE ADJACENT NOISY STREET.

THE EXISTING STRUCTURE WAS CLOSER TO THE STREET THAN CURRENT ZONING REGULATIONS ALLOW, SO THE EXISTING FOOTPRINT WAS RETAINED AND SERVES AS THE BASE FOR THE NEW TWO-STORY, OPEN LOFT STRUCTURE. A SHED ON THE PROPERTY SERVED AS A WORKSHOP DURING CONSTRUCTION. IT WAS CONVERTED INTO STORAGE, STUDIO, AND GARAGE SPACES ONCE THE HOUSE WAS COMPLETED. THE TWO STRUCTURES, ALONG WITH A CLAD SITE WALL, DEFINE AN URBAN COURTYARD. THE HOUSE FACES INTO THE COURTYARD, THE SOLID WALLS ACTING AS A BUFFER FROM THE NOISY STREETS AND BUS STOP.

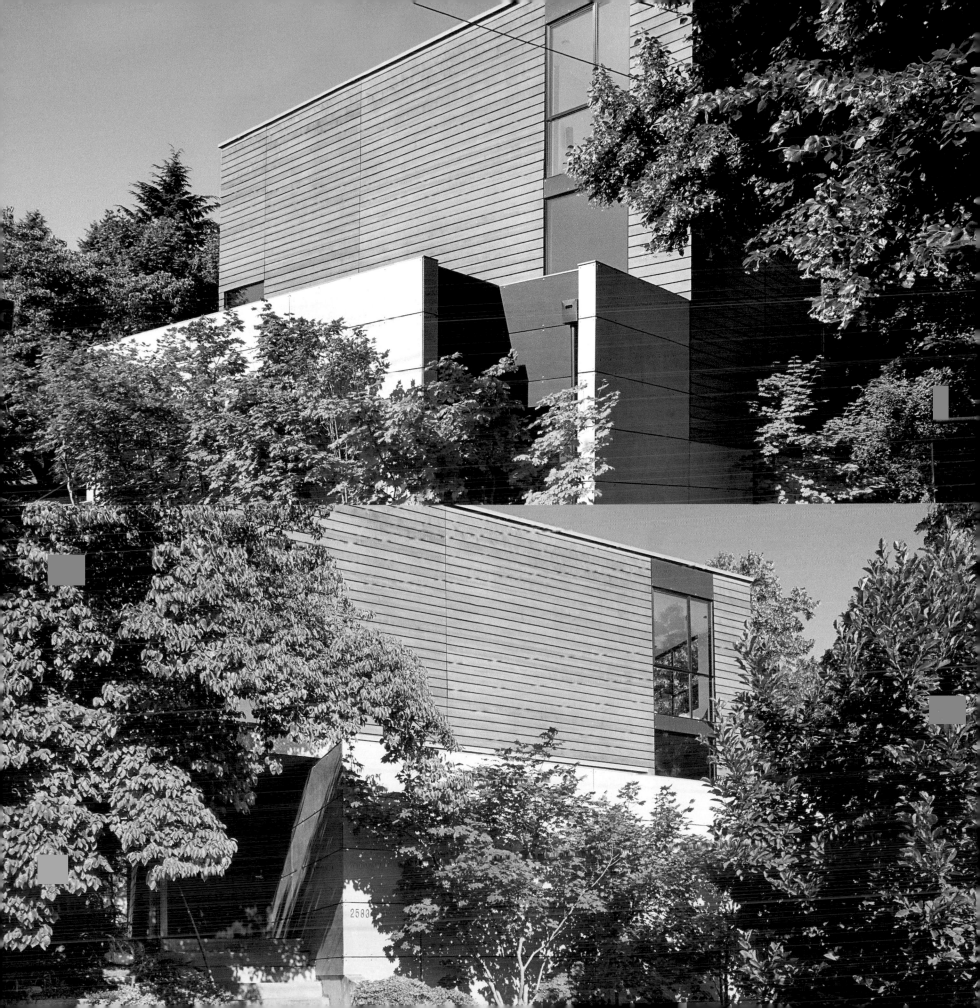

North Elevation

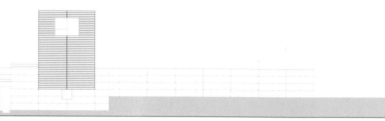

Site Plan/Floor Plan

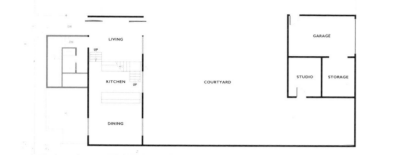

LIVING
UP
KITCHEN
UP
DINING
COURTYARD
GARAGE
STUDIO
STORAGE

Previous Pages: Street
façade
Below Left and Below:
Entry

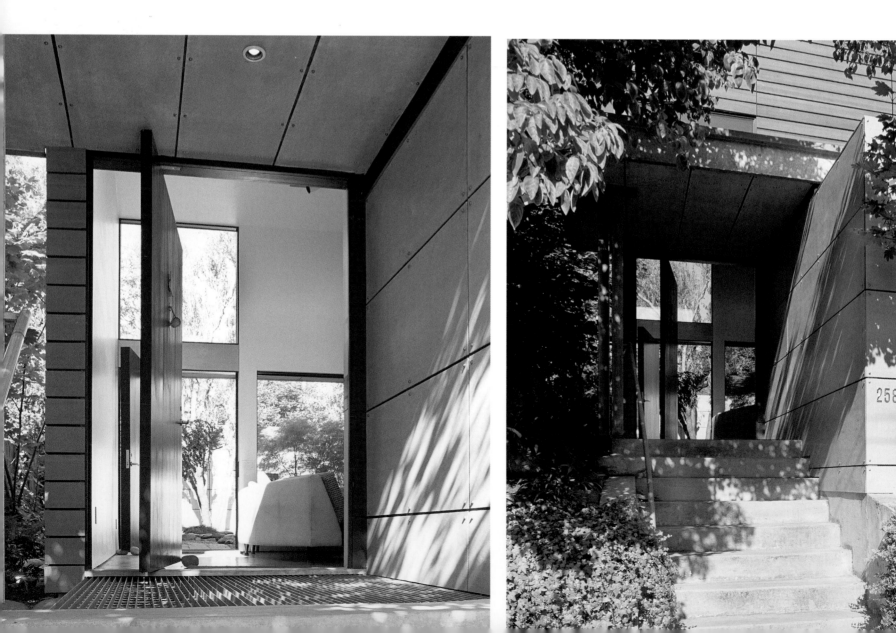

2583

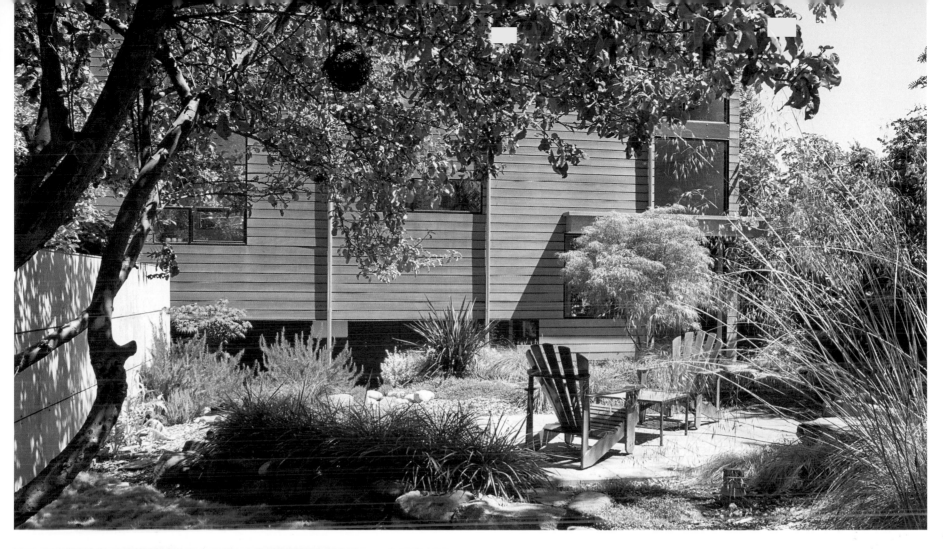

Above: Courtyard
Left: North elevation

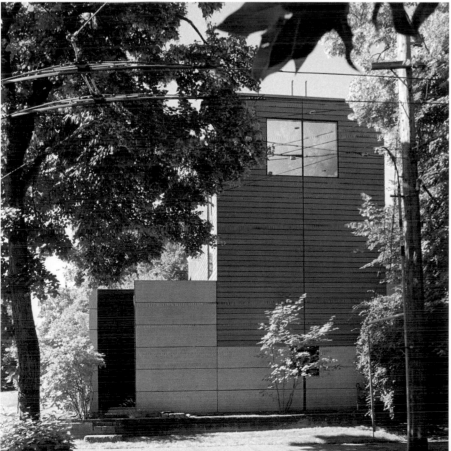

175

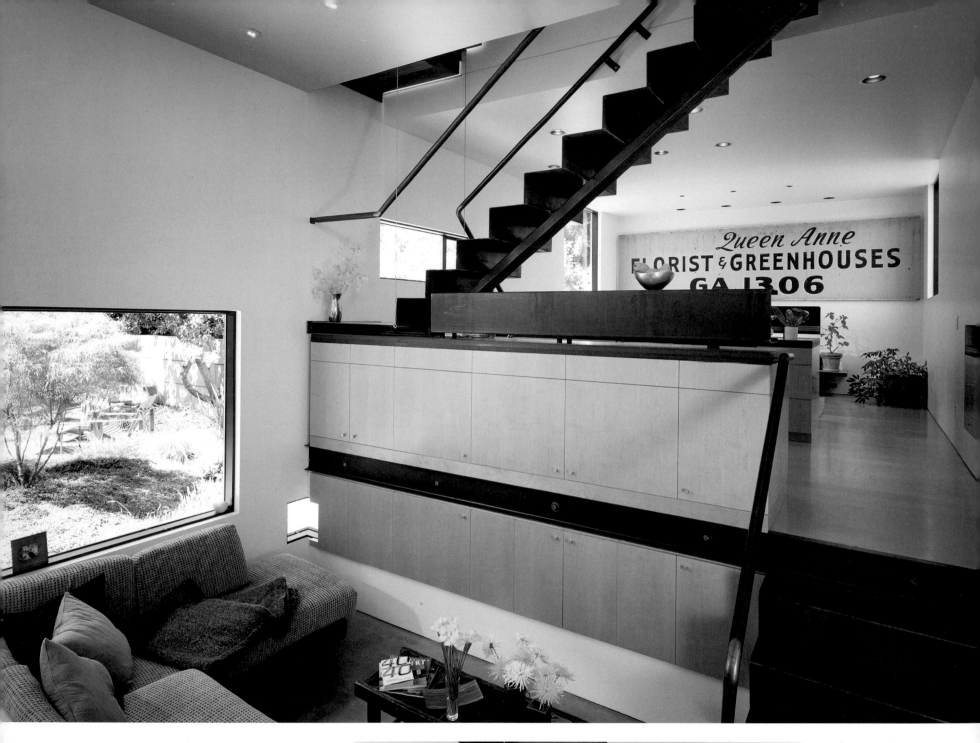

Above: View of kitchen from living area
Left: Stair detail
Above Right: Kitchen
Right: Bedroom

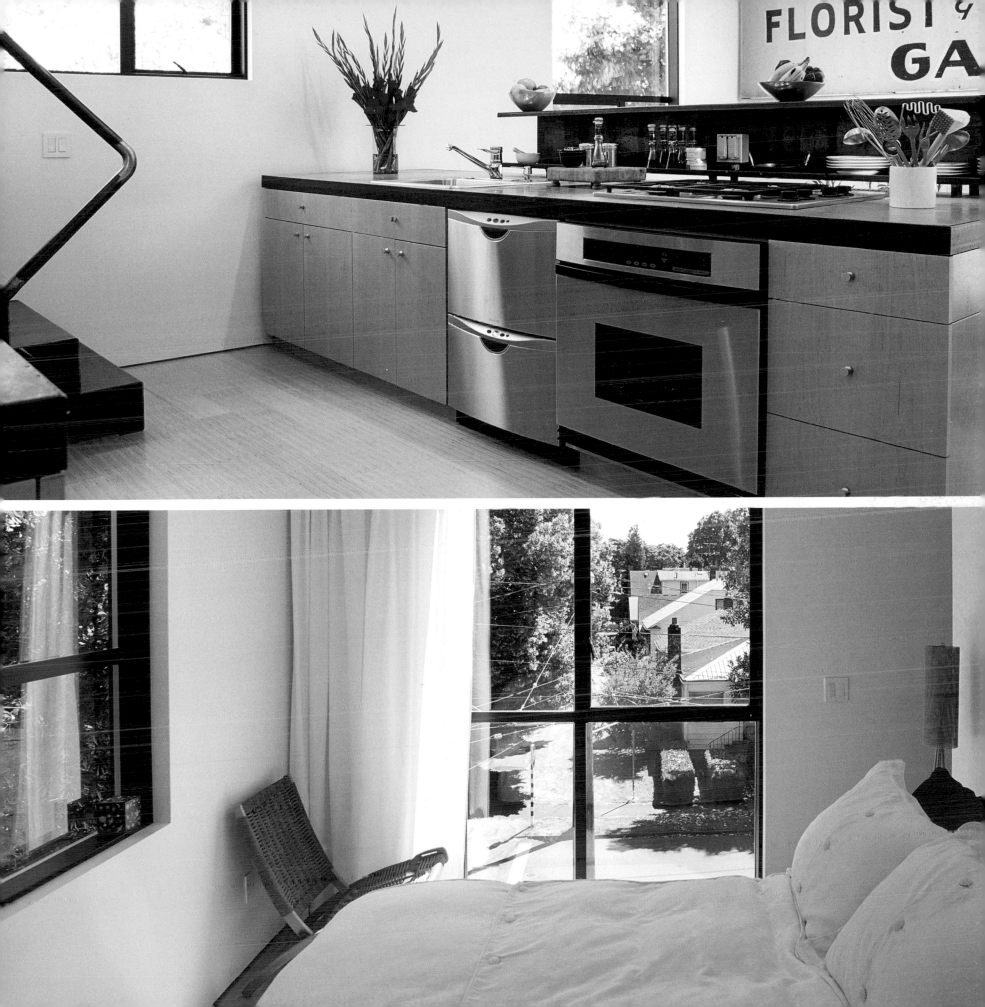

Karuizawa Villa

1100 Square Feet

Office of Makoto Yamaguchi

Photography: Sergio Pirrone

KARUIZAWA IS A WEEKEND DESTINATION FOR TOKYOITES. THE VILLA, DESIGNED FOR TWO MUSICIANS, IS PERCHED ON A STEEP SLOPE ORIENTED SOUTH IN THE FOREST, AND LOOKS OUT OVER A TOWERING VIEW OF MOUNTAIN RANGES. THEY WANTED AN EMPTY, WHITE SPACE THAT COULD FUNCTION AS A HOME, A GALLERY, AND A SALON FOR INTIMATE CONCERTS. INSIDE, GLASS, MIRRORS, AND POLISHED STAINLESS STEEL REFLECT THE LIGHT AND VIEW. THE KITCHEN AND BATH ARE BUILT INTO THE FLOOR SO THAT THE INTERIOR SPACE REMAINS FLAT, WITH NO VISIBLE OBSTACLES. THREE OPENINGS ARE ORIENTED TOWARD THE MOST DRAMATIC VIEWS. THE OUTSIDE FORMS A REMARKABLE CONTRAST TO THE INTERIOR. THE ENTIRE EXTERIOR IS A SEAMLESS, FIBER-REINFORCED PLASTIC SKIN PAINTED WHITE.

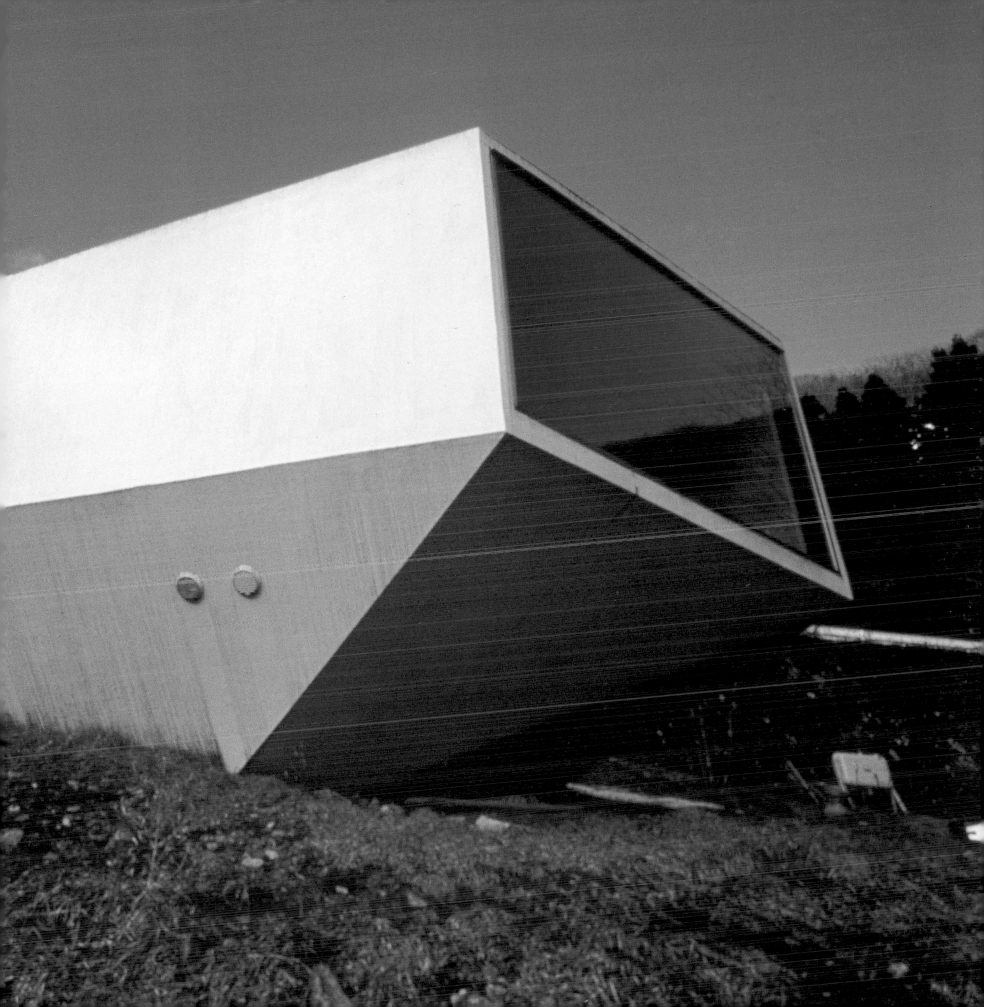

Floor Plan

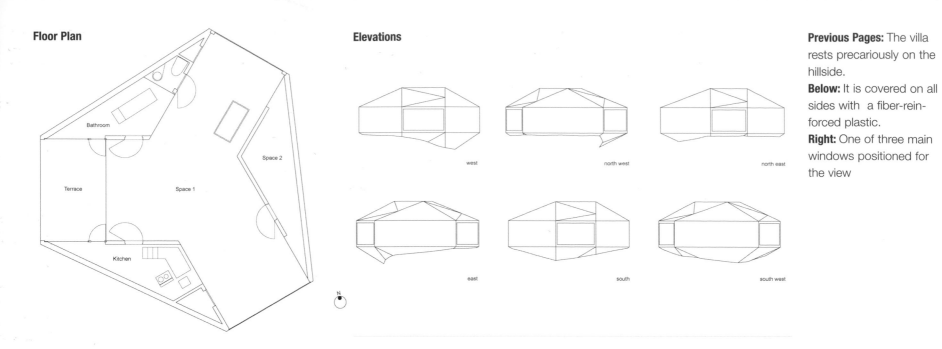

Bathroom

Terrace

Space 2

Space 1

Kitchen

Elevations

west

north west

north east

east

south

south west

N

Previous Pages: The villa rests precariously on the hillside.

Below: It is covered on all sides with a fiber-reinforced plastic.

Right: One of three main windows positioned for the view

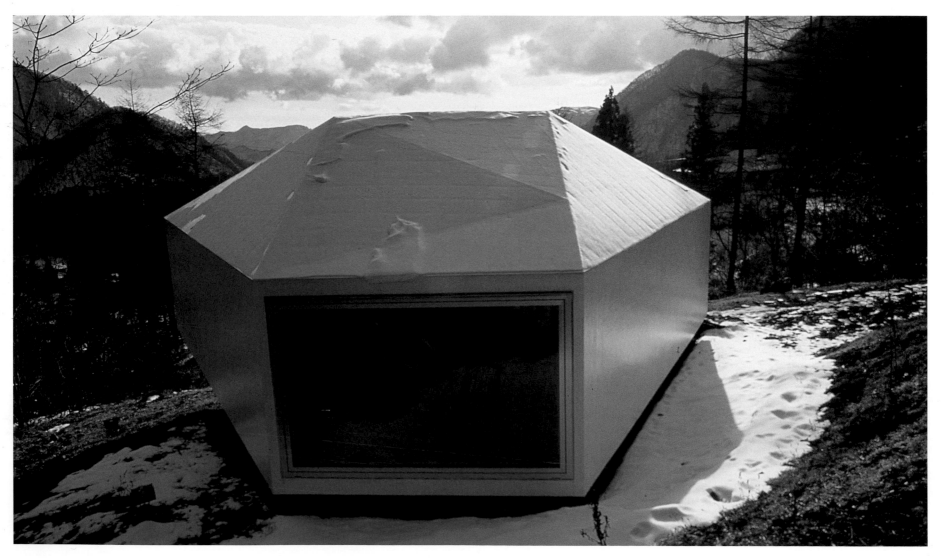

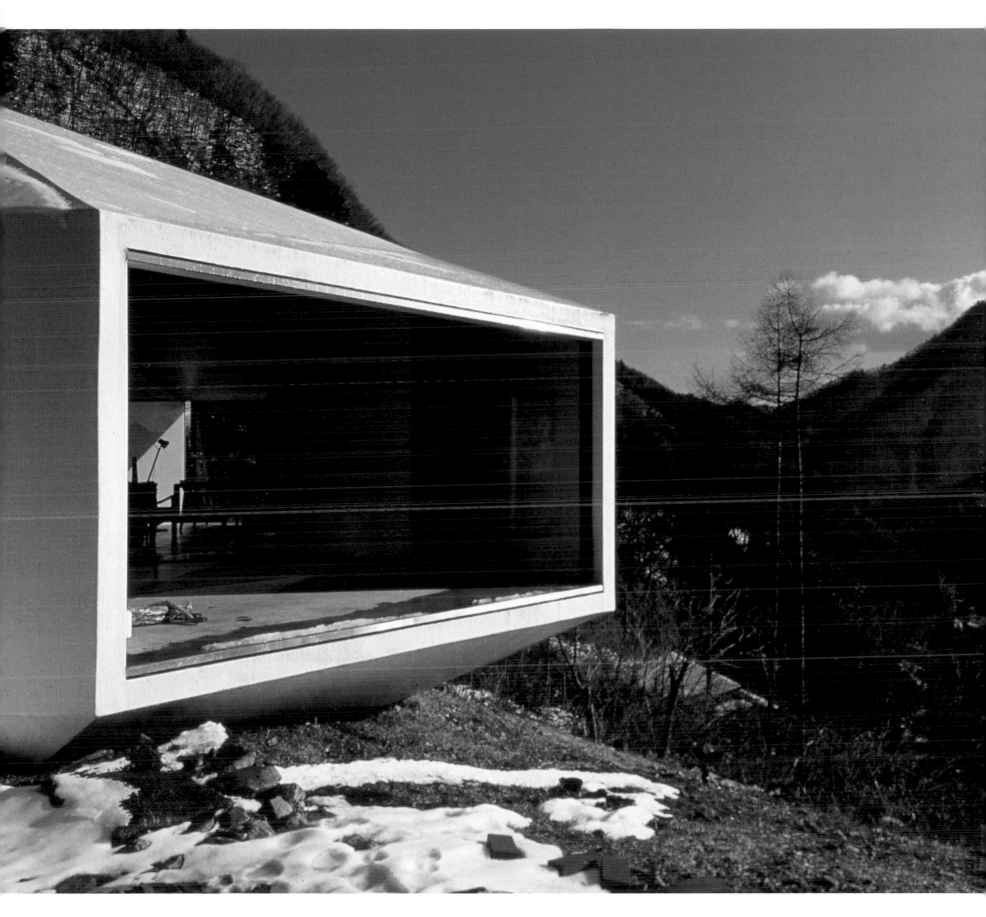

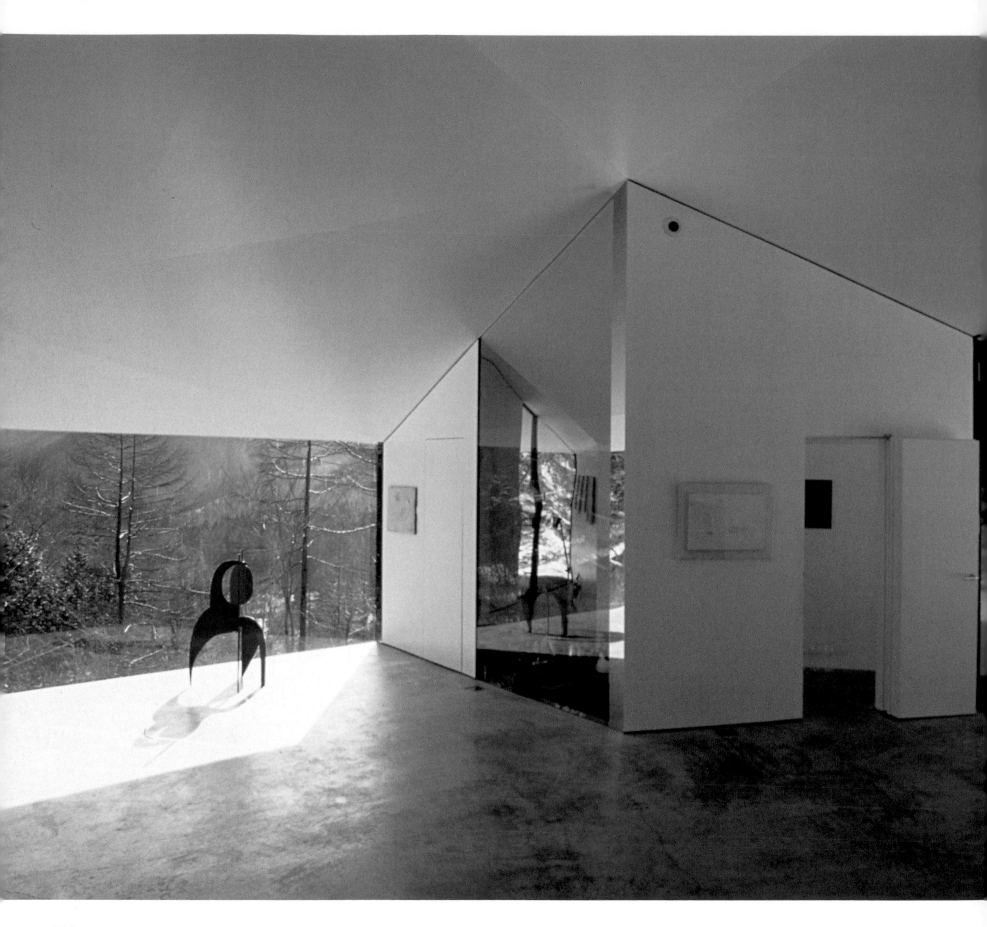

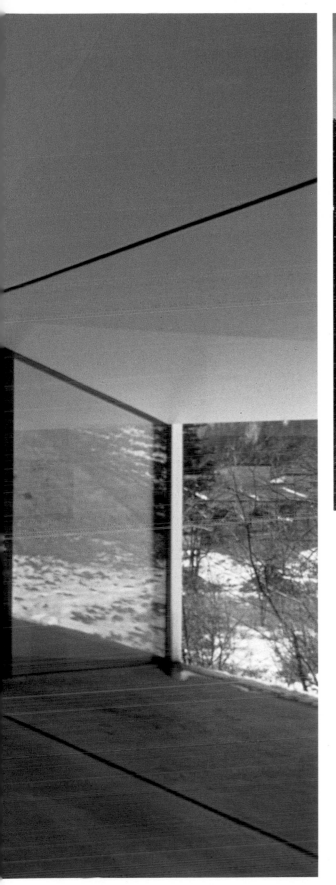

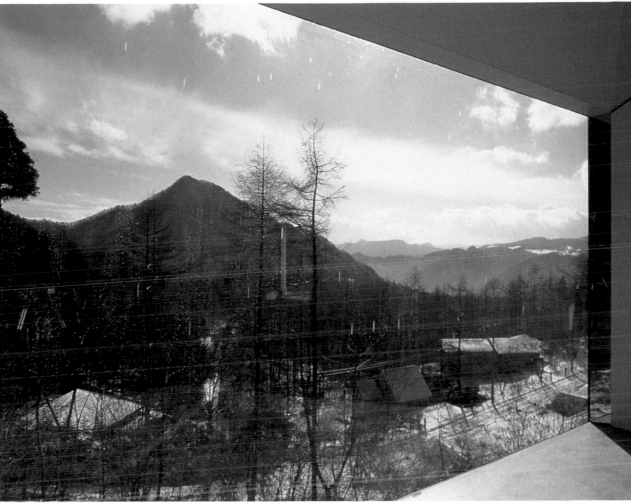

Above: The vast expanse of glazing provides a panoramic view.
Left: The open, interior space is multi-functional.